expressive DRAWING

A PRACTICAL GUIDE TO FREEING THE ARTIST WITHIN

expressive DRAWING

STEVEN AIMONE

LARK
New York

TO KATHERINE...FOR SHARING WITH ME THE WONDER OF IT ALL.

SENIOR EDITOR

Deborah Morgenthal

ART DIRECTOR

Dana Irwin

LINE EDITOR

Allan Fallow

PHOTO ACQUISITIONS EDITOR

Katherine Aimone

PHOTOGRAPHY

David Aimone
Steven Aimone
Lynne Harty
Steve Mann
Stewart O'Shields
Keith Wright

EDITORIAL ASSISTANCE

Mark Bloom
Beth Sweet

EDITORIAL INTERN

Katie Henderson

PRODUCTION ASSISTANCE

Jeff Hamilton
Bradley Norris

COVER DESIGNERS

Dana Irwin
Carl Lehmann-Haupt

Library of Congress Cataloging-in-Publication Data

Aimone, Steven.
 Expressive drawing : a practical guide to freeing the artist within /
Steven Aimone.
 p. cm. -- (Live & learn)
 Includes index.
 ISBN 978-1-60059-281-2 (hc-plc with jacket : alk. paper)
 1. Drawing--Technique. I. Title.
 NC730.A38 2009
 741.2--dc22
 2008042687

10 9 8 7 6

Published by Lark Crafts, An Imprint of
Sterling Publishing Co., Inc.
1166 Avenue of the Americas, New York, NY 10036

Text © 2009, Steven Aimone
Photography © 2009, Lark Crafts, An Imprint of Sterling Publishing Co., Inc.,
unless otherwise specified
Illustrations © 2009, Steven Aimone

Distributed in Canada by Sterling Publishing,
c/o Canadian Manda Group, 664 Annette Street
Toronto, Ontario, Canada M6S 2C8

Distributed in the United Kingdom by GMC Distribution Services,
Castle Place, 166 High Street, Lewes, East Sussex, England BN7 1XU

Distributed in Australia by Capricorn Link (Australia) Pty Ltd.,
P.O. Box 704, Windsor, NSW 2756 Australia

If you have questions or comments about this book, please contact:
Lark Crafts
1166 Avenue of the Americas, New York, NY 10036

Manufactured in China

ISBN 978-1-60059-281-2

For information about custom editions, special sales, premium and corporate purchases, please
contact Sterling Special Sales Department at 800-805-5489 or specialsales@sterlingpub.com.

www.larkcrafts.com

CONTENTS

LOOK AT THIS

PLAY

PROFILE

BUILD

top:

Richard Pousette-Dart
Quartet #13, 1950
Mixed media on paper
22½ x 30⅞ inches (57.1 x 78.4 cm)
Arkansas Arts Center Foundation Collection:
Purchase, Tabriz Fund. 1994.036
© 2008 Estate of Richard Pousette-Dart /
Artists Rights Society (ARS), New York

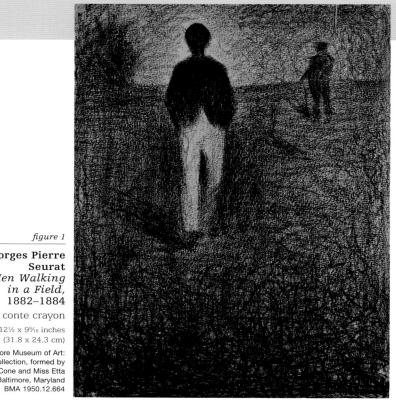

INTRODUCTION

Welcome to a conversation about expressive drawing. Perhaps you've never drawn before but really want to try and just need help getting started. Maybe you drew when you were younger, put your interest on the back burner while raising a family or pursuing a career, and now want encouragement to move forward again. Or you might have been drawing your entire life but long to loosen up and let go of old ideas and techniques.

No matter where you are in your own drawing journey, this book will inspire and guide you along that path.

You may not realize it, but you draw all the time. When you sign your name, for example, you generate a rhythmic linear movement that symbolizes your identity. When you draw a map to show someone how to get from point A to point B, you naturally take advantage of line's ability to indicate movement and direction. Cross out something you've written, and you instinctively use lines and marks to hide what's underneath. When doodling, you give concrete form to your stream-of-consciousness thoughts.

RENEWING YOUR CREATIVE SPIRIT

Put a few crayons and some paper in front of any three-year-old and you'll observe the nearly universal desire—and ability—to draw. You'll also witness a child drawing effortlessly. Children generally don't plan things out in advance; they simply make some marks, and then respond to them. They don't agonize over what they're doing, because to a child there is no "right" or "wrong" way to draw. They don't worry about rendering an exact likeness of the world; they're too busy creating a world all its own. And there's no hesitation about when or whether a drawing is finished: Children simply seem to know when it's time to stop.

And you can experience this liberating way to draw too. That's what this book is about—renewing your creative spirit. My approach to drawing is nurturing and encouraging; by experimenting with a few simple techniques and trusting your inner, artistic self, you'll soon be ready and eager to develop awareness and abilities beyond the reach of a child. And you'll begin to produce rich, satisfying drawings.

THE LANGUAGE OF LINE & MARK

Drawing is a powerful and wonderful language, capable of expressing things not easily conveyed any other way. As you know, drawings can be *descriptive*, by which I mean they can document the people, objects, or landscapes you encounter in the visible world. Perhaps this is the kind of drawing you're best acquainted with but also most intimidated by!

Drawings can also be *expressive*: They can communicate things that are intangible or invisible—your memories, ideas, musings, emotions—even your spiritual world. And the good news is that everyone can draw like this, regardless of age, culture, education, or temperament.

Drawing is one of the most accessible and portable creative activities you can undertake. That's why I've written this book—to furnish guided, hands-on drawing experiences that will help you become fluent in this ancient and universal language while also giving you the confidence to draw.

WORKSHOP IN A BOOK

For more than a decade, I've taught a series of art workshops, one of which forms the basis of this book. In these workshops I've met countless aspiring and experienced artists who are hungry to expand their knowledge and understanding of the drawing language. To my delight, these participants have found the workshops freeing and affirming. As a result, most have gone on to produce a broad range of expressive drawings from which they derive great personal meaning and satisfaction.

The pages that follow are designed to give you a similar opportunity, providing you with a series of workshop exercises to try at your own pace and on your own schedule.

So let's get under way! Turn to page 9 for a description of how the book is organized. By page 28, you'll be ready to take up pencil and paper and begin to draw—directly and openly—in a language that clearly expresses *you*.

figure 2

Leon Goldin
Old Quarry,
1966

Charcoal on paper

19 x 26 inches
(48.3 x 66 cm)

Courtesy of the
James T. Dyke Collection

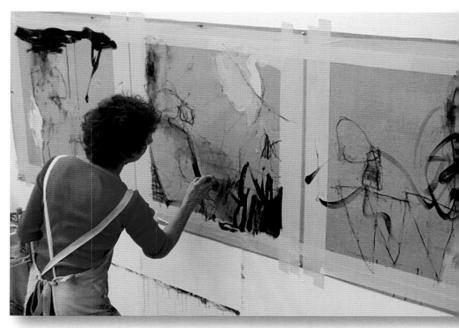

Krista Harris explores three variations in a series about visual weight.

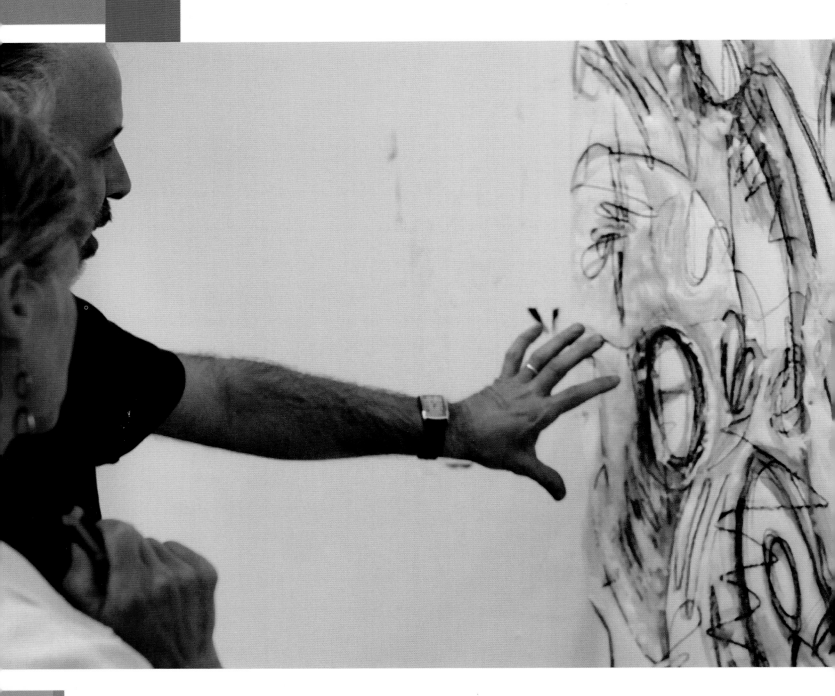

the DRAWING

process

This book, and our exploration of the subject, is divided into three parts: the drawing process, drawing elements, and drawing relationships. I believe that, taken together, these sections provide the inspiration, art theory, and hands-on experience that can make drawing an enriching part of your life and a satisfying way to express your creativity.

In Part One, you'll discover what drawing is, what purposes it can serve in your life, and what the process itself is like. If your experience of drawing is limited and you're a bit intimidated by the whole idea, you'll discover how easy it is to begin. You'll start off by doodling; then you'll make lines and marks; next you'll erase some of these marks; and before you know it, you'll be creating your own expressive drawings!

If, on the other hand, you've drawn a lot in your life but are looking for ways to loosen up and expand what you know and can do, these same hands-on challenges can help you discover new approaches and perspectives. These exercises have the potential to put you in touch with the spontaneity and curiosity you had when you were a child, when you grasped a new crayon and drew for hours without judgment, just for the joy of the experience. In either case, you'll likely never look at drawing in quite the same way again.

Author Steven Aimone discusses the drawing process with workshop participant Eli Corbin.

BASIC UNDERSTANDINGS

Before you begin to draw, let's talk about what drawing is, what it can do for you, what might hold you back from drawing, and what will make it easier for you. The approaches we'll explore together will help you draw with more ease, pleasure, and satisfaction.

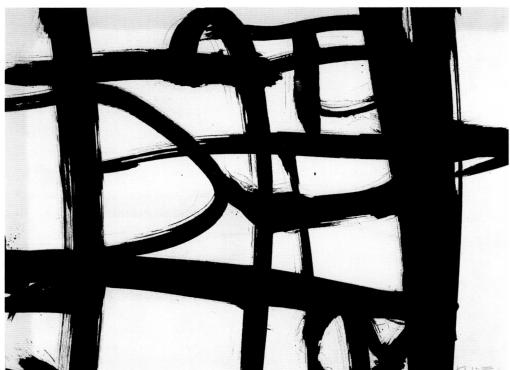

figure 1

Franz Kline
Untitled, 1952
Ink on paper
12 x 15¾ inches
(30.5 x 40 cm)
Photography by PHOCASSO / J. W. White
Courtesy Hackett-Freedman Gallery,
San Francisco
© 2008 The Franz Kline Estate / Artists
Rights Society (ARS), New York

WHAT IS DRAWING?

For our purposes, the following is a working definition: *Drawing is the arrangement of line and mark in space, designed to serve a variety of expressive purposes*. Let's examine this idea in more detail.

1. Drawing is the arrangement of line and mark in space ...

Simply put, drawing is visual arrangement in which line and mark are the primary elements. They take center stage. They have character and personality. They're alive; they do things! When line and mark are joined in a drawing space, they relate to one another in a wide variety of ways.

2. ... designed to serve a variety of expressive purposes.

Drawings can do amazing things. They can tell stories, educate, inspire, reveal, entertain, and inform. They can describe appearances, offer commentary, convey drama, and relate history. Arrangements of line and mark can speak of things visible, imaginary, and even invisible. The drawing process can be liberating, elevating, and therapeutic. When you become immersed in drawing, you're able to lose yourself in the process. You'll perceive and experience the world in ways that transcend the ordinary.

An underlying premise of our study is the following:

You, the artist, are a unique filter through which life's experiences are processed. As a result, responses and expressions emerge that are completely your own. Your drawings reveal things that are not easily spoken of or experienced in any other way.

No matter your style, temperament, or approach, drawings can function on three levels: representational, symbolic, and nonobjective, as described on the following pages. Many drawings simultaneously function on more than one (or even all three) of these levels, although one level is usually considered the primary.

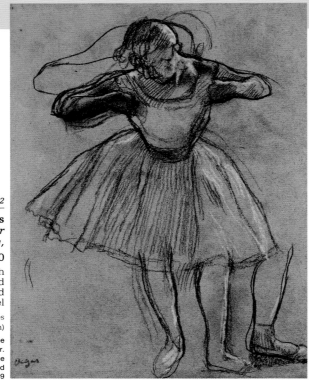

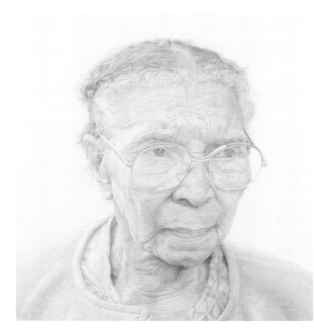

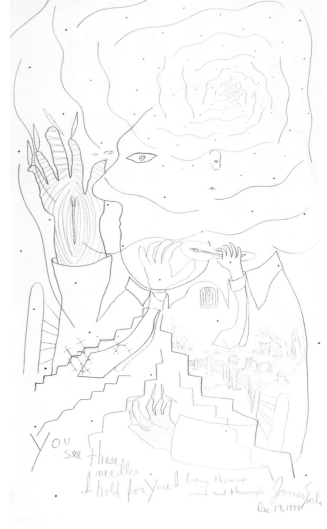

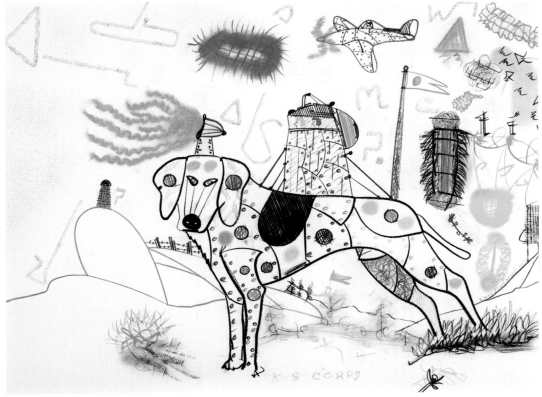

figure 5

Roy De Forest
K-9 Corps, 1974

Ink on paper

25 x 19 inches
(63.5 x 48.3)

Arkansas Arts Center Foundation
Collection: Purchase, Barrett Hamilton
Acquisition Fund and Museum Purchase
Plan of the NEA. 1981.020
© Estate of Roy De Forest / Licensed by
VAGA, New York, NY

Representational drawings describe appearances in the external world. They document the visible. Using a variety of tools and techniques, artists working in this manner convince viewers that they're seeing three-dimensional reality on what is actually a two-dimensional surface. Representational drawings are all abstractions to varying degrees: The artists are translating their experiences of seeing what is "out there" into their own language of line and mark, as illustrated by Degas' dancer (figure 2) and Wyatt's portrait (figure 3).

Symbolic drawings use shorthand configurations of line and mark to convey all kinds of narrative, both literary and poetic. A simple shape formed by line can serve as a sign or symbol for a thing or event. When a series of symbols are grouped together, they have a conversation of sorts with one another. And when an artist uses the same symbols over and over again, they begin to form the artist's own distinct visual vocabulary. Generally, symbolic drawings still contain representational or recognizable elements: We can recognize the hands in James Surls' drawing (figure 4) and the dog in Roy De Forest's drawing (figure 5).

Nonobjective drawings, on the other hand, consist of arrangements of line and mark that make no direct reference to anything in the visible, exterior, or physical world. The artist uses line, mark, pattern, and texture

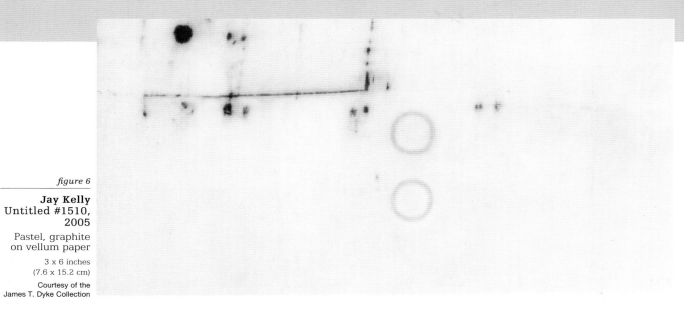

figure 6

Jay Kelly
Untitled #1510,
2005

Pastel, graphite
on vellum paper

3 x 6 inches
(7.6 x 15.2 cm)

Courtesy of the
James T. Dyke Collection

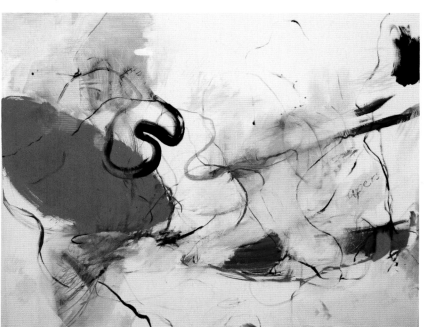

figure 7

Martha Mahoney
Untitled, 2008

Mixed media on canvas

48 x 54 inches (122 x 137 cm)

Courtesy of the artist

to speak metaphorically and poetically of things that are formless, intangible, and unseen. These types of drawings address feelings, the psyche, and the spirit. Works by Jay Kelly, Martha Mahoney, and Gregory Amenoff, are dynamic examples of nonobjective drawing (figures 6, 7, and 8).

Of course, there are times when the lines between descriptive, symbolic, and nonobjective become blurred. For example, the three images on the far right on page 15 could all be considered depictions of a group of apples. The first (figure 9) is a photographic representation by David Aimone; the second (figure 10), a drawing by André Derain, is a partially symbolic distillation; and the third (figure 11), a contour drawing by Ellsworth Kelly, is largely symbolic. Each is a wonderful and valid response to the visible experience of apples; each presents its own reality.

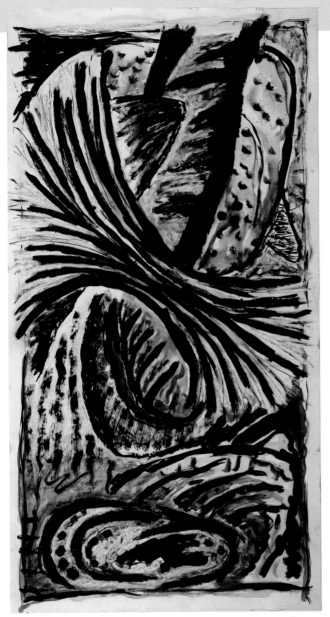

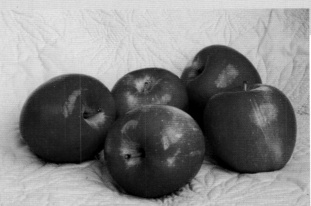

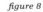

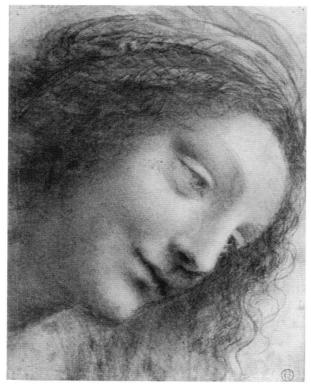

figure 12

Leonardo da Vinci
Head of the Virgin, 1508–1512
Black chalk, red chalk, traces of white chalk
8 x 6⅛ inches
(20.3 x 15.6 cm)

OLD & NEW DEFINITIONS

I n Western culture, people generally equate drawing with *rendering*, or conveying accurate information about the visible world. According to this assumption, drawing involves using line and mark as tools to establish a likeness of a recognizable form: to describe appearances or to document external reality. Indeed, this is one of the things drawing can do. Artists working in this tradition have produced a rich heritage of masterly works, which have since found their way into major museum collections around the world. Visit any bookstore and you'll find an array of drawing books that show you how to draw with this purpose in mind.

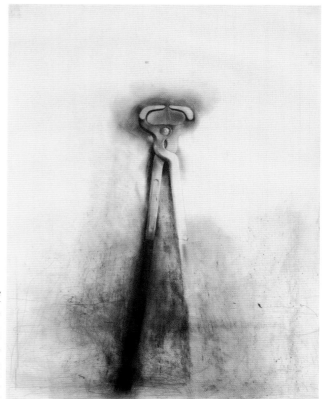

figure 13

Jim Dine
Untitled (Hoof Nipper) from the Untitled Tools Series,
1973
Graphite, charcoal, and crayon on paper
25⅝ x 19¾ inches
(65 x 50.2 cm)

You're likely familiar with thinking about drawing this way. Most of us learned it in elementary school and have remained attached to it ever since. The problem with this definition is not that it's wrong, but rather that it's overly specific and somewhat limiting. It implies that if you don't have a particular talent for rendering, then drawing isn't for you (or at the very least, you're not going to be very good at it).

Most people learn and accept this premise at an early age and are quickly convinced they simply don't have what it takes to be an artist. This idea is reinforced as time goes on. After all, few of us can match the standards set by masters such as Leonardo da Vinci (figure 12) or Jim Dine (figure 13). Allowing these virtuosos to define a standard can make you feel like giving up before you begin!

INNOVATION & CHANGE

Two historical occurrences broadened our ideas about what drawing can be and do. The first was the advent of photography during the 19th century. For the first time in history, people no longer needed to rely on drawing to document appearances. Today, thanks to the invention of digital cameras, camera phones, and other devices, we can record visible reality anytime we want and share it at will.

The second event was the advent of Modernism, the art movement that expanded the definition of art in the 20th century. It challenged the assumptions of the Renaissance art tradition: rather than focusing on appearances in the visible world, Modernism argued that art can be about the *unseen*—it can give form to the formless. In other words, drawings can be about internal realities (feelings, imagination, fantasies, dreams, the spirit), experiences that transcend or underlie the purely visible. Brice Marden's work, figure 14, is a great example.

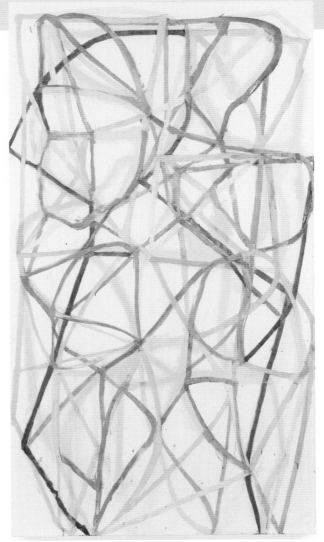

Ultimately, no matter what approach you use, drawing is fundamentally about you, the maker. Even if you're copying the natural world, there's no way you can keep your "handwriting" out of the picture. Remember, whether you're working from a reference or not, you're filtering the experiences of your life to produce a new reality that is uniquely your own. This approach frees you to create your own vision, without any pressure. There's no need to perform, make it perfect, or make it look like this or that. It's purely about your own expression.

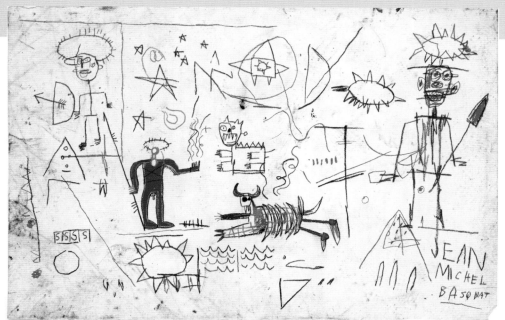

WHAT KEEPS YOU FROM DRAWING?

Now that you've got an idea of what drawing is and what it can do, let's look at a variety of things that might be keeping you from drawing or from drawing with as much pleasure and satisfaction as you would like (and deserve). The list is considerable. By understanding these assumptions, however, you can eliminate much of their power.

1. I'm too old to start (restart) now.

How many times have you paralyzed yourself with this thought? As an antidote, I challenge you to consider the following: Italian Renaissance artist Raphael completed his life's work in 20 years' time. Celebrated post-Impressionist artist Vincent van Gogh completed his large body of drawings and paintings in only 10 years.

Paula Modersohn-Becker became one of the leading early German Expressionist painters in less than a decade. Famous folk artist Anna Mary Robertson (Grandma) Moses (figure 16) didn't begin painting until she was in her 70s. And leading graffiti and Neoexpressionist artist Jean-Michel Basquiat (figure 15) produced some of the most influential work of his generation in a mere eight years. The point? It's simple: You *do* have time. And it's important to realize that you bring more to the table as an artist now than you ever have.

2. I can't even draw a straight line!

When you get right down to it, few people can draw a straight line. Fortunately, the ability to draw perfect lines is seldom essential in drawing. Few exist in nature. With practice, you can learn to draw a line that is straight enough for most purposes. And if you really need one in your drawing, you can use a ruler!

3. My drawings look like stick figures.

Hey, there's nothing wrong with stick figures. They can be very expressive. In fact, some drawings featuring simple drawn figures have received lots of acclaim.

Look again at Basquiat's drawing: Using stick figures can be a viable way to express deep feelings.

4. My drawing doesn't look real.

We addressed this one to some degree when we debunked the myth that drawing is synonymous with rendering. But to counter this "voice in your head" more directly, keep in mind that there is no consensus among artists across time and culture regarding what "real" is, much less on what is the best way of portraying reality.

Let's look at two renderings of a game board (figure 17). On each there are two game pieces, identical in size, and a grid of squares, alternating between gray and white, all of equal size.

The version on the left is consistent with the Western European Renaissance ideal of how to render: Objects are portrayed as the eye seems to see them, based on a linear perspective system in which objects appear smaller as they get farther away. This approach creates an illusion of how we see the visible world from one fixed point of view at one frozen moment in time.

The version on the right represents an alternative interpretation of how to depict what is real. It's consistent with some Byzantine and Modernist ideas, as well as those in many Eastern cultures. Theoreticians refer to this as *isometric perspective*. Here, the two game pieces are the same size, as they indeed are! This depiction of reality shows relationships in scale, regardless of the point of view and time frame of the viewer.

So, which way of describing the exterior world is correct? You guessed it … either or both! The point is you don't have to adhere to a certain idea of perspective or "reality" in order to create drawings that are valid, expressive, and satisfying.

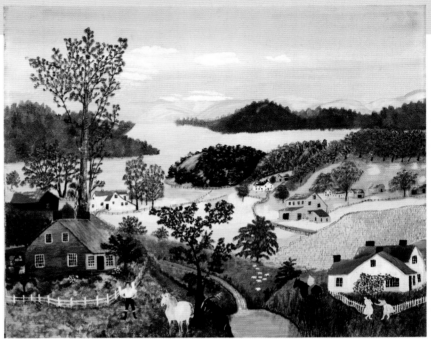

figure 16

Anna Mary Robertson ("Grandma") Moses
A Beautiful World, 1948
Oil on pressed wood
20 x 24 inches
(50.8 x 60.96 cm)
Copyright © 1948 (renewed 1976). Grandma Moses Properties Co.,
New York

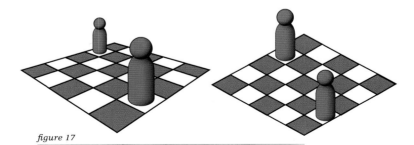

figure 17

Here are two valid, yet different, interpretations of how to convey perspective.

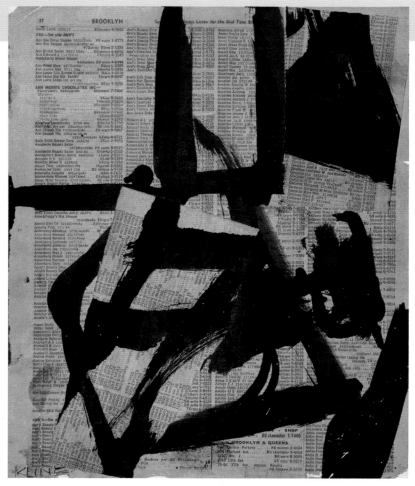

figure 18

Franz Kline
Untitled II,
circa 1952

Ink and oil on
cut-and-pasted
telephone book pages
on paper on board

11 x 19 inches
(28 x 48.3 cm)

Digital Image © The Museum
of Modern Art / Licensed by
SCALA / Art Resource,
NY © 2008 The Franz Kline
Estate / Artists Rights Society
(ARS), New York

Now that we've addressed beliefs that might hold you back, let's look at a short list of ideas that you could adopt to make drawing easier.

WHAT WILL MAKE DRAWING EASIER

1. Be kind to yourself.

More than anything else, make this your motto and your mantra. Overly zealous and harsh self-criticism is the single most inhibiting and destructive force you'll encounter on the road to learning to draw, making you reluctant to try again. After all, if you really feel you're no good, what's the point of trying?

Remember, if you say unkind things to yourself about your drawing, these negative words become ingrained in your psyche. Say these things again and again, and the thoughts and the feelings they create gain strength. So catch that harshly critical voice as it comes up, recognize it for what it is, let it go, and replace it with some self-acceptance and encouragement.

2. Don't worry about being perfect.

No one is perfect, nor is there any such thing as a perfect drawing. Anyone who claims there is has a narrow, specific idea of what a drawing is, what it ought to do, and how it ought to be done. In any event, don't saddle yourself with unreasonably high expectations. Drawing is a process. Expect that process to lead you not to a perfect result, but to a more satisfying place.

In this regard, consider, for example, the drawings shown here by Franz Kline (figure 18) and Oscar Bluemner (figure 19). Are these drawings perfect? How can you tell? What criterion can you use? Most importantly, does the issue of whether they're perfect or not really matter? Likely not! What you *can* deter-

5. I just don't have any talent.

Here's another version of the same argument. Again, what many people regard as talent in drawing is merely the ability to render a dazzling likeness of a physical form in the visible world. But as we've discovered, there's a lot more to drawing than that. For example, you might have a natural affinity for good design. You might have a special fascination with and sensitivity to one particular visual element—for instance, texture—and as a result this shows up in your work. As you can see, there are many different kinds of talent that apply in drawing, and you'll bring your own unique combination of skills to the drawing process.

mine with ease is whether these drawings move you, whether they're intriguing, compelling, alive. For most of us, the answers to these questions will be yes, yes, and yes!

3. Set reasonable expectations.

One sure-fire way to feel bad about yourself is to set the bar so high that you can't jump over it. So set your goals at a reasonable and achievable level at first. You'll feel great about yourself, and before you know it, you'll be raising the bar to the next notch.

4. Enjoy the process of getting there.

Spiritual teacher Eckhart Tolle has observed: "When you no longer need for your story to work out, it actually works quite well." Tolle encourages us to stop worrying about succeeding—and to embrace whatever we're doing now. That, in and of itself, is success. To put it another way: Things flow much more easily when we stop trying so hard.

5. Don't overthink things.

Former New York Yankee baseball great and armchair philosopher Yogi Berra once observed that "you can't think and play at the same time." Well, you can't draw very well and think at the same time either. While you're drawing, trust yourself and tap into your unconscious; use your intuition. Then, when you step back and pause, you can momentarily think, observe, and analyze. But as quickly as possible, take off the thinking cap and get back to drawing.

6. Challenge assumptions.

One common denominator among notable artists is their ability and willingness to challenge assumptions. They constantly ask themselves, "What would happen if I tried this or tried that?" There is no *one way*. So, learn all you can from other artists and teachers, but then find the approaches that work best for you.

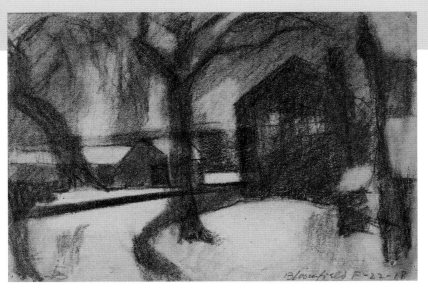

figure 19

Oscar Bluemner
Bloomfield Lock, 1918
Charcoal and pencil on paper

4⅞ x 5⅞ inches
(12.4 x 15 cm)

Arkansas Arts Center Foundation Collection: Purchased with a gift from Helen Porter and James T. Dyke, 1992. 92.076.002

7. Ignore uninformed feedback.

Not everyone is equally qualified to serve as a judge of your work. So it's up to you to carefully select a few people—a knowledgeable instructor, a sensitive and experienced art appreciator, or another artist who shares your artistic viewpoint. This list won't always include your spouse or best friend! Be selective, and discriminate when choosing whom to listen to. In the end, your own voice should have the most power.

8. Find community.

Always be on the lookout for fellow artists who share your frame of reference and mission. You might find these kindred spirits in classes, at art openings, or at other events. Develop and nurture this community: It will serve as a source of encouragement and validation, and you won't be alone on your artistic journey.

Now that we've looked at what drawing is, what it can do for you, what holds you back from drawing, and what kinds of things will help you to draw, let's dive into the hands-on chapters of this book.

You're ready to draw!

Start Now & Get Loose

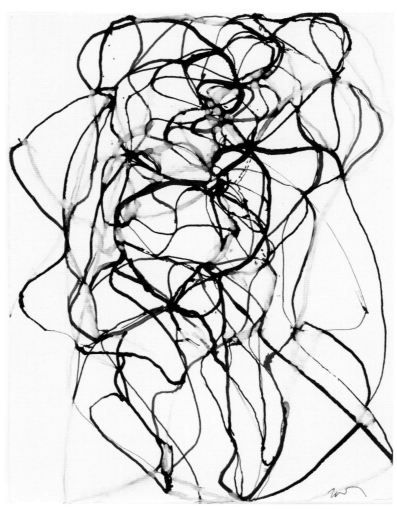

figure 1

Brice Marden
Aphrodite Study, 1992–93
Ink and gouache on paper
9⅝ x 7¼ inches (24.4 x 18.4 cm)

Digital Image © The Museum of Modern Art/
Licensed by SCALA / Art Resource, NY
© 2008 Brice Marden / Artists Rights Society
(ARS), New York

Now let's talk about the process of drawing itself. What's involved? How do you go about it? As you might surmise, there is no single, definitive answer to either of those questions. But the following thoughts may be helpful as you think about what drawing means to you.

The act of drawing usually involves a synthesis of the planned and unplanned, the structured and unstructured, and the logical and intuitive. Drawings can emphasize some of these qualities more than others. Your approach is often influenced, even dictated, by the drawing's purpose. For example, a drawing from which a suspension bridge can be constructed reflects a great deal of planning.

The nature of your drawing materials may likewise determine your approach. Drawing in egg tempera, for instance, requires planning because you can work on only a small area at a time before the medium becomes unworkable.

Descriptive (or documentary) drawing is the sort of drawing most people understand; it's often the default approach in Western culture. It relies on the left-brain, or rational, side of things. Descriptive drawing aims to convey a likeness, to represent the visible. It almost always involves a specific methodology. Take a look at any how-to drawing book and you'll encounter instruction that shows you step-by-step, sequential methods for rendering a likeness.

By contrast, our exploration encourages you to emphasize—and take advantage of—what many people refer to as your right brain, or emotional side. I'll urge you to tap into the intuitive intelligence you possess. All you need is a willingness to improvise. Rather than rely on logic and planning, simply respond sensitively as you work. This process involves exploration and discovery, more than objective analysis. You'll set into motion and then respond to certain drawing elements, one step at a time, until you reach a satisfying resolution.

Without guidance, nurturing, and encouragement, this unplanned approach to drawing can seem a bit daunting at first, or even scary. That's because it offers the artist total freedom—there's no mandated way to go about it, no right or wrong, no correct procedure. Instead there is simply an enriching process and outcomes that are more or less satisfying.

Most people have limited experience and have received little or no exposure to this approach. That's what this book offers. It encourages you to take a leap of faith. It gives you the confidence to jump off the high dive: Once you're in the water, you'll begin to swim, and soon after that you'll be flowing with the current. I'm certain you'll find this manner of drawing liberating. You'll regain some of the ability to express yourself with the freedom of a child combined with the wisdom you've gained as an adult.

So now it's time to get your feet wet. Let's begin our exploration by doing something extremely fun—something most of us do all the time.

DOODLING

All of us have engaged in doodling at some point or another. You know what this means: a kind of mindless scribbling and scratching with no particular purpose. Doodles are often created when the conscious mind is busy, or at least halfway busy, doing something else—talking on the phone, listening to a lecture, sitting through a business meeting. This raises the question: If the mind is busy doing something else, where do doodles come from? We'll get to that in a minute.

Is doodling actually drawing? Can we take doodling seriously? Do doodles have any meaning? The answer is yes! In fact, much can be intuited from the way people doodle. Undoubtedly, any one of us can look at doodles by a number of different people and sense a personality or at least a momentary mood. The growing consensus is that doodles reveal key facets of the doodler's psyche.

Nevertheless, can you really consider doodling to be a form of art?

AUTOMATIC DRAWING

Let's take a look at art history to help answer that question. In the early 20th century, a group of artists took a particular form of doodling very seriously. Associated with the early Modernist movement *Surrealism*, artists such as Jean Arp, André Masson (figure 2), Joan Miró, and André Breton enthusiastically engaged in an activity known as *automatic drawing*.

The idea in itself was a simple one: to draw with no plan, no purpose, no conscious control—to begin generating line and mark in a seemingly random fashion. Those early modernists believed that this kind of drawing could reveal levels of awareness and meaning impossible to divine in any other way. In essence, they advocated de-emphasizing the role of the conscious mind so that a different level of intelligence—subconscious or unconscious—could emerge. This kind of intelligence, they felt, could make the invisible visible or give form to the formless.

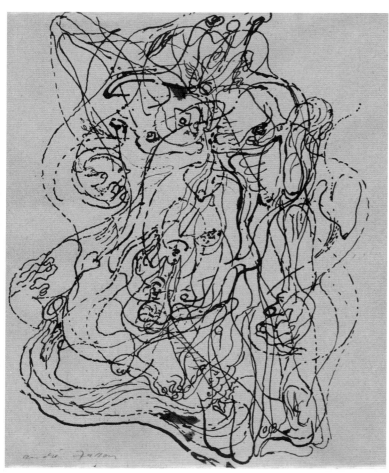

figure 2

André Masson
Automatic Drawing, 1924
Ink on paper
9¼ x 8⅛ inches (23.5 x 20.4 cm)
Digital Image © The Museum of Modern Art / Licensed by SCALA / Art Resource, NY
© 2008 Artists Rights Society (ARS), New York / ADAGP

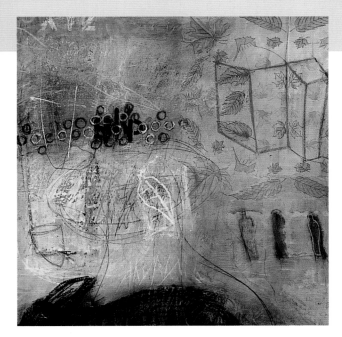

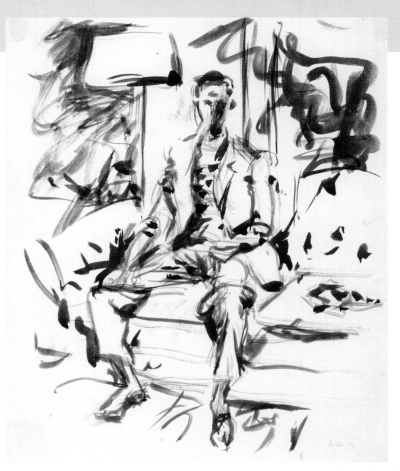

Though it represents an extreme end of the planned-versus-unplanned spectrum, the practice of automatic drawing has directly or indirectly influenced the way artists in the Western tradition have worked ever since. Countless artists have broadened the approach, working in a stream-of-consciousness manner that subordinates the conscious mind and enables one mark or narrative symbol to lead to another and another until completion occurs.

Working in a manner reminiscent of modern artists such as Paul Klee and Wassily Kandinsky, Donne Bitner's *To Remember* (figure 3) is a great example. Rather than beginning with a fixed idea of how her drawings will be made and what they'll look like in the end, Bitner starts by introducing a few visual elements or symbols (rabbit, folding screen, leaves), and responds to them on the basis of feeling. The artist moves things around, adds things, veils and eliminates others, excavates and discovers, continuing until the elements relate to one another fluidly in a new reality all their own. By working in this way, Bitner makes her internal world visible, revealing aspects of reality not accessed in any other way.

Abstract Expressionists—many of whom did purely automatic drawings as part of their artistic routine—added the notion of action painting to the tradition. Often working on a large scale, they valued *doing* over *thinking* and advocated that physical movements were a way of tapping the body's intelligence (see Franz Kline's untitled drawing, figure 1 on page 10, for an example). These kinds of automatic linear movements were incorporated into the representational drawing process as well, as you can see in Elaine de Kooning's *Fairfield Porter* (figure 4).

Automatic drawing can be worthwhile for you as well, whether you're relatively new to drawing or a veteran. Keep an open mind and you'll discover for yourself just how meaningful and liberating it can be.

figure 3 (top left)

Donne Bitner
To Remember, 2006
Acrylic, pastel, collage
(mixed media)
26 x 26 inches
(66 x 66 cm)
Courtesy of the Artist

figure 4 (top right)

Elaine de Kooning
Fairfield Porter,
circa 1956
Ink, casein on paper
13¾ x 11 inches
(34.9 x 27.9 cm)
Courtesy of the James T. Dyke
Collection

LOOK AT THIS JACKSON POLLOCK

JACKSON

Jackson Pollock was perhaps the most famous mid-20th-century Abstract Expressionist artist, and the first to appear on the cover of *Life* magazine. Through works such as this untitled drawing (figure 5), the public first became acquainted with nonobjective art in the 1950s. Such drawing was considered audacious at the time. In fact, legend has it that when Pollock first began working in this style, his wife and fellow artist Lee Krasner asked him where these drawings came from and what their subject matter was; surely he must be working from *some* reference in nature, she insisted. His audacious response: "I am nature!"

This automatic (or semi-automatic) drawing was executed in Pollock's signature fashion: He threw, dripped, and flung ink from the end of a stick or brush, using his body and enlisting gravity to generate drawing *events*. As a result, he managed to convey a great deal of liveliness—of life energy. Once he became experienced at working this way, Pollock was able to exert more control over the process than you might expect.

Notice the drawing's two vertical clusters. They can be metaphorically read as human figures. Each leans to the right, implying movement and force. The drawing is unified by the consistency of repeated line and dot. It is very alive. It rhythmically *breathes* from left to right, alternating from empty, passive space (no-thing-ness) to energized cluster (things), back to space, then cluster, then space. Isn't it amazing what a few drips and flings from the hand of an artist can do?

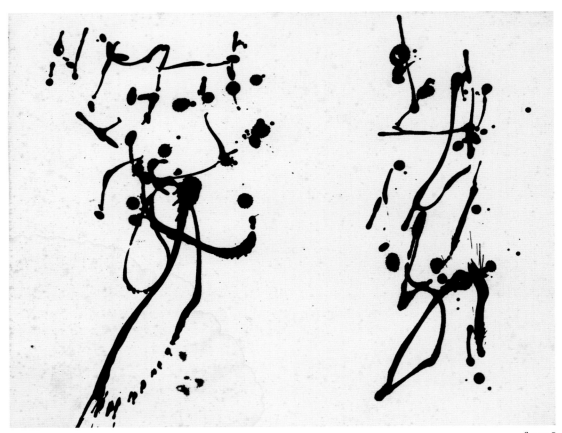

figure 5

Jackson Pollock
Untitled, circa 1950

Ink on paper

19 x 24 inches (48.3 x 61 cm)

PLAY 1 ■ AUTOMATIC DRAWING

For this exercise and for many of the other ones you'll be doing, a heavy-weight, opaque vellum or Bristol board works very well. If you're on a bud-get, craft paper or butcher paper is a fine substitute. (Buy your paper by the roll, if possible.)

1 On a vertical surface, tape or tack a sheet of drawing paper, the larger the better (at least 48 x 36 inches [122 x 91 cm], if possible). You can attach your paper to a wall, or you can attach it to a sheet of plywood, fiber-board, or other relatively smooth surface propped against the wall.

2 Place the following items within arm's reach: a 1-inch (2.5-cm) china bristle brush (available at any hardware store), a container three-quarters full of water (to place your wet brush in when you're

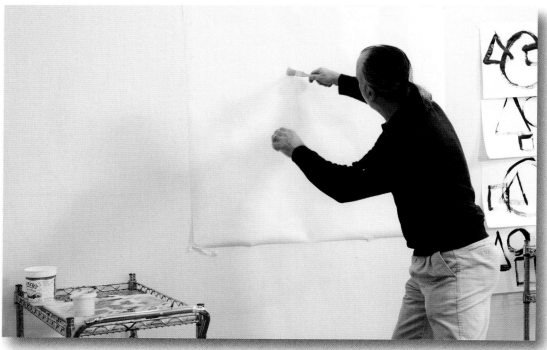

The author demonstrates the ideal setup and posture for automatic drawing. Below, Annie Miller discovers the simple pleasure of making marks on paper.

not using it), and black or any other dark-color acrylic paint, whether artists' acrylics or house paint.

3 Once you're set up, you're ready to go! Approach the drawing surface as if you're a fencer, with one of your feet forward and the other back, as opposed to standing

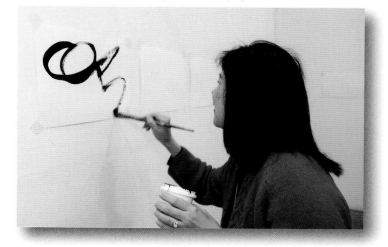

parallel to the drawing surface. Stand far enough away from the surface that you need to stretch (or lean forward) a bit to reach it. Hold the brush by the end of the handle in the palm of your hand (rather than as you would hold a pencil).

4 Load your brush with paint. Approach the surface as described in step 3. Then, without thinking or planning at all, make a line, a squiggle, a doodle— capture the first impulse that comes to you on the drawing surface. It doesn't matter what you do, but rather how you do it. Generate this initial visual element from your body: Feel it; enjoy it.

5 Next, step back about 6 feet (1.8 m) or so (space allowing) and look at the line or lines you just made. Look just long enough to take in the drawing. Then, as soon as any urge to respond in any way occurs to you, do it—make another mark. Don't worry about justifying it, explaining it, or understanding it. (I often say to my students that I listen to what my elbow or the side of my neck says

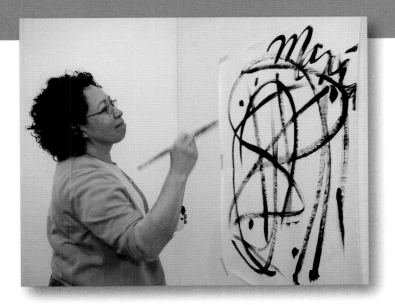

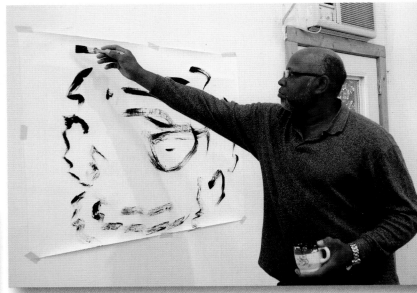

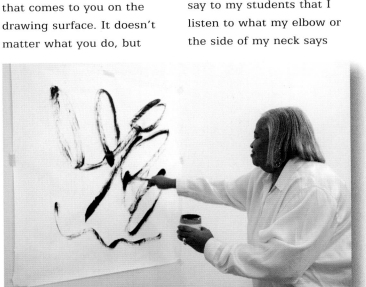

Maria Rodarte-Reyes (top), George Rice (above), and Nancy Rice (left) express themselves by working with automatic drawing.

needs to be done, and I do it.) Whatever works for you is fine.

6 After you've completed this second action or set of actions, step back once more and take in what you've done. As soon as an urge to respond comes up, go forward and make another mark. Keep going back and forth, acting and responding, until nothing more occurs to you, or until you really like what you see. Then stop—your drawing is finished.

Remember, you can't do a good automatic drawing or

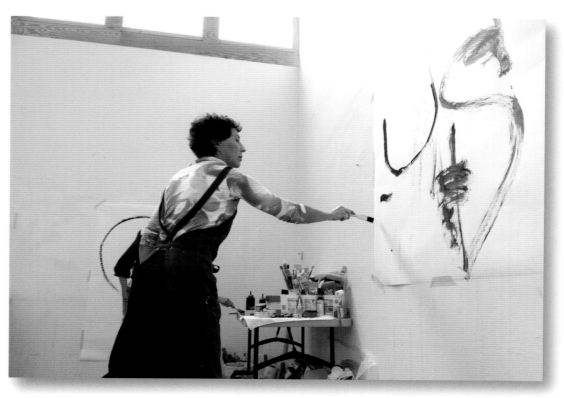

a bad one, only a more or less satisfying one.

Did you enjoy the activity? Did it feel liberating? And how about the finished drawing: What kind of feeling does it evoke in you? What adjectives would you use to describe it?

Krista Harris (top), Eli Corbin (left), and Judy Alvarez (right) develop automatic drawings.

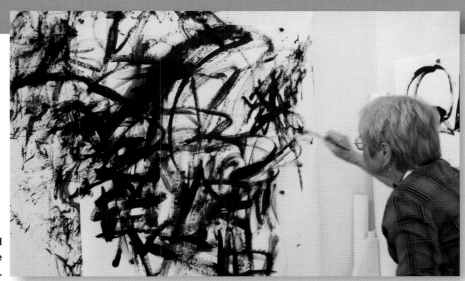

Diana Gilson (right) and Una Paris (below) enjoy the drawing process.

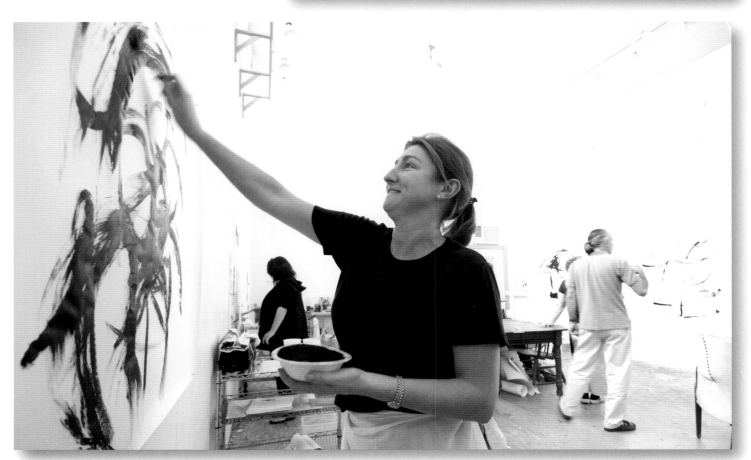

VARIATION A

Other methods can help you loosen up. Feel free to try any or all of these:

• Execute the drawing with your nondominant hand (your left hand if you're right handed). This will make it harder to control things, allow you to work without the baggage of your main-hand memory, and alter expectations. The results can be wonderful.

• Execute the very first movements in the drawing with your eyes closed. Then respond with your eyes open again. Closing your eyes will take some of the pressure out of drawing, and help you draw from your body's inner intelligence.

• Attach your brush to the end of a yardstick (or any kind of stick) by wrapping it well with duct or masking tape. (I once had an artist attach her brush to the end of a pool cue, for instance.) Hold this new tool at the end opposite the brush (not in the middle) and execute an automatic drawing. This exercise helps you keep your distance, literally and figuratively, diminishing the control and expectation factors that tend to get in your way.

Robin Whitfield draws with a brush attached to the end of a stick. Below is her finished artwork.

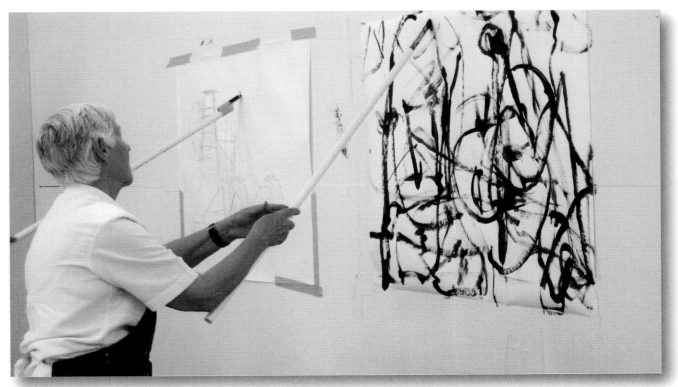

Jean Banas loosens up her drawing
by using this workshop exercise.

A watercolor crayon (top) or
charcoal (bottom) are good
choices for expressive drawing.

VARIATION B

If you're unable to work with
paint, work on a large scale, or
work standing up, you can still
do automatic drawing. Start by
leaning a drawing pad in a nearly
vertical orientation (up against a
box on a table, for example).

Select a drawing implement
(pencil, felt-tip pen—whatever
is available) and hold it at the
far end from the tip (again, not
as you do when you write). Then
follow the procedure outlined on
page 28.

ARTIST PROFILE

JIM THOMAS

1938–2007

The working mantra of Jim Thomas, who began drawing and painting later in life, was "Often wrong, but never in doubt!" Jim was an inspiration on many levels. More experienced artists marveled at his fearless, direct, joyous approach to his work. And they admired how he persevered to produce a body of highly accomplished drawings and paintings.

When he was in his early 50s, Jim was diagnosed with Parkinson's disease. A self-confessed type-A personality at the time, the highly respected anesthesiologist was forced to retire from his profession and reexamine his assumptions about life. At the urging of his wife, artist Charlene Thomas, Jim decided to try his hand at making art. What he lacked in artistic training, he decided, he would offset through sheer inquisitiveness and courage. And what he might lose in physical steadiness, he would make up for by embracing passion and authenticity.

The results were striking. Jim produced a broad body of work that included landscapes, still-lifes, narrative collages, and nonobjective compositions. None, however, were more noteworthy than the automatic drawings he regularly produced, two of which are shown here. Large, forceful, and engaging, these drawings convey emotional and spiritual energy drawn directly from the maker's body.

—*Katherine Aimone*

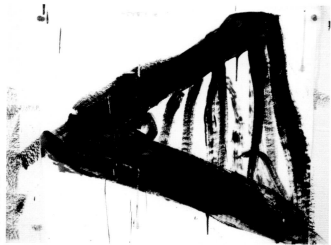

figure 6

Jim Thomas
Automatic Drawing #7, 2007
Black acrylic paint on paper
30 x 30 inches (76 x 76 cm)

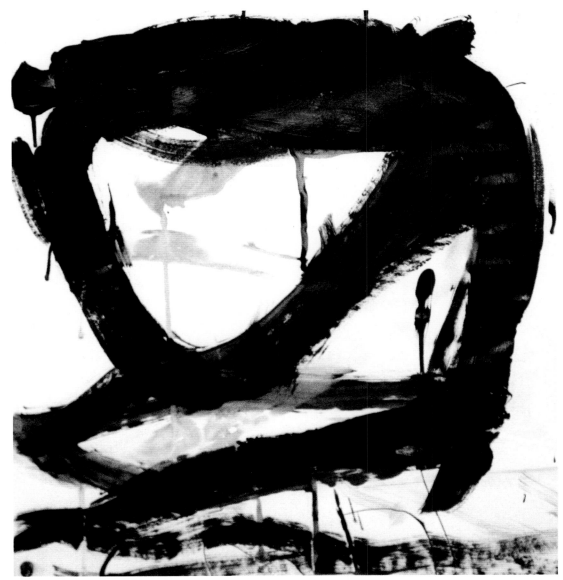

figure 7

Jim Thomas
Automatic Drawing #2,
2007
Black acrylic paint on paper
30 x 30 inches (76 x 76 cm)

IN FLUX

Look at you! You jumped in, took a leap of faith through automatic drawing, and now you're engaged in the process.

Next we'll discuss ways to embrace the process of *flux* in drawing. So let's keep going.

ASSERTING AND OBLITERATING

Here's a second way to simply and directly express yourself through drawing: Erase, cover up, or partially cover up lines and marks as you draw them. Add some marks while taking others out. In other words, as you draw, you proceed with the knowledge that you can remove parts of what you have done and keep right on working from that point. In my workshops, I refer to this as *asserting and obliterating*—what could be more fun and non-intimidating than doing this! Nothing you do in a drawing needs to be etched in stone.

There are no mistakes, only things you put in and take out. And the more you put things in and take things out, the richer the drawing can become. Charlotte Foust's drawing (figure 8) is a wonderful example of flux.

In an interview with Charlie Rose aired on PBS in 2006, artist Brice Marden (see figure 1 on page 22) tells a story about going to an art-supply store and buying a bunch of erasers, to which the store attendant responded, "Wow, you must make a lot of mistakes!" As Marden himself might tell you, putting in and taking out, addition and subtraction, assertion and obliteration can be much more constructive than that. In fact, it is central to the process of exploring and discovering. You try one thing, then another, then another. At some point, you cover up one or more of those things to make room for new ones.

But it gets even better than that! Read on.

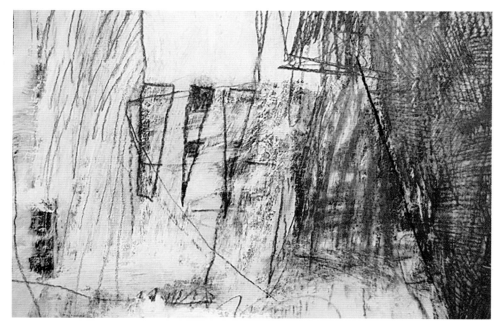

figure 8

Charlotte Foust
Untitled Workshop Drawing
(detail), 2007

Charcoal, pencil, and white acrylic paint on paper

42 x 48 inches (106.7 x 121.9 cm)

Courtesy of the Artist

By engaging in the process of doing and undoing, you'll create drawings *automatically* that speak metaphorically. The cycle of doing and undoing is akin to the cycle of life in nature—and in us.

If you've ever walked through the woods and closely observed your surroundings, you've likely been moved by the cyclical nature of things. You've noticed that everything is in flux. A tree has newly fallen; others that fell earlier are beginning to decompose. Some of this substance begins to take on the qualities of soil. And out of this broken-down material emerge seedlings—new tree forms grow. And so the cycle continues, with no clear beginning and no clear end.

You may notice the same thing as you watch waves crash into a rocky coast. A wave lifts, crests, breaks, and tumbles in; the water rolls into the crevices while the undertow pulls water back out into unity with the sea. Meanwhile, other waves are forming. The process is continuous and alive.

Drawings, too, are alive. Visual elements come and go. In (or on) their surfaces stands evidence of continual flux, as Richard Diebenkorn's *Seated Nude* (figure 9) showcases. Some are completely intact, highly prominent, and full. Others feel as if they're dissipating or on the verge of arising. In this way, your drawings are a record of your touch, your movements, and your responsive interactions with the elements in the drawing. What a wonderful, liberating, and expressive way to work!

Let's look at a couple of drawings that were done this way, and then give it a try.

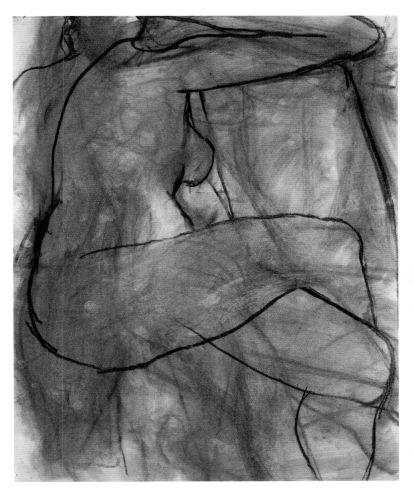

figure 9

Richard Diebenkorn
Seated Nude, Profile, 1966

Charcoal, oiled charcoal, and compressed charcoal, with smudging and erasing, on cream wove paper

23⅞ x 18¹⁵⁄₁₆ inches (60.7 x 48.1 cm)

Courtesy of the Art Institute of Chicago,
Gift of the Diebenkorn Family; restricted gift of Adele and William Gidwitz
© The Estate of Richard Diebenkorn

LOOK AT THIS CHARLOTTE FOUST

The process of asserting and obliterating, of marking and veiling, is at the core of Charlotte Foust's drawings. Influenced by contemporary masters such as Cy Twombly and Brice Marden, Foust explores the processing and arranging of line and mark. Figure 10 below is typical of her style.

In the jargon of fine art, Foust's drawings are full of *visual information*; each offers the viewer an exceedingly *rich history of surface*. Spend a minute or two with her drawings, and you'll see (and feel) layers upon layers of scribbling and covering. You can see where she put lines in, took them out, put new ones in. The finished works feature evidence, or remnants, of things that happened at various stages in the drawing process. Some marks appear to stand right on top of the surface, fully intact. Others feel (and often actually *are*) imbedded into the surface. By implication, those elements seem as if they're phasing in or out of existence. As a result, the drawings fluctuate vibrantly. In the end, each stands as a dense recording of the artist's movements, intuitions, and decisions.

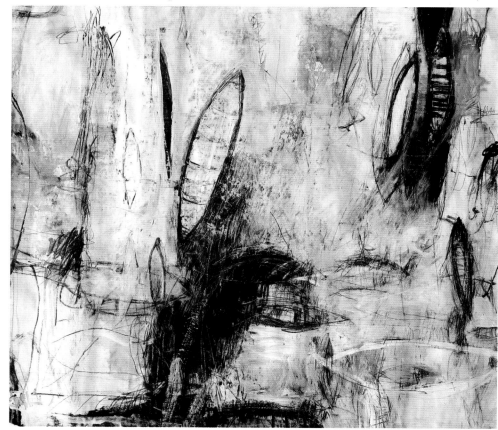

figure 10

Charlotte Foust
Untitled Workshop Drawing, 2007
Charcoal, pencil, and white acrylic paint on paper
42 x 48 inches (106.7 x 121.9 cm)
Courtesy of the Artist

LOOK AT THIS DONNE BITNER

Contemporary artist Donne Bitner applies in-flux processing (asserting/obliterating) to the realm of the symbolic in works such as *Face to Face*, shown here.

In drawings reminiscent of the dreamlike paintings of Paul Klee, Bitner develops compositions in a largely intuitive manner. Rather than beginning with a fixed idea of how she'll make her paintings and what they'll look like in the end, Bitner starts by introducing a number of drawing elements (shapes, marks, symbols) and then responds to them on the basis of feeling. She moves things around, adds new elements, veils and eliminates others, excavates and discovers, continuing until she reaches a satisfying resolution. By working in this way, Bitner makes her internal processing visible, revealing aspects of her "inner reality" not accessed in any other way.

Face to Face is an intriguing example. Here we see recognizable symbols from Bitner's visual vocabulary—a rabbit, a conical vessel, leaves, written fragments, the numeral five, masks, and so on—fluidly relating to one another in a world all their own. Forms come and go; relationships are in flux. Meaning is sensed rather than understood. Bitner presents us with a world that is beyond the rational and concrete, a world that stands metaphorically for the mysterious and transcendent.

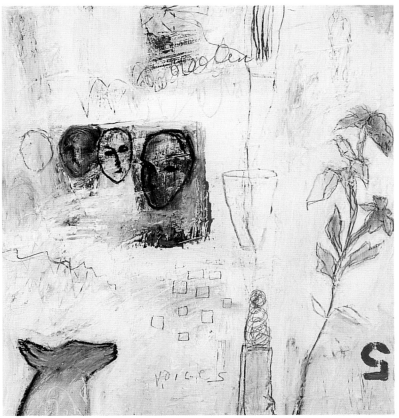

figure 11

Donne Bitner
Face to Face, 2007
Oil pastel, graphite
20 x 16 inches
(50.8 x 40.6 cm)
Collection of the Artist

PLAY 2 ■ WORKING WITH FLUX NONOBJECTIVELY

For this drawing, you'll need the following: a couple of conventional abrasion drawing tools (pencil, charcoal, conté crayon); white acrylic paint (artist's grade, or house paint); a 1- or 2-inch (2.5- or 5-cm) china bristle brush; and a container of water (to hold your paint-filled brush when not in use).

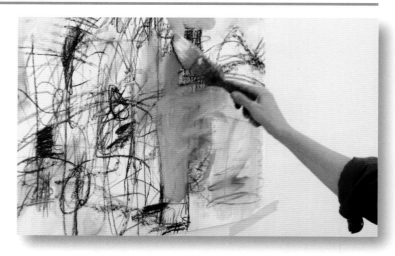

1 When I teach this exercise, I get artists going by acting as a square dance caller of sorts. You can have someone else do this for you or you can use a timing device such as an egg timer. I call out **"Draw!"** and participants begin doing some automatic drawing (again, no need to render—just generate lines and marks at whim).

2 After a minute or so, I call out **"Obliterate!"** or **"Veil!"** At this point, the artists put down their drawing tool, pick up the brush, and load it with some white paint. They stand back to momentarily take in the contents of the drawing, then start covering up parts of the drawing with the white paint. (Note: This does not mean to draw with the paint, but rather to cover up or veil things.)

3 Before the artists completely cover up their drawings, I call out **"Draw!"** again or **"Switch!"**—at which time the artists put their brushes down and start to draw again, in blank areas of the surface or right into the wet paint.

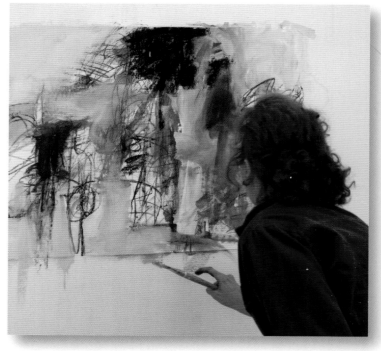

Audrey Phillips uses the assert and obliterate method described above.

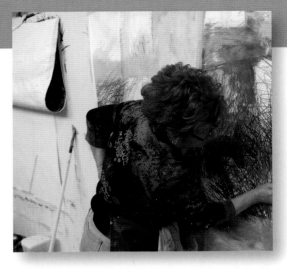

4 Now it's your turn. Start a new drawing using the approach explored in Play 1 on page 28. After a while of working in this way, stop: Assess your marks. Keep areas or passages of the drawing that intrigue you and get rid of others that aren't as satisfying (or that seem as if they don't contribute to the whole).

As in all unplanned drawing, keep this processing of things going until nothing else occurs to you to do—or until you really love what you see.

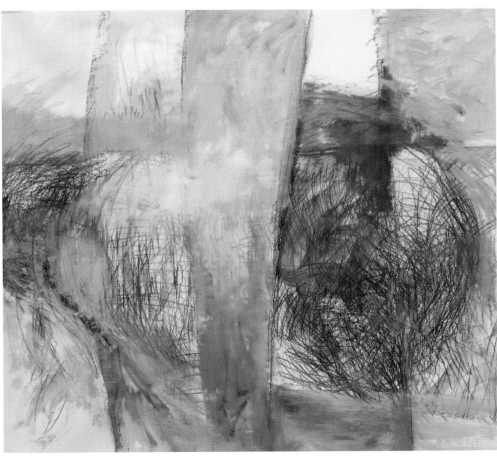

**Marijane Whitfield
asserts and obliterates (top);
her finished drawing (left) is
shown here.**

BUILD ▪ WORKING WITH FLUX NARRATIVELY

This Build challenge is a logical and intriguing extension of the Play 2 challenge you just completed. You'll use the same (or similar) tools and materials and work on a drawing surface. And you'll do much the same kind of exercise—only this time, you'll use visual symbols and text, and you'll act as your own "square dance caller."

1 Begin your drawing by making symbols and/or writing text on the drawing surface.

2 Work in a stream-of-consciousness manner: Start with one element or a few elements, then step back and briefly take things in. Pay attention to both the nonobjective line and mark that is emerging, as well as the narrative content.

3 Again, as in automatic drawing, respond by trusting your first urge to add more symbols or text. You'll notice, by the way, that the uniformity of your handwriting or printing naturally unifies your drawing.

4 As you continue adding elements this way, begin to consider taking them out or veiling them by covering them with white paint.

5 Continue asserting and obliterating, developing the drawing both visually and narratively.

6 When nothing more occurs to you to do, stop. Put the drawing aside. Take a walk or a break of some sort. Come back later and take another look. If it still doesn't call out to you to be changed— or if you really like the drawing just as it is—it's finished!

Erin Jones develops a drawing that features text and symbols.

Erin Jones' finished workshop drawing from this Build exercise shows how she worked with flux in a narrative way.

the ELEMENTS

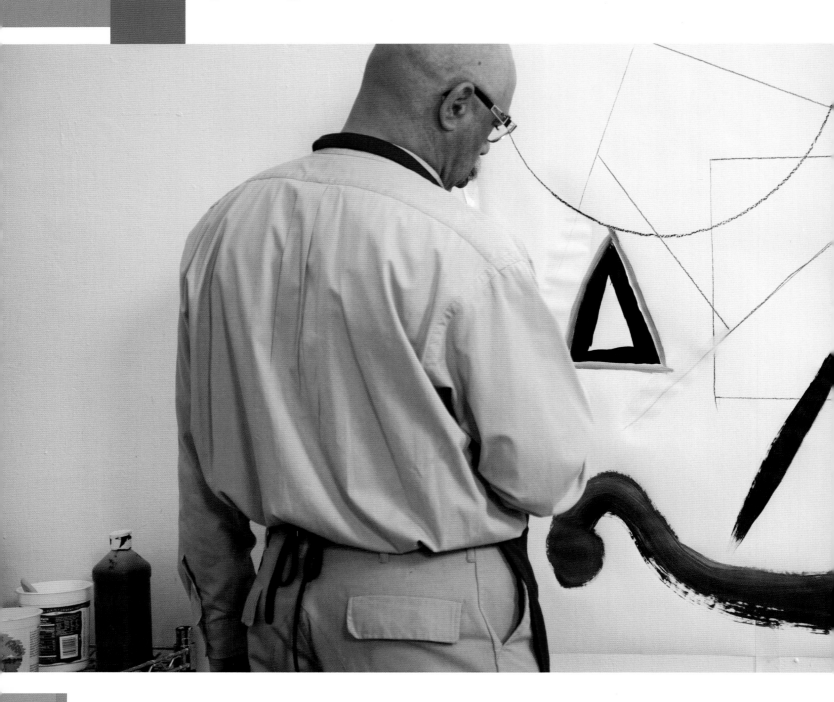

of drawing

Now that you have some initial drawing experience under your belt, it's time to explore the elements of drawing in Part Two. Understanding and working with these concepts in the next three chapters will leave you with a solid understanding of the important fundamentals.

Chapter 3 will introduce you to the primary elements of line and mark. Chapters 4 and 5 will segue into the secondary elements of shape and texture.

If you envision your blank paper as a stage or arena on which your story unfolds, these elements are akin to the actors or players on that stage—each with their own distinct energies and abilities. In concert with one another, these drawing essentials can accomplish stunning results. So join me as I explore their expressive and varied potential.

Tim Proctor works on an exercise that contrasts geometric and organic shapes, explained in Chapter 4.

LINE & MARK

The most fundamental thing you can do to a drawing surface is make a mark on it. Most of the time, a drawing starts out with a blank surface of some kind, usually paper. This surface is almost always flat (two-dimensional) and, generally, passive (empty). So as soon as you do something—anything—to it, you've marked, or *activated*, it.

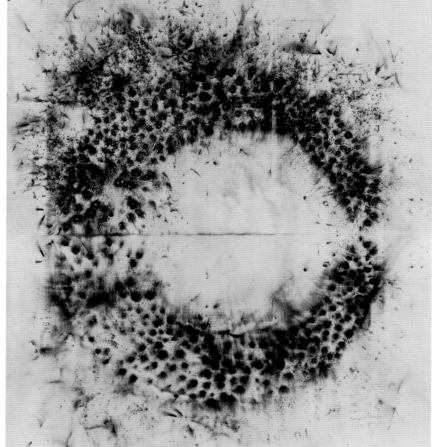

figure 1

Cai Guo-Qiang
Transient Rainbow, 2003
Gunpowder on paper
198¹³⁄₁₆ x 157½ inches (505 x 400 cm)
Fractional and promised gift of Clarissa Alcock Bronfman
Collection of the Museum of Modern Art, New York, NY, USA
Digital Image © The Museum of Modern Art / Licensed by SCALA /
Art Resource, NY

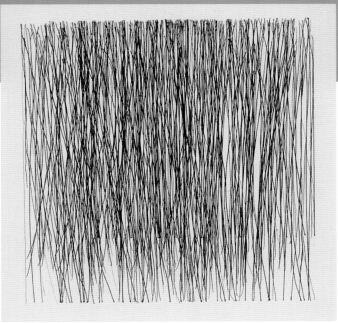

figure 2

Kocot and Hatton
13 August–17 August 2005, 2005
Ink on rag paper
15⅜ x 15⅜ inches (39 x 39 cm)
Courtesy of the Artists and Larry Becker
Contemporary Art, Philadelphia, PA
© 2005 Kocot and Hatton

A mark is an impression, deposit, or remnant left on a surface as the result of contact by a tool or object. In the world of drawing, this usually is achieved with pencil, charcoal, crayon, pastel, or paintbrush. Traditional examples of marks include things such as dots, dashes, check marks, commas, arrowheads, fingerprints, brush marks, and so on (figure 3, page 48).

Modern artists use all kinds of nontraditional tools and means to make marks: drips, stamps, stains, burn marks, punctures, stitches—you name it. Cai Guo-Qiang's work (figure 1) shows the remnants of a gunpowder explosion. Kocot and Hatton (figure 2) use traditional pen and ink on paper to create elegant linear movements.

But there's more to a mark than you might think. For most of us, what gives a mark much of its meaning is that it's made by an individual artist with his or her particular hand. So let's add to our understanding that a mark is an impression *left by a maker*. After all, drawing tools are virtually always held in your hand, which in turn is attached to your body. The tool becomes an extension of you. And as a drawing evolves as a series of marks made over time, it stands as a recording of your hand's movements and actions. Every drawing can therefore be considered a kind of self-portrait, in that it *mirrors* your temperament, personality, and mood, as well as *records* your process of responding and making decisions. Imagine that—you reveal things about yourself every time you draw!

A *line* is a specific kind of mark—one that is much longer than it is wide. In the strictest definition, a line is a one-dimensional mark—it has length only, with one unit of height and width. For our purposes, though, a broader and more useful idea is that of *linearity*, or line as an extended mark. From this perspective, it's accurate to refer to the brushstroke in figure 4 on page 48 as a line (a mark that has linearity). So when we refer to a line, we'll most often be talking about a *linear mark* rather than something purely and academically one-dimensional.

Naturally, this distinction is somewhat contextual. The mark in the middle of figure 5 on page 48 reads as a line

figure 3

figure 4

figure 5

figure 6

in comparison with the mark on the left, but it reads as a mark in comparison with the line on the right.

Artists think of lines as living things. Lines have many attributes: They can be long and short, thick and thin, light and dark. They can be continuous (fully intact) or broken (lost and found), as in figure 6.

Lines can be straight, curvilinear (rounded, looping), or angular (pointed, jagged), as in the Charlene Thomas drawing below. They can be oriented in three ways: as horizontal (grounded, settled), vertical (upright, stable), and diagonal (assertive, dynamic). And they generally relate to one another in one of three ways: They are parallel to one another, they converge, or they intersect. A great example of line interaction is Hans Hartung's etching (figure 7).

Line can do a great many things. Most notably, you can use it to indicate movement and direction, establish value, create emphasis, serve as symbol, represent edge, and convey energy and express mood.

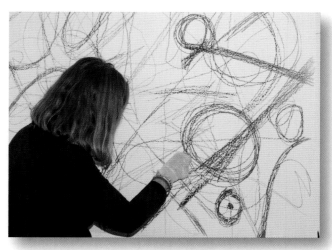

Charlene Thomas juxtaposes straight and curvilinear lines.

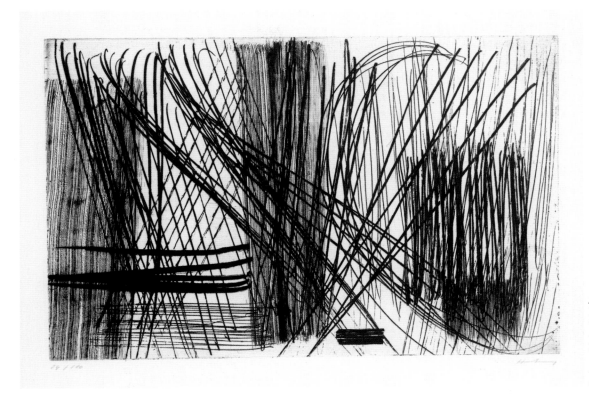

figure 7

Hans Hartung
Etching, 1953
Etching on paper, print
14⅞ x 20⅜ inches (37.8 x 51.7 cm)
Tate, London / Art Resource, NY © 2008 Artists Rights
Society (ARS), New York / ADAGP

1. Indicate Movement and Direction

Another classical definition of line is as *the recorded movement of a dot on its journey from one place to another*. This sense of linear movement implies a direction or a sequence of directions. It accordingly implies a sense of time—in other words, line most often has a beginning and an end, and to experience it takes time.

People use line to indicate direction and motion all the time, even if they don't think of themselves as *drawing*. This expressive quality comes into play whenever someone draws a map, diagrams a football play, blocks out a family tree, and so on.

In expressive drawing, this quality can help you lead the viewer on a journey through the drawing space, whether through continuous line or through a series of linear fragments that serve as pointers. In essence, line enables you to act as a sort of visual choreographer, directing the eye from one place to another and another.

2. Establish Value

Contrast of value (or tone)—the relationship between light and dark—plays an essential role in all drawing. It is *the* essential contrast in monochromatic works (drawings with no color). In these drawings, the color attributes of hue (redness, blueness, and so on), saturation (purity), and temperature (warm and cold) are absent, so contrast of value takes center stage. And even when hue/saturation/temperature are present in a drawing, every color contains a tonal value, which means each color has a value equivalent. So, in descriptive drawing, when you render a subject that has color, you translate color into tone—a radical form of abstraction. See the color-to-value translation in figure 8.

Line and mark can establish value in a number of ways, alone or, in many cases, in concert with one another. Varying the pressure when you apply a drawing tool is one way to achieve this result. Another is to load a drawing tool with more or less of a fluid drawing medium, such as ink or paint. See examples of line and mark in these ways in figure 9.

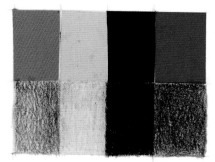

figure 8

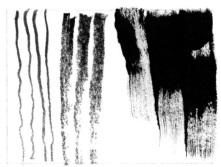

figure 9

Another way in which line and mark can create tone is through *density* of application. This means that when you are working with similarly weighted lines or marks in any given area, the more lines or marks you have, the darker a value you achieve. Look again at Kocot and Hatton's *13 August–17 August 2005* (figure 2, page 47), where fewer lines in the bottom of the drawing result in a lighter tonal area, or an airier feeling.

Sometimes, creating tone through density is achieved by more strictly organized methods known as *hatching* (parallel lines) and *crosshatching* (two or more sets of parallel lines that cross over one another). The latter is used most effectively by George Bellows in *Study of Leon Kroll* (figure 10). Note the way Bellows used crosshatching of heavyweight lines to create the feeling of weight and darkness in his subject's vest.

3. Create Emphasis

Line can also serve as a choreographic tool: Changes in weight—achieved through changes in value, thickness, or character—can be used to establish varying degrees of emphasis in drawing.

Whenever a line meanders along and suddenly becomes thicker or darker, for example, the eye is drawn to it—and that portion of the line becomes the focus of attention. Think of this portion of the line as exerting more pressure on the surface of the drawing, and you've got the idea. Quickly scan Keiko Hara's mixed-media drawing (figure 11) and you'll be drawn right to those linear pressure points created by thicker, darker lines (and, subordinately, by color). That extra-thick, brown line near the center gets top billing!

Likewise, whenever a line proceeds in an even, fluid manner and then becomes frenetic and energetic, it demands more attention.

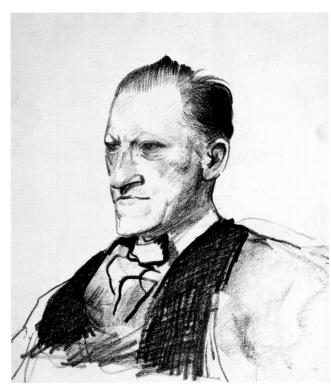

figure 10

George Wesley Bellows
Study of Leon Kroll, 1915–16
Crayon on wove paper
10½ x 8¾ inches (26.7 x 22.2 cm)
Collection of the Columbus Museum, Columbus, Georgia; Promised Gift, Dr. and Mrs. Philip L. Brewer Collection. 2002.47.1

4. Serve as Symbol

As part of our visual language, line is often symbolically expressive. That is, certain configurations of line can serve as a shorthand symbol to represent objects or concepts. The detail of a musical score from composer Steven Palmieri (figure 13, page 52) demonstrates a specific example of line and mark as symbolic language.

All of us use and respond to line in this way every day. The numerals and letters that compose our handwriting or printing are linear symbols. So are many other notations, such as stick figures to indicate male and female or a circle with a diagonal slash across it to indicate the notion of "anti" or "no."

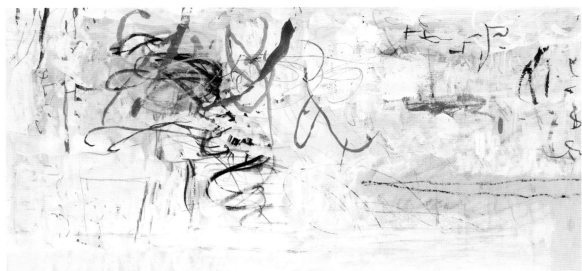

figure 11

Keiko Hara
Verse from Sea Series, 2002
Mixed media on paper
10 x 20 inches
(25.4 x 50.8 cm)
Courtesy of the James T. Dyke Collection

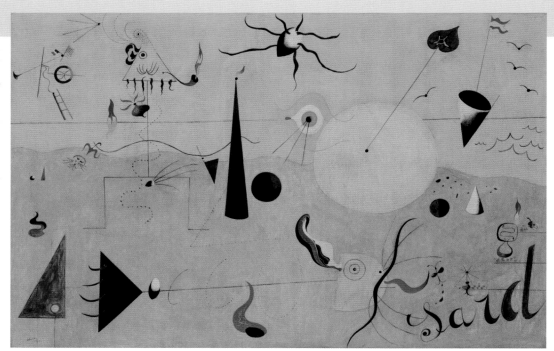

figure 12

Joan Miró
*The Hunter
(Catalan
Landscape),*
1923–24

Oil on canvas

25½ x 39½ inches
(64.8 x 100.3 cm)

Digital Image © The
Museum of Modern Art /
Licensed by SCALA / Art
Resource, NY
© Successió Miró / Artists
Rights Society (ARS), New
York

Remember that driving test that required you to memorize signs? For example, the squiggly line with an arrowhead at the end on a road sign indicates a curvy road ahead.

In fine-art drawing, you can do this, too—you can use a combination of linear symbols to convey a narrative. This approach is especially emphasized in drawings that put forward a stream-of-consciousness or indirect narrative, such as the one in Joan Miró's *The Hunter* (figure 12). Here, a bit of text, an empty conical form, a ladder, worm- and spider-like elements, simple linear notes that read like birds and waves, a couple of concentric circles that read like eyes, an upside-down heart shape, and more all share the same space, juxtaposed in a way that makes no sense according to the normal, visible world. Instead, they form their own, new world, making sense in ways that are mysterious and magical.

5. Represent Edge

One specific way that line can serve as symbol is when it's used to represent an edge. An edge is the place where one drawing area or form stops and the next one begins. Put another way, line is often used to represent the place where one shape butts up against another.

This function is essential, even indispensable, in representational line drawing. Great examples of this are found in drawings by Ellsworth Kelly and William Beckman (figures 14 and 15). In our culture, we are

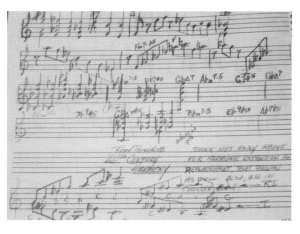

figure 13

Steven Palmieri
*Working Score
(detail)*
Pencil on paper, 2008
Courtesy of the Artist

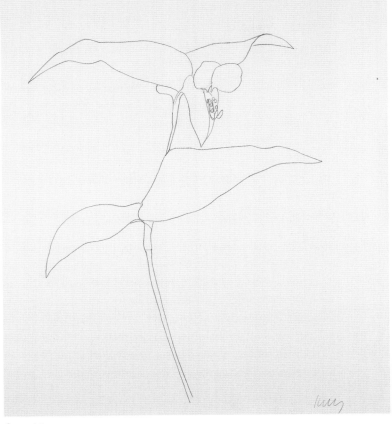

figure 14

Ellsworth Kelly
Asiatic Day Flower, 1969
Pencil on paper

29⅞ x 22 inches (75.9 x 55.9 cm)

Arkansas Arts Center Foundation Collection: Purchase, Tabriz
Fund and Museum Purchase Plan of the NEA. 1981.015
© Ellsworth Kelly

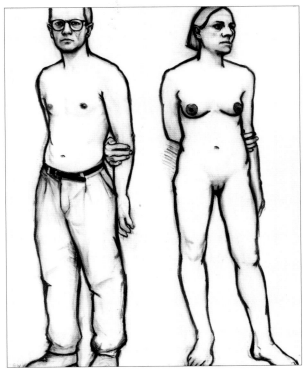

figure 15

William Beckman
Scale Study for "Woman and Man," 1988
Charcoal and crayon on gessoed paper

90 x 71¼ inches (228.6 x 181 cm)

© William Beckman, courtesy of Forum Gallery, New York and Los Angeles
Arkansas Arts Center Foundation Collection: Purchase. 1988.043

figure 16

figure 17

trained to recognize this symbolic role that line can play. In fact, many would consider Kelly and Beckman drawings to be realistic or descriptive of actual appearance.

In reality, however, quite the opposite is true: Strictly speaking, there are no lines in nature. Instead, artists use line as an *abstract symbol* to designate the outer parameters of shape and form. Consider figures 16 and 17 which show how this works. Figure 16 is a drawing of several shapes of tone; figure 17 is an artist's translation of tonal area into a line drawing.

6. Convey Energy and Express Mood

Lines also have character and personality, in and of themselves. They can express mood, energy, and spirit. Linear character results from the nature of the line itself and from the nature of the line's contextual role in the drawing. Fat, dark lines can feel heavy, assertive, strong. Jagged lines can feel aggressive, threatening, sharp. Looping lines can feel lyrical, soft, rhythmic. We'll observe and work with these and other linear attributes throughout our exploration.

For an example of how this works, look at two figurative drawings. Pablo Picasso's *La Sieste* (figure 18) feels voluptuous, fluid, and harmonious. Its character results not from the nature of the subject matter but from the nature of the artist's line: exceedingly curvilinear, with only delicate variations in weight. Here Picasso uses line almost solely to define contours in a clear and understandable manner. Louis Freund does the opposite in *Pieta* (figure 19), which feels tumultuous and wildly energetic. Freund's line is exploratory and in flux; specific contours are lost and found, and are submerged in an overall feeling of linear frenzy.

Finally, as we'll see in the next chapter (page 72), line can serve as *shape-maker*.

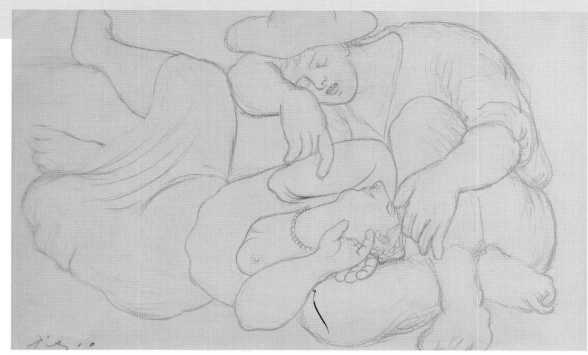

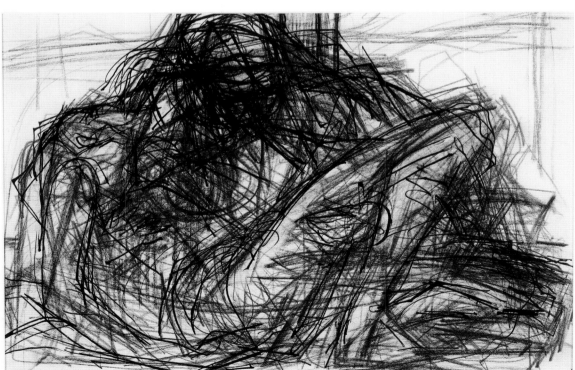

t's remarkable how much can be expressed and revealed by a community of simple, straight lines (or nearly straight lines). Eve Aschheim's drawings are superb explorations in this regard. Each of her line compositions has its own distinct energy, resulting directly from the nature of the line she chooses and the ways in which she arranges them.

Aschheim's drawings focus in on two linear properties in particular. The first involves contrasting degrees of surface presence or intactness—in other words, a sense of flux. Some lines feel as if they are at the very top of the drawing's surface, fully intact. Others seem to be more embedded; some seem to be dissipating altogether, while others seem to be emerging or re-emerging. The second linear property involves orientation: the contrasting degrees of horizontality, verticality, and diagonality, and the corresponding feelings that come with them.

Title, Title (figure 20) is a wonderful case in point. It features a rich and intriguing range of linear character and orientation. Additional drawings can offer the viewer clues to the meaning of this drawing, so let's explore those first.

Rungs Without a Ladder (figure 21, page 58) explores horizontality. Horizontals run parallel to the ground in a landscape, the floor in a room, and the top and bottom of the drawing space itself, and offer a feeling of being supported, level, stable. They make the drawing as a whole feel this way. At the same time, slight deviations (bits of diagonal tilting) create very subtle variations and vibrations.

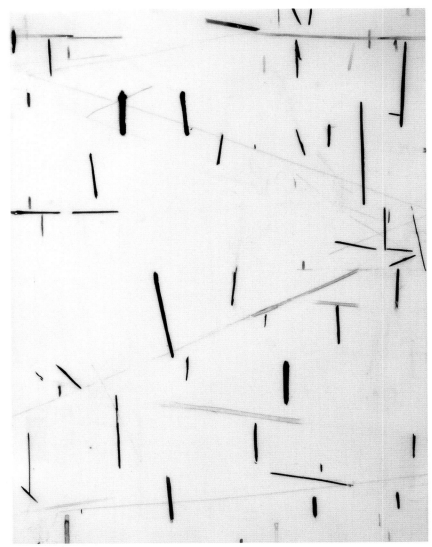

figure 20

Eve Aschheim
Title, Title, 2006
Ink, gesso, and graphite on
Duralene mylar

12 x 9 inches (30.5 x 22.9 cm)

Courtesy of Larry Becker Contemporary Art,
Philadelphia, PA
Photograph by Kocot and Hatton

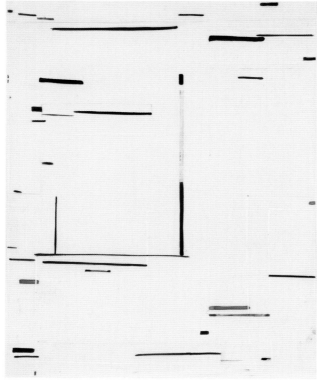

figure 21

Eve Aschheim
Rungs Without a Ladder, 2005
Ink, black gesso, and graphite on Duralene mylar
14 x 11 inches (35.6 x 27.9 cm)
Courtesy of Lori Bookstein Gallery
Photography by Farzad Owrang

Plural Blur (figure 22) explores verticality. Not quite as settled in as the horizontal, vertically oriented lines feel sturdy, erect. The sensation results from the fact that these lines run perpendicular to the horizontal, and parallel to the left and right edges of the drawing space. The preponderance of vertical lines also elicits a sense of rising, of elevation. And, once again, when some of Aschheim's vertical notes tilt ever so slightly, there's a hint of animation and tension.

Industrial Strength (figure 23) explores diagonality. Here there are no horizontals and only one or two verticals. Diagonals abound. Some are relatively gentle (those that are short in length, others that are light in tone or seemingly embedded, still others that are only mildly inclined). But the drawing is clearly dominated by strong, dark, and elongated lines that are severe in slope, creating a powerful rocking rhythm. As a result, the drawing feels alive and full of vibration.

Look back at *Title, Title* (figure 20, page 57) and you'll see it combines all these orientations beautifully and effectively. Straight vertical lines dominate the drawing, giving it a feeling of sturdiness and on overall sense of upward motion. A number of horizontals and near-horizontals add to the sense of stability and groundedness. A few diagonals are incorporated as well, lending just enough tension and an element of dynamism. *Title, Title* also employs contrasts of scale, width, and value to create a rich sense of mystery and depth. The longest and darkest of the lines come forward. Bits of overlapping here and there create a sense of depth, as do very subtle changes in the width and darkness of the line. Shorter and mid-tone lines recede, the very faintest of which again seem to be about to either dissipate or emerge, making the drawing feel very much in flux and alive.

Imagine, all these sensations and feelings elicited from drawings that employ only straight lines and dashes!

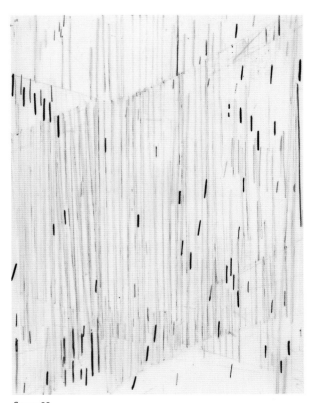

figure 22

Eve Aschheim
Plural Blur, 2006
Gesso, black gesso, ink and graphite on Duralene mylar

12 x 9 inches (30.5 x 22.9 cm)

Courtesy of Lori Bookstein Gallery
Photography by Farzad Owrang

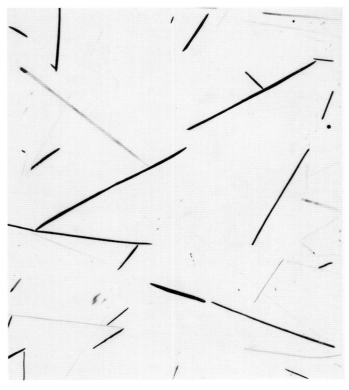

figure 23

Eve Aschheim
Industrial Strength, 2005
Ink, black gesso, and graphite on Duralene mylar

17 x 14 inches (43.2 x 35.6 cm)

Courtesy of Lori Bookstein Gallery
Photography by Farzad Owrang

This ink drawing by Henri Matisse illustrates how eloquently and expressively line and mark can serve as abstract symbols in drawing.

In *The Necklace* (figure 24), Matisse's line often serves as symbol for an edge—the place where one area or form ends and an adjacent one begins. In formal drawing terms, this is referred to as a *contour line*. A good example of this kind of symbol is found in the line you see here that loops from the base of the neck down to the elbow. It represents where the upper arm stops and the space to the right and behind the figure begins. You see this kind of symbolic line in effect elsewhere in the drawing—where the line represents the edge of the waist and hip on the right side, where the line represents the belly and hip on the left side, and so on. It's important to realize that none of these lines actually exist out there in nature; instead, they are abstract representations.

Line and mark serve as a type of shorthand symbol in Matisse's piece. Short, diagonal dashes serve as symbols for both eyes, the mouth, and the eyebrow to the right. A series of dashes represent fingers. And, as pointed out by the drawing's title, a series of dots that form a rhythmic sequence around the neck and a cluster between the hands imply a delicate necklace.

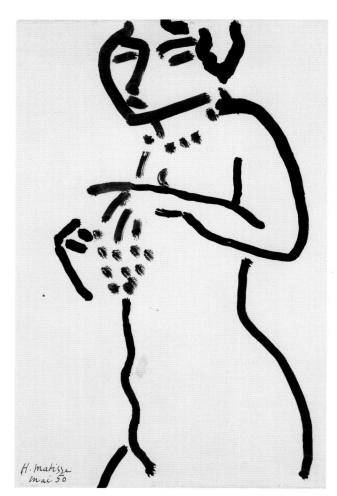

figure 24

Henri Matisse
The Necklace, 1950
Brush and ink on paper
20⅞ x 16⅛ inches (53 x 40.7 cm)

I n *Valspar 06–02* (figure 25), I used a very dense arrangement of highly energetic line to elicit depth and mystery as well as monumentality and strength.

The first thing you'll notice about the drawing is that it's alive; it's very much in flux. While some linear movements are sharp, focused, and intact (especially around the edges of the space), the vast majority are harder to nail down. A great deal of overlapping occurs. Many lines are relatively transparent. Things become blurred and more challenging to comprehend, especially in passages in the interior. Some linear movements seem on the verge of emerging, while others appear to be fading away.

You'll also notice that the drawing feels powerful and assertive—qualities directly attributable to the nature of the lines, which are predominately thick, dark, and black with a few mediating grays. Linear elements that are thinner or more delicate are fewer in number and assigned clearly subordinate roles. In some passages, lines are clustered to form extensive areas of darkness that carry great visual weight, creating an overall effect of substantiality.

The drawing also has a sense of monumentality—it feels big, despite its one-foot-square dimensions. This illusion happens because most concrete, hard-edged, and well-defined drawing elements are located near or at the outside edge of the space. For instance, notice the three short rhythmic lines at the top right, the circular loop in the bottom right corner, the lines that define the triangular void in the bottom left corner, and the pair of lines that cross the edge on the left side near the top.

Anytime a drawing element engages the edge it gains power. And when all of the edges and near-edges are emphasized as they are here, your attention goes to the outer parameters of the space. There is an implied sense that some movements continue beyond the edges of the drawing, resulting in a sense of grandness.

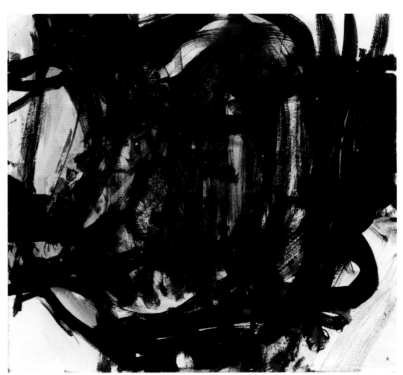

figure 25

Steven Aimone
Valspar 06–02, 2006
House paint on 300# hot press watercolor paper
12½ x 12 inches (31.8 x 30.5 cm)
Courtesy of the Artist

PLAY 1 ■ LINE SAMPLERS

Traditionally, when people first learned to embroider with thread, they produced samplers—individual compositions on which they stitched their name, the date, as well as the alphabet and other numbers. Similarly, in this challenge, you'll practice making a range of line and mark, using a variety of drawing tools on different drawing surfaces.

Try all or some of the following tools: ballpoint pen, felt-tip pen, graphite pencil, stick of charcoal, crayon, pastel stick, and a small artist's paintbrush (brush size #2, #4, or #6) with black ink or water-soluble paint. For drawing supports, gather two or more sheets of drawing paper: at least one smooth (drawing vellum, or hot-press watercolor paper) and at least one rough or highly textured (cold-press watercolor paper, pastel paper, or charcoal paper). Now you're equipped to create several line samplers.

1 Begin with the smooth drawing support. Use one tool to create a cluster of straight, vertical lines.

2 Right next to those, create another similar cluster using a second tool; next make a cluster with the third tool, and so on.

3 Repeat the sequence, this time with clusters of looping lines, then angular (zigzag) lines, and so on, using a variety of tools for each.

4 Pause for a moment: Observe the differences in the nature of the lines made by the different tools. In your own handwriting, jot down some adjectives you'd use to describe the contrast between the lines made by one tool and those made by another.

5 Finally, continue filling up the space with additional lines. Make the sampler look and feel good to you; enjoy the process.

6 Next, repeat the entire process, this time applying the lines to the rough support. Note the difference the rough support makes. Again in your handwriting, describe what you observe and sense directly on the drawing itself.

7 Continue making clusters of different kinds of line, arranged in pleasing ways, until the sampler feels complete.

Jeff Brooks develops his line sampler.

I n *Valspar 06–02* (figure 25), I used a very dense arrangement of highly energetic line to elicit depth and mystery as well as monumentality and strength.

The first thing you'll notice about the drawing is that it's alive; it's very much in flux. While some linear movements are sharp, focused, and intact (especially around the edges of the space), the vast majority are harder to nail down. A great deal of overlapping occurs. Many lines are relatively transparent. Things become blurred and more challenging to comprehend, especially in passages in the interior. Some linear movements seem on the verge of emerging, while others appear to be fading away.

You'll also notice that the drawing feels powerful and assertive—qualities directly attributable to the nature of the lines, which are predominately thick, dark, and black with a few mediating grays. Linear elements that are thinner or more delicate are fewer in number and assigned clearly subordinate roles. In some passages, lines are clustered to form extensive areas of dark-ness that carry great visual weight, creating an overall effect of substantiality.

The drawing also has a sense of monumentality—it feels big, despite its one-foot-square dimensions. This illusion happens because most concrete, hard-edged, and well-defined drawing elements are located near or at the outside edge of the space. For instance, notice the three short rhythmic lines at the top right, the circular loop in the bottom right corner, the lines that define the triangular void in the bottom left corner, and the pair of lines that cross the edge on the left side near the top.

Anytime a drawing element engages the edge it gains power. And when all of the edges and near-edges are emphasized as they are here, your attention goes to the outer parameters of the space. There is an implied sense that some movements continue beyond the edges of the drawing, resulting in a sense of grandness.

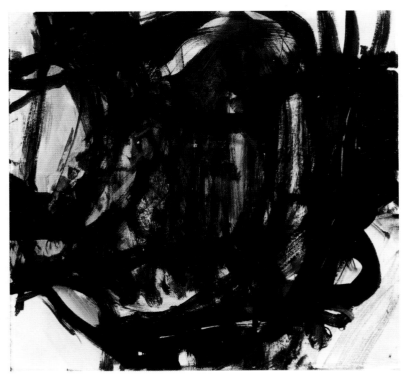

figure 25

Steven Aimone
Valspar 06–02, 2006
House paint on 300# hot press watercolor paper
12½ x 12 inches (31.8 x 30.5 cm)
Courtesy of the Artist

PLAY 1 ▪ LINE SAMPLERS

Traditionally, when people first learned to embroider with thread, they produced samplers—individual compositions on which they stitched their name, the date, as well as the alphabet and other numbers. Similarly, in this challenge, you'll practice making a range of line and mark, using a variety of drawing tools on different drawing surfaces.

Try all or some of the following tools: ballpoint pen, felt-tip pen, graphite pencil, stick of charcoal, crayon, pastel stick, and a small artist's paintbrush (brush size #2, #4, or #6) with black ink or water-soluble paint. For drawing supports, gather two or more sheets of drawing paper: at least one smooth (drawing vellum, or hot-press watercolor paper) and at least one rough or highly textured (cold-press watercolor paper, pastel paper, or charcoal paper). Now you're equipped to create several line samplers.

1 Begin with the smooth drawing support. Use one tool to create a cluster of straight, vertical lines.

2 Right next to those, create another similar cluster using a second tool; next make a cluster with the third tool, and so on.

3 Repeat the sequence, this time with clusters of looping lines, then angular (zigzag) lines, and so on, using a variety of tools for each.

4 Pause for a moment: Observe the differences in the nature of the lines made by the different tools. In your own handwriting, jot down some adjectives you'd use to describe the contrast between the lines made by one tool and those made by another.

5 Finally, continue filling up the space with additional lines. Make the sampler look and feel good to you; enjoy the process.

6 Next, repeat the entire process, this time applying the lines to the rough support. Note the difference the rough support makes. Again in your handwriting, describe what you observe and sense directly on the drawing itself.

7 Continue making clusters of different kinds of line, arranged in pleasing ways, until the sampler feels complete.

Jeff Brooks develops his line sampler.

PLAY 2 ▪ WEIGHTED LINE

PART ONE: CHANGING LINE WEIGHT SEQUENTIALLY

One proven way to make line expressive and establish emphasis is to vary its weight. You can achieve this by making it thicker and thinner, or lighter and darker. When you use simple dry media such as a pencil or stick of charcoal, you can vary the weight or pressure with which you apply the drawing tool. When you use wet media such as paint or ink, these variations can be achieved by adding pressure and by varying the amount of liquid, or load, on the brush.

Your challenge in this exercise is to vary the weight of your line, both from one line to the next and within the movement of a single line. Again, to get the most from this Play challenge, try doing this with more than one drawing tool on more than one kind of drawing surface.

1 Begin with a smooth support and a drawing tool of your choice. Create a series of parallel lines, equidistant from one another, using the same drawing tool. Generate the first line with medium pressure (i.e., what seems normal to you).

2 Now, create an adjacent line to the right that is a bit darker.

3 Then, to the right, follow with another darker/heavier line.

4 Finally, add a line that is as heavy/thick as you can make it.

5 Then begin to reverse the sequence. Continuing on, make the next line a touch lighter/thinner, the next another step lighter/thinner. Continue until the line is as light/thin as you possibly can make it, while still rendering it visible. When done, you should have a beautiful, visible sequence or movement.

Tim Proctor and Kelly Richards change the weight of lines in a sequence.

6 If you'd like, execute several more sequences, making the variations more irregular. See what variations in movement and feeling you can create.

7 Next, repeat this drawing challenge with each of your various drawing tools.

8 Then, proceed through the challenge with each of the tools again, this time on a rough support.

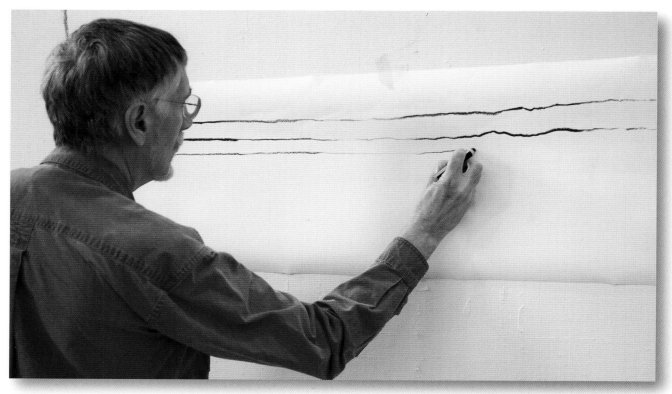

Jim LaFerla develops drawings for the weighted line challenge.

PART TWO: CHANGING THE WEIGHT OF THE LINE ITSELF

The second part of this challenge is to change the expressive quality of line by altering its weight as it moves through space. Again, you'll do this challenge with each of the drawing tools, on both smooth and rough supports.

1 On each surface, begin by generating lines of any kind: straight, curvilinear, zigzag.

2 This time, as you draw each line, vary its width/weight along the way. When you're using abrasion tools, you'll need to vary the pressure; using a brush, you can vary pressure and/or vary the amount of paint or ink it carries.

3 After experimenting with this on both kinds of paper, try the following:

• Draw a series of lines running parallel to one another at regular intervals.

• Change the weight of these lines in the same way so that they mimic one another, as demonstrated above. You'll see how easy it is to create a rhythmic feeling of coming in and out, forward and back.

BUILD 1 ■ CONVERSATIONS BETWEEN LINE WEIGHT

Here's a chance to explore what variations in weighted line can do to alter and enhance the expressive quality of a drawing. The requirements are simple: a ballpoint pen, a charcoal pencil and sharpener, a kneaded easer, one sheet of drawing paper that is 8½ x 11 inches (21.6 x 27.9 cm), access to a photocopy machine, and half a dozen sheets of photocopy paper.

1 To begin, use the ballpoint pen to generate a simple line drawing on the sheet of drawing paper. This may be a quick automatic drawing (see page 28).

2 When you're finished, make six photocopies of your line drawing.

3 Tape all six drawings to the wall.

4 Using variations in linear weight to change the dynamics of the arrangement, compose several different versions of your original line drawing. Think of this as creating six differing metaphors for personality or feeling. You can work on one at a time, or get all of them going at once.

5 Working on a wall in front of you is ideal: You can step back and see, feel, and compare all of the drawings at once. Remember, you are free to erase or veil (narrow or lighten) lines as well as to create or emphasize them. When you're through, you'll have a small series of drawings that relate to one another in exciting and personal ways.

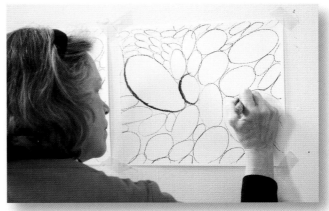

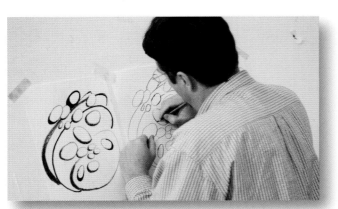

Workshop participants Mark Combs (left) and Dana Irwin (right) explore the weighted line challenges.

BUILD 2 ■ CONVERSATIONS
BETWEEN ORIENTATIONS

In drawing (as in life), vertical, horizontal, and diagonal orientations elicit differing sensations, both emotional and physical. We saw how Eve Aschheim worked with these dynamics in her drawings on pages 56–59. Now try your hand at exploring these expressive possibilities in a group of three drawings, each processed in the *assert* and *obliterate* manner you employed on page 40. You'll need an abrasion tool, white paint, and three sheets of drawing paper (each the same size and proportion). You'll work on all three drawings at once.

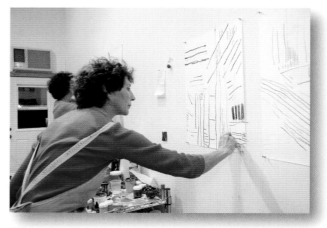

1 Start all three by introducing a series of straight or fairly straight lines. Include some horizontals, verticals, and diagonals. Cluster some of your lines together; leave others in isolation. It's okay if a few overlap or intersect, but keep the majority separate from one another; you can vary the weight as well.

2 After you've got all three started, put them up on a wall and survey your results. Then, based on nothing but your gut feeling, develop one of these drawings so that it has a primarily horizontal orientation, with verticals and diagonals playing a subordinate role.

3 Develop a second drawing so that its orientation is primarily one of verticality, with horizontals and diagonals relegated to secondary roles.

4 You guessed it: Develop the remaining composition so that diagonals rule while horizontals and verticals play supporting roles. When you're done, you'll have three distinct drawings, all very much related but each with a different expressive mood. Imagine that!

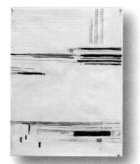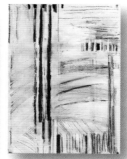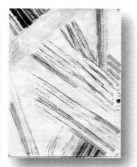

Krista Harris (above) explores horizontal, vertical, and diagonal orientations in these three drawings.

PLAY 3 ▪ CREATING EXPRESSIVE LINE

A line, in and of itself, can express and represent an enormous range of psyche, emotion, and spirit. You can create these animate personalities—all *you* need to do is let it happen. In workshops, I call out a word indicating an emotion or feeling, and ask the artists to create a line or lines that feel that way. Let's try that now.

1 Select a drawing tool that you enjoyed using in the Play challenges earlier in this chapter.

2 Next, gather half a dozen drawing supports. Any kind of paper will do, but if possible choose a larger surface rather than a smaller one.

3 Then, adopt the automatic-drawing approach we employed on page 28. Without thinking, planning, worrying, or analyzing, generate a linear movement or movements that feel angry—let 'er rip. When you're done, write the word "angry" underneath, using the same angry line.

4 Next, on a second support, generate linear movements that are serene—again, just let them flow. When you're done, write the word "serene" underneath, using a line of similar character.

5 Repeat this process several times, using several adjectives from the following: confused, frenzied, excited, melancholy, lyrical, rhythmic, aggressive (or come up with other emotions, adjectives, or personalities of your own).

6 When you're done, stand back and appreciate the unique series of drawings you've just created!

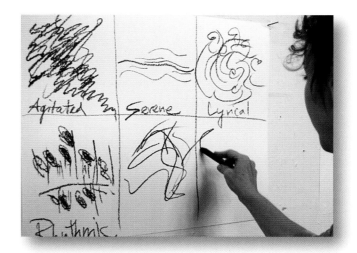

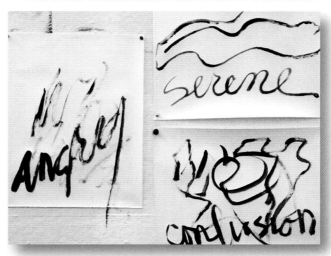

Top: Katherine Aimone enjoys the line challenge.
Below: A variety of expressive outcomes are displayed.

BUILD 3 ▪ CONVERSATIONS
BETWEEN EXPRESSIVE LINE

Now that you've experienced generating lines that elicit a range of feeling and personality, it's time to build a full-fledged composition based on the contrasts between two or more of them. Using the tools and support of your choosing, you can do this in one of two ways.

PART ONE: PLANNED LINE

1 Mentally pair two internal states—agitated versus serene, for example—and prepare to build a drawing around the relationship between them. Start by introducing one kind of line—say, the agitated. Your beginning may consist of a single line, several lines, or a cluster of lines—whatever you like.

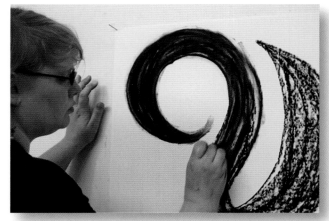

Erin Jones participates in the expressive line exercise. Her finished piece is shown below.

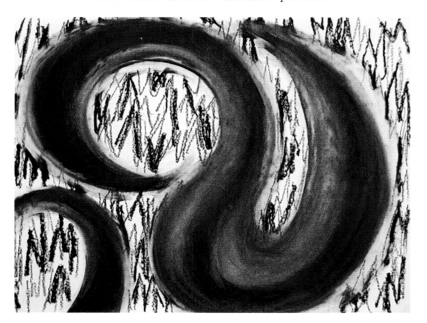

2 Respond to that initial feeling by generating one or more examples of its counterpart—in this case, the serene.

3 Continue alternating between one and the other, responding as you wish until the relationships in the overall drawing space feel satisfying to you. Along the way, feel free to erase some elements in order to make room for others. Of course, if you wish to explore the drawing in more depth and variation, you can adjust the composition by changing the weight and character of the lines as well.

1 With no pre-planning at all, begin by generating lines automatically. Then, as described in the Chapter 2 challenges (page 40), process the lines by obliterating and asserting.

2 As the process goes along, embrace one linear character, then a second in response, to arrive at a dialogue among two or three main linear characters.

3 Process the drawing surface in any way you wish. Remember, don't worry about making a perfect or correct drawing here. Simply trust your instincts until you arrive at an arrangement that is satisfying—or, at the very least, intriguing!

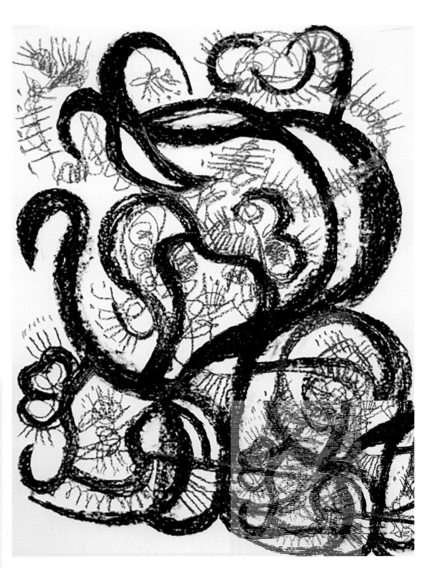

**Mary Margaret Jones improvises with line.
Her finished drawing is shown at right.**

ELIZABETH LAYTON

1910–1993

Elizabeth Layton was the daughter of a newspaper publisher in Wellsville, Kansas. A mother to five children, she was a journalist and creative writer who, following her father's death, served as the manager of the newspaper. For 30 years, however, she suffered from severe bouts of manic-depression.

After the death of her youngest son in 1976, she spiraled into a crippling despair. At her sister's suggestion, she took a drawing course at the age of 68. "It was a desperate, last-ditch effort to bring purpose to her older years," noted Don Lambert, her friend and publisher.

When she learned about "blind contour drawing"—staring at the outline of an object while drawing a methodical, continuous line—she ran with it. Holding a small mirror, Elizabeth produced numerous self-portraits in various incarnations, such as mother, social activist, homemaker, goddess: personas both real and imagined. Her work reflects the process of aging without apology or disclaimer (figure 26). She also addressed global issues such as AIDS, Alzheimer's, censorship, hunger, and race with a multifaceted sense of the comedic/tragic (figure 27).

Her intelligence and talent gained her national recognition, and her work toured the country. Hank Burchard nicknamed her "Grandma Moses on Tabasco sauce" in the *Washington Post*. In 1987, Elizabeth's work was shown at the National Museum for Women in the Arts in Washington, and the Smithsonian Institution's National Museum of American Art exhibited it the same year. Now the majority of her work is housed at the Lawrence Arts Center in Lawrence, Kansas.

In essence, her willingness to reveal her true voice saved her life. In a 1992 article in *USA Today* by David Zimmerman, she denied understanding why her mental health was so dramatically affected by her artwork. "I don't really have anything to say about what goes onto the paper ... My theory is that what I do is draw my feelings as I see them in the mirror, from the eye through the brain and down the arm and out the hand."

—*Katherine Aimone*

figure 26

Elizabeth Layton
Skipping Down Christo's Walkway, 1978
Colored pencil and crayon on paper

28 x 22 inches (71.1 x 59.9 cm)

The Nelson-Atkins Museum of Art, Kansas City, Missouri. Gift of
Elizabeth Layton in honor of the sustaining members of the Junior
League of Kansas City, Missouri, Inc., F81-17.
Photograph by Robert Newcombe.

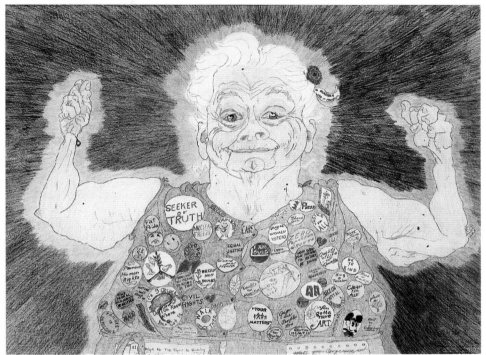

figure 27

Elizabeth Layton
Buttons, 1982
Crayons and colored pencils

22 x 30 inches (55.9 x 76.2 cm)

Courtesy of Don Lambert

SHAPE

Perhaps more than any other drawing element, shape has the ability to serve as a metaphor for personality, emotion, psyche, and spirit. Further, when we experience shapes in relation to one another, these interactions can be understood as metaphors for relationships among people in families and communities, as well as our relationship with nature—and even with the realm of the transcendent. Simply put, shapes are like us—living individuals that take part in shared experiences.

figure 1

Donald Sultan
*Lemon and Egg
(February 28, 1987)*, 1987
Charcoal, chalk on paper
30¼ x 23¼ inches (76.9 x 59 cm)
Courtesy of the Arkansas Arts Center Foundation
Collection: Purchase, Tabriz Fund. 1992.066.002

[SHAPES] ARE UNIQUE ELEMENTS IN A UNIQUE SITUATION. THEY ARE
ORGANISMS WITH VOLITION AND A PASSION FOR SELF-ASSERTION. THEY
MOVE WITH INTERNAL FREEDOM, AND WITHOUT NEED TO CONFORM WITH
WHAT IS PROBABLE IN THE FAMILIAR WORLD.

Mark Rothko

A *shape* is a two-dimensional area with identifiable boundaries. Shapes come into being in a number of ways, most often resulting (directly or indirectly) from the action and presence of line and mark. We saw in the previous chapter that one of the most powerful things that line can do is indicate movement and direction. One of the by-products of linear movement can be the formation of shape. It works like this: Whenever a line sets off in motion through space and crosses back over itself, it encloses an area. We refer to this enclosed area as a shape. In addition, and more subtly, all line really has to do is flirt with, or hint at, crossing over itself to create a shape. Examples of this are when line butts up against itself, nearly crosses over itself, or implies by continuation that it crosses over itself (figure 2). Of course, two or more lines working together also can give birth to shapes, in much the same way.

Shapes can have a huge range of attributes, and these traits, alone and in combination, result in shape's character, personality, and spirit. Many of these attributes fall into pairs of categories.

figure 2

figure 3

Louise Lieber
Plan View #10, 2007
Charcoal pencil, colored pencil, and pastel
on vellum
11 x 17 inches (27.9 x 43.2 cm)
Courtesy of the Artist

GEOMETRIC
& ORGANIC

Shapes are either geometric or organic in nature. *Geometric shapes* are universal forms; they can be described in precise terms. For example, if someone were to tell you to draw a square, you would know exactly what was meant. You'd draw four equal sides arranged to form four 90° angles. The same would hold true with a circle, a triangle of any specification, a rectangle, and so on. As personalities, geometrics are perfect, idealized, understandable, explainable, predictable, and universal. So, if you want to make drawings that speak metaphorically about people, relationships, or things that embody these kinds of traits, making use of geometric shapes will work quite nicely.

Organic shapes are quite the opposite. When you draw them, you create forms that are truly unique—one of a kind. They are hard to fully comprehend and describe in words. They feel like they have grown into being.

Compared to geometric shapes, they are "imperfect," replete with surprising and nuanced eccentricities that give them individual character. Again, you can use organic shapes to elicit feelings or refer metaphorically to things with these kinds of attributes.

Architectural site plan drawings, such as Louise Lieber's *Plan View #10* (figure 3), make use of this geometric-organic contrast as a natural matter of course. As you can see, geometrics represent man-made building forms, while organics represent forms in the nearby landscape.

In fine-art drawing, relationships between the geometric and the organic can be (and often are) at the core of the meaning of the work. To view examples, spend a few moments taking in drawings by Stuart Davis and Umberto Boccioni (figures 4 and 5). The two artists' approaches are radically different, and considering them together is quite illuminating.

Davis's drawing is overwhelmingly geometrical. Rectangles and modified rectangles abound; most of the architectural forms are simple and easily understood. Underlying rectangles run parallel to the outside edges of the drawing space, lending a feeling of solidity. Little rectangular shapes and marks are arranged in rhythmic rows—they feel very orderly. Near the top, two rows of little triangles introduce a bit of diagonal tension. The architectural forms become more animated as they move forward—most are oriented on a diagonal, while some feature bits of triangularity. Surprisingly, however, the key to the drawing's arrangement can be found in the presence of the one element that doesn't fit: the modified oval, near the bottom right—the one organic shape in the space. It lends variety and breadth to the drawing, standing as the organic foil to an otherwise geometric community.

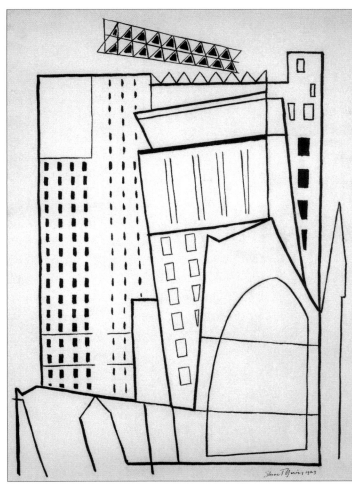

figure 4

Stuart Davis
Untitled, 1923
Ink on paper

5 x 6⅞ inches
(12.7 x 17.5 cm)

Arkansas Arts Center Foundation Collection: Purchase, Barrett Hamilton Acquisition Fund. 1984.001
© Estate of Stuart Davis / Licensed by VAGA, New York, NY

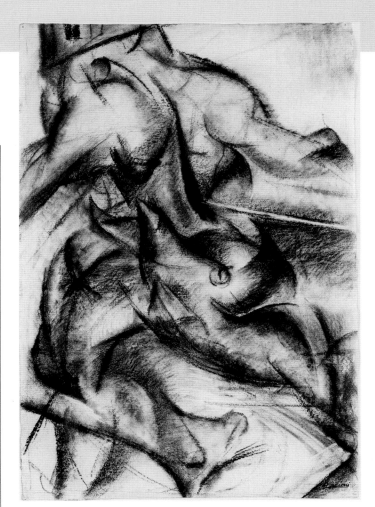

figure 5

Umberto Boccioni
Muscular Dynamism, 1913
Pastel and
charcoal on paper

34 x 23¼ inches
(86.3 x 59 cm)

Digital Image © The Museum of Modern Art / Licensed by SCALA / Art Resource, NY

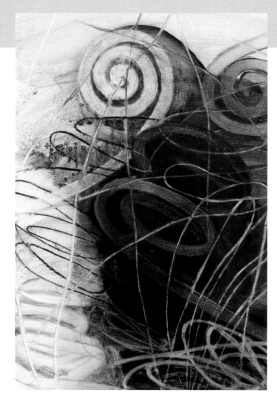

figure 6

Natalie Alper
August #2, 1996
Mixed media on
paper
22 x 15 inches
(55.9 x 38.1 cm)
Courtesy of the James T.
Dyke Collection

In contrast, Boccioni's *Muscular Dynamism* (figure 5, page 75) is overwhelmingly organic. As its title suggests, muscle-like forms appear in motion, twisting and turning, asserting themselves as powerful and unique individuals. The whole space is in flux. The subordinate bits of geometry, however, stand in supportive contrast. Notice the squared-off forms in both the upper left and lower right corners. Adding poignancy to the composition is the large, modified, lost-and-found rectangle, set on a diagonal, encompassing 50 percent of the drawing's surface (from just above the middle and running off the space, bottom right). This serves as a geometric foundation for and contrast to the organic nature of the community.

STATIC & DIRECTIONAL

The personality of shape is either *static* or *directional* in nature. This principle is quite simple: shapes indicate movement and direction in accordance with their longest axis. So, any shape that has a longest axis implies motion. Ovals, rectangles, elongated triangles, and numerous organic shapes are good illustrations. Some shapes, however, have no longest axis. They serve as pointers equally in each direction; they are completely static. Circles, squares, equilateral triangles, and some organic shapes are classic examples. Naturally, there is a continuum here: some shapes are relatively static and at the same time more directional in relation to others.

Natalie Alper's mixed-media drawing *August #2* (figure 6) illustrates the difference nicely. Hers is a world with a predominance of ovals, all of which indicate motion and directional pressure. Nearly all of them point on a similar diagonal, from lower right to upper left. So in this world of motion-indicators, which elements stand in contrast? The two circular spirals, both near the top of the space. As circle/spirals, they indicate little or no directional push and sit as still entities in Alper's otherwise motion-filled arrangement.

SIMPLE & COMPLEX

Shape personalities also fall on a continuum between the simple and the complex. Obviously, here is another way that shape characteristics can indirectly speak of the characteristics of people, personal relationships, states of emotion, and so on.

Simple shapes are relatively easy to grasp; they can also be experienced in a relatively short period of time. The most common are geometric shapes (circle, square, triangle); some organic shapes are simple ones as well (the shape of an egg or a teardrop, for instance).

Complex shapes, on the other hand, are harder to understand, and it takes more time to experience them, to take them in. Some geometric shapes (a regular decagon—10 equal sides and 10 equal angles—is an example) fit the bill. However, the vast majority of complex shapes are organic (think of the overall shape of an elephant, for instance, or an oak leaf).

Here's another way of explaining complex shapes: Consider two shapes, both of which would fit snugly in the same-sized space container. Now, if you were to imagine the outside edges of these shapes to be roads, which shape would take you longer to drive around? Driving around simple shapes would consist of a more direct route, more akin to driving as a crow flies, and take relatively less time; driving around complex shapes would be a meandering journey that would take much more time.

ANGULAR & CURVILINEAR

Just as was the case with line, shapes can be either angular or curvilinear. *Angular shapes* are sharp, hard-edged, pointed. Their contours are most often composed of an abundance of straight lines, and they feel assertive in character. In the process of drawing them, you experience a sense of starting and stopping; there are abrupt changes in direction. And as these shifts in direction occur, it's obvious where one movement ends and the next movement begins. Dorothy Dehner's *Tensions* (figure 7) features these kinds of shapes exclusively, and the drawing evokes all the feelings and sensations associated with angularity.

Curvilinear shapes are those whose contours consist of lines that are curvy. They are rounded, soft, looping, and often graceful. In the process of using line to draw them, you experience a feeling of relative fluidity and continuity. Changes in directional movement are most often gradual, with less abrupt changes in movement and direction. Richard Deacon's drawing (figure 8) is

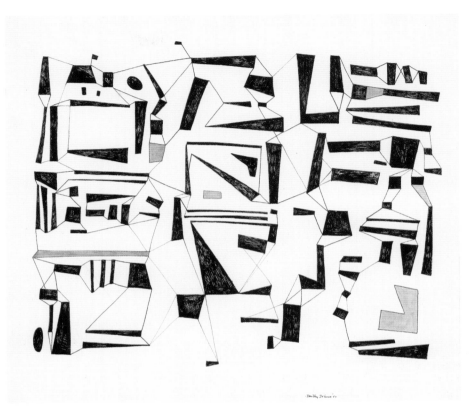

figure 7 (top)

Dorothy Dehner
Tensions, 1950
Ink on paper
17¾ x 20¼ inches
(45 x 51.4 cm)
Courtesy of the James T. Dyke Collection

figure 8 (bottom)

Richard Deacon
Untitled Drawing, 1980
Pencil on paper
18⅛ x 25⅖ inches
(460 x 645 mm)
Tate, London / Art Resource, NY

figure 9

figure 10

a superb example of a community of curvilinear movements combining to form one large, complex, curvilinear shape. The resulting drawing is wonderfully bulbous and curvaceous; the forms and movements are continuous, with no beginning or end.

AND MORE...

In addition to these categorical pairings, shapes can relate (and speak metaphorically) to one another in a variety of ways. They can join together by interlocking, kiss one another by abutting, be in front or in back of one another by overlapping, stand in near proximity, stand apart in isolation, act as a foundation or support by sitting below ... so many possibilities!

Shapes can also serve a number of additional drawing purposes. Let's look at the most significant.

SHAPE AS SHAPE-MAKER

Line is not the only visual element capable of creating shape—shapes can get together and accomplish this as well. This "birthing process" can take place when shapes butt up against one another and/or with the edges of

the drawing space (figure 9), and through overlapping (figure 10). In representational drawing, this often leads to the notion of "positive" and "negative" shapes, with the original shapes considered as active or positive and the newly created shapes as passive or negative. This distinction sometimes applies in nonobjective drawing, though in many cases the distinction is intentionally blurred or even omitted.

SHAPE AS CONTAINER

Shape can also serve as a vessel or container for other visual elements such as texture, pattern, and tone. In this role, shapes can "compartmentalize" the drawing space into a series of distinct containers that stand in contrast to one another. Roy Lichtenstein uses shape in this way in *Study for Aviation* (figure 11), where each shape contains a particular color, linear cluster, texture, or both. Drawings like this employ the parameters of shape to keep visual elements separate and distinct. When an entire drawing is compartmentalized in a highly structured manner, you can wind up creating a grid. (We'll explore the grid as foundational structure further in Chapter 10, page 192.)

Figure 11

Roy Lichtenstein
Study for Aviation, 1967
Pencil, crayon, collage on paper

22 x 26 inches (55.9 x 66 cm)

Arkansas Arts Center Foundation Collection:
Purchase, Tabriz Fund and Museum Purchase Plan of
the NEA. 1976.019
© The Estate of Roy Lichtenstein

figure 12

Robert Motherwell
Hollow Men, 1985–1986
Aquatint

Image: 4⅜ x 5⅞ inches
(11.1 x 14.9 cm)

Paper: 11 x 11⅞ inches
(27.9 x 30.2 cm)

© Dedalus Foundation, Inc. / Licensed by
VAGA, New York, NY
Collection of the Kass/Meridian Gallery

Robert Motherwell was a brilliant explorer of—and eloquent spokesperson for—the language of nonobjective drawing. He (and his Modernist colleagues) passionately believed that even a few simple shapes—ones that did not bear direct resemblance to particular things in the visible world—could work together to create and convey a great deal of meaning. He also believed that a drawing surface was not so much a place for picture-making as it was a *stage* or *arena* in which an abstract play or narrative could take place.

This aquatint drawing, *Hollow Men* (figure 12), is a tangible example of these beliefs. Motherwell gives us three simple shapes, all in black on an off-white surface. Each is like a character in a play, or a member of a family. Each is alive, replete with its own personality.

To the left is a modified rectangle that stands erect and is very stable in character. Its defining lines are similarly medium in weight. The shape points straight up and down, and it's situated comfortably parallel to the left side of the drawing space. Its modified geometry is decidedly imperfect, making it a unique individual (its bottom veers off on a diagonal to the lower right, and there it nonchalantly crisscrosses with the line of the right side).

In the middle is a radically different personality: a bulbous and voluptuous modified circle. It's thick-lined—heavy

in weight, bold, and assertive. This circle's eccentricities make it feel organic. Its longest axis indicates strong movement on a diagonal from lower left to upper right, while its defining contour line at the top extends beyond the enclosed form, moving up and slightly to the left.

On the right, the third member of the family is a modified triangle with a rounded base—put another way, an upside-down pear shape with a pointed top. It leans slightly on a diagonal, not as dynamically as its circular companion, but more so than its rectangular colleague. It's the largest of the three, enhancing its presence. Most distinctively, the triangle is the only shape that is open in nature—its right side contour line is lost and found, dissipating and then re-establishing itself. Less assertive and at the same time more hospitable than the others, it invites you in, allowing you to enter freely and exit with ease.

The fact that each of these actors in the play has its own, very individual characteristics tells a good part of the story of the drawing. The relationships *between* the players tell the rest! First, the three join together to create one large cluster; they're all connected. No one feels alone. Starting on the left (as we usually do, all else being equal), the rectangular shape stands as a solid vertical block, a stable starting place in our experience of the drawing. At the same time, it joins with the modified triangle on the right to frame the modified circle in the center. As powerful as the circle is, the two shapes to the sides contain its energy; it fits snugly between them. Finally, the modified triangle on the right serves as a nice ending to the three-shape sequence, opening up and allowing us to emerge into the open, inviting space to the right.

Circle, Square, Triangle (figure 13) by Tacy Apostolik, done in the spirit of the Motherwell, offers a terrific contrast (you'll be doing this kind of drawing shortly in the first Play section in this chapter). Apostolik's line is beautifully fluid, fresh, and direct. Her linear movements give birth to three shapes that combine to convey feeling. On the left are two shapes joined together. At the bottom is a large organic shape, a modified circle/oval. It tilts gently from upper left to lower right, and its defining contours are graceful and varied. It supports the second shape, a modified triangle/oval perched on top. The two are merged by the common line that forms the top of the large shape and the bottom of the small one. Then, on the right, alone at the bottom, is one small, modified square. Its defining contour lines are relatively thin and light, reinforcing its smallness. On the other hand, it sits low in the space, roughly parallel to the edges, settled and stable. It serves as a "stopper," keeping the big cluster from rolling off the right side of the drawing.

figure 13

Tacy Apostolik
Circle, Square, Triangle, 2008
Acrylic on paper
14 x 17 inches
(35.6 x 43.2 cm)
Courtesy of the Artist

LOOK AT THIS NICOLAS CARONE

Nicolas Carone's engaging charcoal drawing (figure 14) is like Motherwell's drawing on steroids—similar elements, but many more of them, in a much more intricate and dense arrangement, with shape relationships that are equally intriguing and dynamic.

Carone's drawing explores many of the shape contrasts we discussed earlier in the chapter. There is a wonderful play between the curvilinear and the angular (that large, pointy four-sided shape to the right and above middle contrasts nicely with all the rounded forms in the drawing); simple shapes (such as that same pointed one) play off against more complex ones (such as the large shape that abuts it to the left). At the very foundation of the drawing is a dialogue between the organic and the geometric. Virtually all of the shapes in the drawing are organic, so where is the contrasting geometry? You find it in the series of straight horizontal and vertical lines that are present or implied "underneath"; they serve as an underlying foundation for the entire drawing, as shown in figure 15. (We'll discuss foundational structure further in chapter 10.)

Carone establishes a rhythmic movement of small, mostly modified circle shapes that make a large curving motion around the bottom of the drawing (as shown in figure 16). This movement in turn frames the two large shapes (in the upper middle of the drawing) I referred to earlier, both supporting and highlighting them as "headliners" in the visual play.

Finally, Carone's drawing feels alive because it's in flux; his working process involved a great deal of putting in and taking out, as discussed in chapter 2. Throughout the drawing, you can see and sense elements that are either dissipating, standing as remnants of things that once were, or emerging or feeling like they might emerge anew!

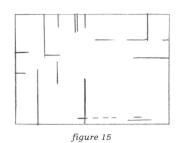

figure 15

figure 16

figure 14

Nicolas Carone
Untitled, 1950s
Charcoal on paper
19 x 24¾ inches (48.3 x 62.9 cm)
Courtesy of the James T. Dyke Collection

The untitled drawing by Nicolas Carone and *Granite Rocks, Dogtown,* by Marsden Hartley (figure 17) are kindred spirits. In spite of the obvious difference—Hartley's has a direct and obvious reference to the visible world, while Carone's did not—the two drawings are similar in shape-making, shape arrangement, energy, and mood. Hartley's piece features a dialogue between the curvilinear and the angular, playing the round, fluid, and looping against the sharp, abrupt, and hard-edged. The tall pointy tree on the right overlapping or intruding on the round rock behind it is a good example. The resulting tension is palpable. Similarly, Hartley juxtaposes the organic and geometric, playing universally comprehensible elements (small rectangular shapes near the bottom, and the larger two quasi-rectangular rocks in the lower left) against one-of-a-kind organics such as the bulbous rock or bush form to the left of the middle. This creates rich visual tension as well.

In addition to the representational versus nonobjective difference between the drawings, there is another clear difference: underlying structure. Whereas the Carone work hinted at a grid, Hartley's drawing relies on a zigzag, rocking rhythm to serve as the unifying thread. You can feel it even before you see it. To experience it, look for one large movement on a diagonal through the space, then find another movement that runs on the counter or opposite diagonal, then look back at the first, and so on. Hartley's underlying rocking rhythm is shown in figure 18. (For more on rhythm as unifier, see chapter 7, page 126.)

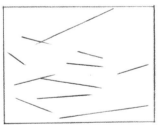

figure 18

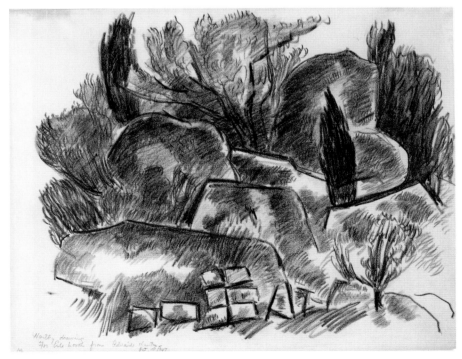

figure 17

Marsden Hartley
Granite Rocks, Dogtown, 1934
Crayon on wove paper
12⅝ x 16⅛ inches (32 x 40.7 cm)
Courtesy of the Columbus Museum, Columbus, Georgia; Promised Gift, Dr. and Mrs. Philip L. Brewer Collection

WORKSHOP

PLAY 1 ■ THREE-SHAPE COMPOSITIONS

This Play challenge is the one I give artists at the start of every workshop I teach. It's easy to do, yet I think you'll find it expressive, even profound, in meaning. Don't skip this challenge because it looks so simple! It gives you the chance to really understand and embrace the power of shape, shape relationships, and the drawing language.

What you'll do here is create a series of drawings that feature three animate entities that will 1) share a space together and 2) enter into a set of relationships that evoke a feeling or mood. Try to view each drawing composition as metaphor or poetry—each will speak indirectly about relationships inside you, in your family, community, and so on. These exercises take their cue from the Motherwell and Apostolik drawings in Look at This on pages 80 and 81. Before starting to play, you'll want to review that discussion to refresh your memory.

Be sure to keep in mind here that there is no right or wrong way to do these drawings. You can't make a mistake—what comes out of you comes out, and it will be both fun and intriguing. There'll be no need to justify or validate any of these drawings. If (or, as is more likely the case, when) your internal critics begin to act up, tell them to take a hike! Simply put, there will be no good or bad drawing here—only drawings that are more or less satisfying.

PART ONE: CIRCLE, SQUARE, TRIANGLE

Gather three drawing surfaces and one monochromatic drawing tool. The following is recommended (though any variation on the theme will do):

● Three pieces of 11 x 14-inch (27.9 x 35.6 cm) or 11 x 17-inch (27.9 x 43.2 cm) paper, the cheaper the better (the less expensive, the less pressure to treat the drawing as too important or precious)

● Black (or any dark color) acrylic paint or latex house paint

● 1-inch (25 mm) china bristle brush (available at any hardware store)

● Container of water for holding or cleaning your brush

1 If it's possible, tape, tack, or staple the three drawing surfaces to the wall or vertical board in front of you. As an alternative, you can place the three either on a large table in front of you or on the floor.

2 Next, place some black paint on a palette, or open the paint can so it's ready to access.

Figure 19

Louise Lachance Legault's workshop drawing shows one way to express the circle, square, triangle relationship.

3 Now—without thinking, planning, or worrying—give your attention to one of the drawing surfaces and, using contour line, draw *one circle, one square, or one equilateral triangle*. Draw only one of these entities right now—it doesn't matter which one you draw first. Remember, these shapes are neutral in terms of motion: they don't have a longest axis and therefore as shapes don't indicate any directional movement. So, loosely speaking, make the circle a circle (not an oval), the square a square (not a rectangle), and the triangle one with three sides of equal length (figure 19). Don't worry about being perfect in this regard. Just let 'er rip!

4 Pause very, very briefly if you like, and take it in. Then, in the manner of the automatic drawing you did in Chapter 2 (page 28), follow your first instinct or urge and place the second of the three shapes into the drawing in response to the first.

5 Again, pause very briefly to take in the new state of the drawing. Experience how your two-shape pairing feels; sense how the shapes relate to one another and to the space they inhabit.

6 Finally, in response, trust your first instinct once again and add the third and final element to the drawing. You've now completed your first three-shape drawing composition.

7 Next, move on to the second surface and do the same thing. Remember, no thinking, planning, or worrying—no validating or justifying your movements.

8 Then, do the same to the third and final drawing surface. When you're done, stand back and take in the three drawings. Enjoy them.

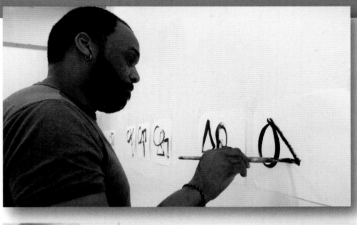

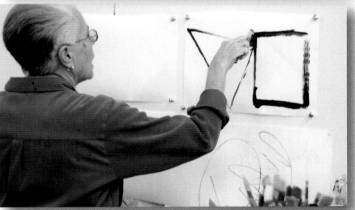

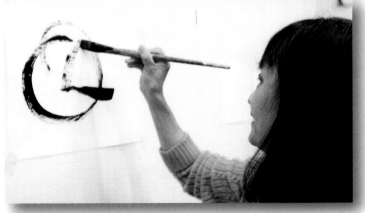

Top to bottom: Jeff Brooks, Toni Slick, and Judy Alvarez explore the power of simple shapes.

PLAY 1 ■ THREE-SHAPE COMPOSITIONS

TAKING STOCK

Make notes regarding each of the three drawings you created in Play 1 by answering or responding to the following questions:

- What is the overall mood elicited by the drawing?

- Describe the personality of each shape, and note what you think makes them feel the way they do.

- Describe the series of relationships between the shapes. For example:

 Which shape is the dominant, and why?

 Which is subordinate, and why?

 Have two or more of them joined together to create additional shapes?

 Do two shapes form an allegiance, leaving the other in isolation?

 Do any feel imposing or nurturing, and why?

- Which one of these drawings is most exciting, most soothing, or most disturbing, and why?

If you're just reading at this point, and plan to work with this Play exercise later, use figure 20 by Tacy Apostolik, and figure 21 by Krista Harris as samples to practice with, answering and responding to the above. Respond to them as individual drawings, and then compare the two drawings to one another.

figure 20

Tacy Apostolik
Circle, Square, Triangle, 2008
Black acrylic paint on paper
11 x 17 inches (27.9 x 43.2 cm)
Courtesy of the Artist

figure 21

Krista Harris
Circle, Square, Triangle, 2008
Black acrylic paint on paper
11 x 17 inches (27.9 x 43.2 cm)
Courtesy of the Artist

PART TWO: OVAL, RECTANGLE, ELONGATED TRIANGLE

Now let's try the same kind of three-shape compositions that you just drew, this time using shape elements that are *directional* in nature.

1 We'll stick with geometrics and draw a simple arrangement of an oval, a rectangle, and an elongated triangle. (Stick with the instructions and guidelines outlined in Part One on page 84.)

2 When you're done, pause and take in the three drawings as a group. Compare them to the three drawings you did in Part One. You'll likely find that, all else being equal, the sense of motion in this second set of drawings is more dynamic than in the first.

3 Now, use the same set of questions and queries outlined in Taking Stock (page 86) and apply them to this second set of drawings.

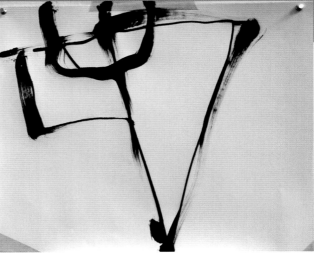

figure 22

Krista Harris
Dialogue between Directional and Non-directional, 2008
Acrylic on paper
11 x 17 inches
(27.9 x 43.2 cm)
Courtesy of the Artist

PART THREE: DIALOGUE BETWEEN DIRECTIONAL AND NON-DIRECTIONAL

In this exercise, you'll create a dialogue between shapes that are motion-indicators and those that are not.

1 To do so, simply select one or two elements from the circle-square-equilateral triangle group along with one or two elements from the oval-rectangle-elongated triangle group (your total of shape personalities in these drawings will remain at three).

2 Again, follow the guidelines you've been using in the previous exercises. This time, when you finish drawing, respond to the interactions and relationships between the static elements on one hand and the motion indicators on the other.

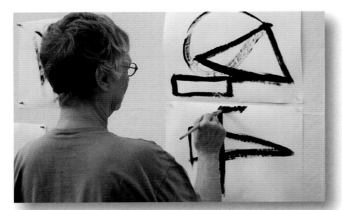

Maggie Rodman develops elongated triangle, oval, and rectangle drawings.

BUILD 1 ■ SHAPE COMPOSITIONS

Let's expand on the idea of the three-shape drawing. The following drawings can feature more than three shapes, so long as the number of shapes is limited. We'll continue to limit these pieces to one-color and white only, though if you wish to use a few colors here, you can. For each variation, you can choose your drawing media and tools, as well as the size and format of your paper supports.

PART ONE: ANGULAR & CURVILINEAR

Create a drawing that features the interaction between the angular and the curvilinear. Angular shapes are sharp, hard-edged, and abrupt (think of how these qualities can apply to people and internal feelings as well as shapes), while curvilinear elements are rounded, graceful, and fluid (all sorts of things in nature can be indirectly referred to through shapes of this kind). Katherine Aimone's drawing (below) is a great example of a drawing focused on the dialogue between these two shape families. Notice how the angular elements assert a great deal of tension, while the curvilinear elements temper the mood.

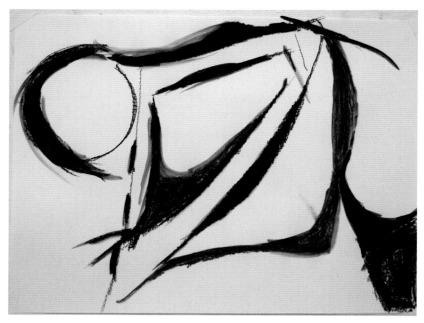

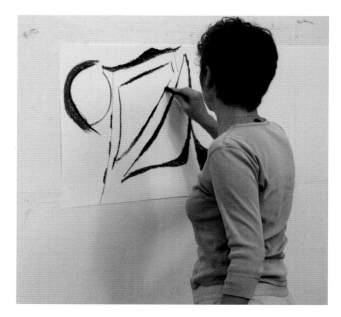

Katherine Aimone plays with the angular and curvilinear (right); her finished drawing is pictured above.

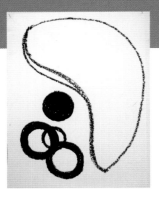

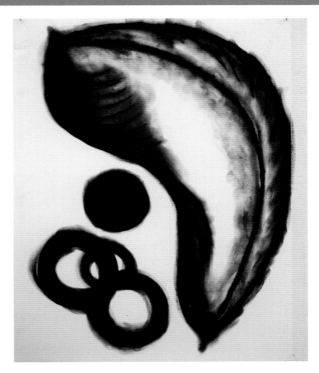

Erin Jones outlines the organic and geometric (left, below); her finished drawing is shown at right.

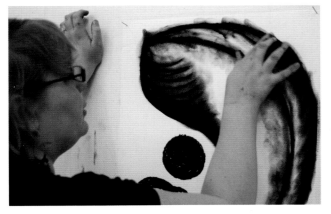

PART TWO: ORGANIC & GEOMETRIC

As you recall from our discussion earlier in the chapter, geometric shapes act as metaphors or surrogates for the universal, precise, and understandable (and therefore predictable), while organic shapes refer to things that are one of a kind, harder to describe or define, and feel like they have grown into being. In the following drawing, explore this particular shape contrast, making it the primary subject, or nonobjective narrative.

1 Begin by setting out your drawing media and tools.

2 From here you can proceed in one of two ways.
- Introduce one family of shapes (geometric or organic) into the drawing space, and then respond by countering with the opposite shape family.
- Begin with automatic drawing, and then recognize and embrace geometric and organic shapes, or hints of them, as they emerge.

3 In either case, continue to develop the drawings in an improvisational manner. Remember, you can obliterate, veil, or subtract—using overlapping elements, erasing, or painting over—as well as continue to add.

4 Continue processing until the drawing feels satisfying and conveys an intriguing dialogue between the geometric and organic. When it does, stop—your drawing is finished!

BUILD 2 ■ WORKING FROM OBSERVATION

Figure 23

Giorgio Morandi
Still Life, circa 1950
Pencil on paper

7¼ x 10½ inches
(18.4 x 26.7 cm)

Arkansas Arts Center Foundation
Collection: Purchase, Memorial
Acquisition Fund in memory
of Christian Townsend Wolfe.
1981.033
© 2008 Artists Rights Society
(ARS), New York / SIAE, Rome

1 Set up a still life of everyday objects around you—simple forms like apples, pears, eggs, a coffee cup, a candle, and so on. Or, if you prefer, simply look at the view out your window.

Want to see the relevance of all these exercises to drawing from observation? Giorgio Morandi's mid-20th-century still life drawing (figure 23) furnishes the answer. His composition is essentially a circle, rectangle, triangle arrangement, with an oval thrown in for good measure.

Morandi spent much of his career painting and drawing the same set of bottles, jugs, and containers, interpreting them anew with each work. This usually involved distilling his experience of them into simple shape essences. Your challenge now is to do the same.

2 Spend a moment or two really studying your reference. Look to find simple shapes in your subject—that is, things that can be read as simple shapes: rectangles, circles, triangles, or modified versions of those shapes. Whenever possible, for the sake of simplicity and clarity, distill a series of the little shapes you see into one larger shape.

3 Remember, look at your reference as a series of *shapes only*, rather than as a cluster of objects with identifiable labels or names (such as "apple," "pear," "picket fence," and so on).

4 Now, translate your subject into a series of five to seven big shape essences and put your translation down on the drawing surface. Remember, draw the big shape essences and nothing more. Repeat this challenge several times using the same reference.

BUILD 3 ■ MULTI-SHAPE DRAWINGS

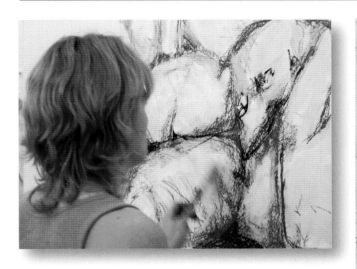

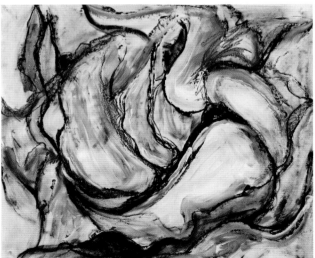

Beverly Munchel-Kievet completes her composition (left). Her finished work is at right.

Let's conclude the hands-on portion of this chapter by combining and synthesizing what you've explored thus far into more complex and open-ended drawings. Again, using drawing materials and supports of your choice, execute one or more drawings with shape and shape relationships as the primary subject. You may use more than one color here if you'd like. You may begin by assigning yourself a designated challenge (for example, organic versus geometric or simple versus complex). Alternatively, you can begin these as automatic drawings and allow the shapes and shape contrasts to emerge. Remember, covering things up or taking things out (erasing) can be as constructive an activity as putting things in. (Refer to the images shown here for inspiration.) Write down your responses to the two drawings, describing how they make you feel, how they are similar, ways in which they differ, and why. When you're ready to start, tell the internal critic to take a walk. Enjoy yourself!

figure 24

Maggie Rodman
Multi-Shape
Composition, 2008
Mixed drawing media
on paper
36 x 42 inches
(91.4 x 106.7 cm)
Courtesy of the Artist

Like so many of us, Pam Moran enthusiastically created drawings as a child. When she decided to pursue this more seriously in college by majoring in art, however, she hit a roadblock in her first composition class.

The material seemed like a specialized language she couldn't understand. She recalls her feelings: "The wall between me and the 'real' artists felt insurmountable."

Pam still felt a creative yearning, so she turned to the more familiar medium of fabric, drawn to the patterns, colors, and textures of cloth. She created functional pieces, later expanding into dyeing and screen-printing fabric, and sewing pieced collages.

figure 25

Pam Moran
Pod, 2008
Graphite, charcoal, chalk, acrylic paint on paper
38 x 42 inches (96.5 x 106.7 cm)
Courtesy of the Artist

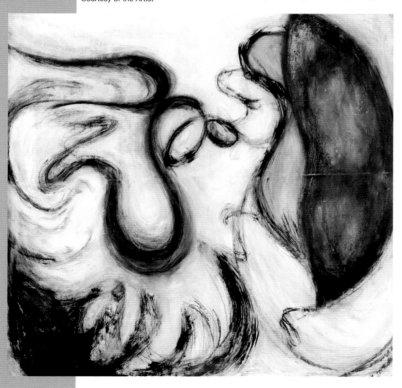

She gained recognition in the fiber-arts field, but eventually lost her enthusiasm for the medium. "Creating cloth, choosing fabrics, and cutting and placing them began to feel more like editing than creating," she notes. "I wanted more direct access to the surface."

Pam returned to her childhood passion. In 2007, after taking an art class during the week of her 60th birthday, she began to draw. She claims she regained the uncensored artistic freedom she experienced as a girl, and drawing came naturally because she was so ready to embrace it.

"The more I make art, the more I become myself ... I try to begin with an empty mind and let my hand and arm do whatever feels right," she explains. Her drawing process is personal, intuitive, and meditative (figures 25 and 26). The organic, undulating shapes in her work express the artistic liberation she so enjoys.

—*Katherine Aimone*

AS A CHILD, I FOUND NOTHING AS SATISFYING AS A BOX OF CRAYONS AND A BIG BLANK SHEET OF PAPER. DRAWING WAS LIKE A MAGIC PORTAL THAT ALLOWED ME ACCESS INTO ANOTHER WORLD.

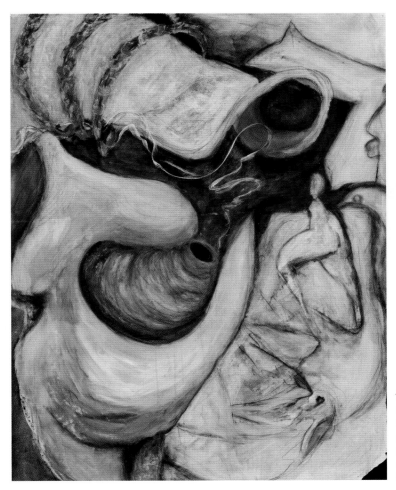

figure 26

Pam Moran
Untitled, 2008
Graphite, charcoal, chalk, acrylic paint on paper
42 x 48 inches (106.7 x 122.5 cm)
Courtesy of the Artist

TEXTURE

One of the most expressive and satisfying things you can do with line and mark is to convey a sense of texture. The fact that line and mark can do this is a testament to the power of the language of drawing. Imagine that—a few simple marks on a piece of paper can evoke sensations such as flat, smooth, shiny, glossy, glittery, velvety, feathery, soft, wet, furry, sandy, crackled, prickly, rough, bumpy, puffy, gnarly, ribbed, ridged, grainy, pebbly, jagged, pointy, hairy, fuzzy, knotted, tangly—phew, amazing possibilities!

figure 1

Sketches for illustrations to the Vimalakirtinirdesha Sutra, Tang Dynasty, early 10th century
From Cave 17, Mogao, near Dunhuang, Gansu province, China
Ink and colors on paper

© British Museum / Art Resource, NY

figure 2

Paul Gauguin
Album Noa-Noa: Woman Seated, c. 1880s
Drawing
Reunion des Musées Nationaux / Art Resource, NY

IMAGINARY TEXTURE

However, in drawing, there is very little actual texture. Minor variations in surface can result from impressions left on the surface from pressure applied by a drawing tool, or from the buildup of certain media such as pastel, paint, and so on. Instead, when drawing, you work with *imaginary texture*—line and/or mark arranged in such a way as to elicit the sensation of what the drawing surface would feel like if you touched it. We'd all agree, for example, that in Gauguin's drawing *Woman Seated* (figure 2) the woman's skirt seems bumpy, her blouse feels ridged, the background sandpapery to the touch.

The creation of imaginary texture involves a degree of illusionism, similar to a magic trick. After all, when you draw you almost always work on something that is quite flat and relatively smooth, and with tools that do little to alter the character of that surface. When you employ imaginary texture, you fool the eye into believing and the body into feeling that there are three dimensions when there are actually only two.

Imaginary texture can function for you on two fundamental levels: descriptive and metaphorical.

I n everyday speech, the word *texture* refers to a sensation or sensations you receive through your sense of touch. In the visual arts, this is referred to as *actual texture*. All physical surfaces have attributes that speak to you in this way: A baby's belly feels soft and smooth; the finish of a new car feels slick and glossy; a roofing shingle feels coarse and granular; garden moss feels fuzzy; a wicker basket feels ribbed; oatmeal feels thick and gooey; and so on. Actual texture is a main concern in three-dimensional art (sculpture) and in two-dimensional works that feature thickly built-up surfaces.

figure 3

David Hockney
Portrait of Dwight, 1979
Pen, black ink on paper
17 x 14 inches (43.1 x 35.6 cm)
Courtesy of the James T. Dyke Collection
© David Hockney

David Hockney uses texture effectively in his *Portrait of Dwight* (figure 3). He moves our eye around the space from one textural passage to another: from the coarseness of his hair to the loosely-ribbed feeling of the shoulder and sleeve of his sports coat (bottom left) to the markings or bunched-up fibers on his T-shirt.

The two colored pencil drawings by Lynn Drexler (figures 4 and 5) employ descriptive texture to varying degrees. Untitled (rocks and sea), figure 4, is relatively literal; textures (and corresponding colors) are used to describe recognizable forms. Very dense, straight-line hatching describes the weightiness and solidity of the rock forms on the bottom and bottom left; a cluster of dense wavy lines describe the heavy rocking rhythms of parts of the sea; aqua-colored curly lines and dots describe sunlit portions of the sea to the left; and gray bands and clusters of dots describe broad areas of wispy foam at the top and right.

Untitled, figure 5, is more indirectly descriptive. The colors, various blues and greens, continue to hint at a reference to land (grasses, perhaps) and sea. The comma-shaped lines and marks in the blue areas, associated with water, elicit feelings of waviness and fluidity. The green marks and shapes are rectangular and oriented on horizontals and diagonals, eliciting a contrasting sense of solidity, static-ness, and stillness more associated with the earth. While equally textural, this second drawing begins to steer away from straight description and leans instead to the metaphorical, which brings us to our second category.

DESCRIPTIVE TEXTURE

Descriptive texture is defined as line and mark arranged in a way that documents appearances in the external, visible world. At times, descriptive texture is quite literal: The arrangement of line and mark bears some resemblance to the reference (eyebrows signified by a series of orderly, parallel comma-shaped marks, for example). At other times, descriptive texture is relatively abstract, serving more as a shorthand symbol for visible things (a cluster of straight, parallel vertical lines symbolizing architectural forms in the distance, for example).

figure 4

Lynn Drexler
Untitled (rocks
and sea), 1980s
Colored pencil
on paper

8 x 10 inches
(20.3 x 25.4 cm)

Private Collection

figure 5

Lynn Drexler
Untitled, 1969
Colored pencil on paper

8 x 10 inches (20.3 x 25.4 cm)

Private Collection

Frank Piatek
*Abstract
Configuration #2,*
1987–1990

Gesso, graphite, white
lead, and oil on paper

46 x 60 inches
(116.8 x 152.4 cm)

Arkansas Arts Center Foundation
Collection: Purchase, Tabriz
Fund. 1992.018
Courtesy of the Roy Boyd
Gallery

figure 7

Sean Scully
Untitled, 1984
Charcoal, chalk on
paper

30¼ x 23¼ inches
(76.8 x 59 cm)

Arkansas Arts Center
Foundation Collection:
Purchase, Tabriz Fund.
1992.066.002

METAPHORICAL TEXTURE

Metaphorical texture comes about when line and mark are arranged to describe what the internal world of emotion, psyche, and spirit feels like. It's symbolic and poetic. Metaphorical texture makes no direct reference to the outside world; it speaks of things that cannot be described in words or images. It makes the invisible visible, the intangible tangible. For example, large clusters of jagged marks bearing down on a few areas of rounded marks can convey an internality that feels discordant and unsettling.

Consider the surface quality established in Sean Scully's untitled drawing (figure 7). An exceedingly dense clustering of thick, heavy lines creates the sensation of being coarse, heavy, and tarry; these adjectives can easily apply to corresponding states of emotion and psyche. Likewise, Frank Piatek's *Abstract Configuration #2* (figure 6) feels fibrous and dense, eliciting analogous feelings of emotional complexity and depth.

PATTERN

Finally, when visual texture is arranged and presented in an orderly, organized way, it creates a sensation referred to as *pattern*. *Sketches for illustrations to the Vimalakirtinirdesha Sutra*, shown at the opening of this chapter (figure 1, page 94), is a great example. Not only is the drawing replete with wonderful textures, but they're compartmentalized into a quilted patterning, alternating ribbed, bumpy, gnarly, and so on.

Let's look in more depth at several drawings that demonstrate the expressive range and potential of visual texture.

ADAMS

Renie Breskin Adams's *Blue Birds of Happiness* (figure 8) is a joyful and unabashed celebration of how line and mark can be used to elicit sensations of visual texture. Using her digital pencil, formidable drawing skills, and abundant imagination, Adams offers us a dreamlike world offering a dense and delightful textural smorgasbord.

Densely overlapped and highly energized line describes the coarse and wavy nature of the woman's hair on the bottom right, while a slightly looser and less dense arrangement of line describes the man's relatively fine hair at the top. The wings of the bumblebees on the upper left are passive, indicating a smooth surface, and hard-edged, indicating that they'd be razor sharp to the touch.

The back of the man's chair is filled with dots of many colors, giving it a pebbly feel. A few scattered elements on the table and the back on the dog-like bee by the table edge are similar in handling and feeling. The two blue birds at the table have soft little zigzag marks on them and feel feathery; the striped lines on the bees make them seem ribbed in surface quality.

Notice, too, that the drawing surface in general is nearly completely activated with lightly energized mark, giving it a sense of overall vibration, while a few passive passages—the head of the yellow bee, center left, and the sleeve of the shirt on the man's arm, top middle—call for our attention because of their relative smoothness.

It's interesting to note that, while Adams produces drawings, paintings, all kinds of mixed-media works, and digital drawings such as this, her primary medium is fiber. Some of her most acclaimed works have been embroideries in which short stitches function as marks, much as many of the short dashes and dots of her drawing do here.

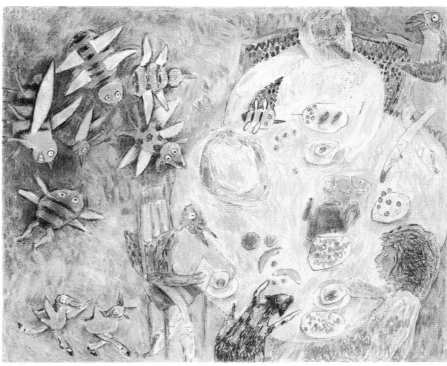

figure 8

Renie Breskin Adams
Blue Birds of Happiness, 2007
Digital drawing
4¾ x 5¾ inches
Courtesy of the Artist

Textural diversity and contrasts are central to this drawing by Milton Avery (figure 9). Differing textures, often compartmentalized by shape, play off of one another, each enhancing and enriching the other.

At the core of the drawing are three horizontal bands of contrasting texture. At the bottom is a broad band of very uniformly hatched surface of medium value. It feels moderately dense and fibrous. Just above is another band of similar width. It's much less densely marked; the marks that are there are light and delicate, alternating between dashes that fan out, feeling "grassy," and dots that in turn feel pebbly. At the top is the third band, which is both the thinnest and the most powerful. It's full of assertive marks: long, straight diagonals and sharp, horizontal hatchings, contrasting with swirling circular lines. As a result, this passage is not only darker and heavier; it feels rough and jagged.

In the context of this banded underpinning, Avery moves the eye up and down the space beautifully, using tex-ture to do so. The weight of the singularly rough band at the top is offset by the one-of-a-kind surface quality of the white goat embedded in the bottom band. It contains no marks at all and as a result feels exceedingly smooth. The shape of the white goat moves on a diagonal from lower left to upper right, which points the eye toward the head of the black goat, embedded in the light, middle band. Its texture is closely related to and aligned with that of the bottom band as well, connecting the two. Then the shape of this black goat zigzags, first from lower right to upper left, then from lower left to upper right, ending in an accented tail that points back up to the energized band at the top, where we started. Texture to texture to texture…

figure 9

Milton Avery
Black Goat, White Goat, 1958
Ink, color pencil on paper
20⅛ x 26¼ inches (50.8 x 66.7 cm)
Arkansas Arts Center Foundation Collection:
Purchase, Tabriz Fund. 1984.025
© Milton Avery Trust / Artists Rights Society
(ARS), New York

LOOK AT THIS RICHARD POUSETTE-DART

As was the case with Adams and Avery, it's fair to say that abstract expressionist Richard Pousette-Dart was virtually obsessed with visual texture. This untitled oil and graphite drawing on paper (figure 10) illustrates his passion for line and mark. And because the drawing is completely nonobjective (no recognizable forms from the visible world, and no literary narrative), texture, textural contrasts, and the feelings elicited by them are actually the *subject matter* of Pousette-Dart's drawing.

The first thing that strikes you about this drawing is that it's densely textured all over. It's jazzy, frenzied, full of life. It's also grounded in a gridded structure that makes for a rock-solid composition. The textural story begins with long movements of lines clustered together to form the strong horizontal elements of the grid. These lines feel wiry and taut.

Countering these are vertical and semi-vertical lines that move from left to right. These are lighter and thinner than the horizontals but still wiry and taut. Then, between and beneath the gridded wires lie two kinds of linear movements that elicit differing and contrasting textural sensations. Many of the movements are angular and pointed, creating sensations of sharpness and prickliness. At the same time, many other movements are rounded; some are elongated curvilinear lines, while others form complete circular movements and shapes. These evoke sensations of relatively benign and comforting smoothness and elongation.

figure 10

Richard Pousette-Dart
Untitled, 1978
Titanium white and
graphite on paper
22½ x 30 inches (57.2 x 76.2 cm)

© 2008 Estate of Richard Pousette-Dart / Artists
Rights Society (ARS), New York
Property of a Canadian couple

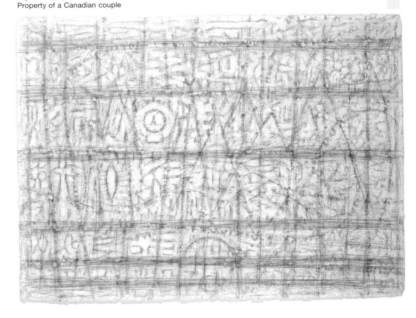

PLAY 1 ■ SMORGASBORD OF TEXTURE

This is one of my favorite exercises because it encourages you to really look at the world around you with all its wealth of textures, and then capture some of them on paper.

1 Fill a large sheet of drawing paper with a variety of visual textures. Draw as many variations as you like—you know, make the lines and marks seem rough, smooth, jagged, and so on.

2 On the same sheet of paper, explore pairing textures together in interesting ways. As you did in chapter 3 with line (pages 62–64), use a range of drawing tools to discover potential advantages of each for yourself. Most of all, have fun—no expectations, no planning, and no worrying. Keep in mind that there is no right or wrong way of doing this, so simply enjoy the process of playing and discovering. When you're done, you might be surprised at how satisfying your final "drawing" can be!

Eli Corbin works on her texture exercise. The finished drawing is above.

PLAY 2 ■ TEXTURE & EMOTION

Just as you did in the Play portion of chapter 3 (page 67), this challenge calls on you to explore the correlation between texture and emotion (or spirit).

1 Begin with one large or several small drawing surfaces and, without thinking or worrying or planning, create texture that expresses the following emotions: anger, serenity, confusion, certainty, joy, sadness, and so on.

2 As you finish each emotion, write the name of the emotion next to it. Beneath it, write a few words to describe what it felt like to make the texture: Did the process of making the marks feel fast or slow, ponderous or delicate, forced or fluid? This drawing challenge will make you more aware of the ability of texture to express things that are internal.

Maggie Rodman takes the texture and emotion challenge (above); workshop example that feels "knobby" (left).

WORKSHOP

BUILD 1 ▪ COMPOSITE DRAWING

As an alternative to traditional descriptive drawing, where a description of the visible world consisted of one fixed viewpoint frozen at one split second in time, modern descriptive drawing opened the door to a variety of "composite drawing" approaches. More than one point of view and more than one moment in time were referred to. Cubists, for example, included views of the same visible forms from more than one viewpoint at once. Artists such as Paul Klee, who often worked from stream-of-

Eli Corbin uses nature as a reference to create a textural sampler.

consciousness or from sketchy memories of dreams, introduced recognizable forms and symbols one at a time and in response to one another, until a poetic and metaphorical narrative emerged. For them, the juxtaposition of elements was determined without regard to how they might actually appear in the "real" world.

Now it's time for you to try a composite drawing from observation—from life. For this challenge, you'll need two large drawing surfaces and some dry or abrasion drawing tools of your choice (charcoal, pencils, graphite pencil, and pastel are among the examples).

First you'll need to decide on a reference: That is, select a portion or series of elements from the visible world to refer to. It might be a cluster of objects on a table, your view of the room, the contents as they appear inside an automobile's engine compartment, the arrangement of elements visible in your back-yard ... the possibilities are endless. You can do this indoors or outside.

PART ONE: TEXTURAL SAMPLER FROM A REFERENCE

1 Spend a few minutes with your selected subject matter; take it in, sense the range of textures present in the reference. Remember, focus on textures, not things.

2 Then, on your first drawing surface, using line and mark, begin by drawing one texture, any texture (the texture that seems easiest to draw, or one that seems to draw itself).

3 Then, move your eye around (and your body too, if you'd like) and select and then draw a second texture. Take your time and enjoy.

4 Continue to add textures until you've exhausted the possibilities, or until your drawing surface is full. When you're finished, you'll have a textural sampler from life ... and a recording of your personal experiences and decision-making over time!

PART TWO: COMPOSITE DRAWING FROM A SAMPLER

1 Next, on your second sheet of drawing paper, create a composite drawing using only the textures from your sampler—a textural drawing of your subject with little or no regard to how the textures might have been configured in the visible world. Juxtapose the textural elements in any way you like. You can work within a pre-planned structure, as Eli Corbin did in her grid composition (figure 11, right). Or you can place one texture in the space and respond by placing another and another based on your intuition, continuing until the drawing satisfies you. This is how Nancy Farrell created her improvisational piece (figure 12).

2 When you're done, study your drawing for a while. You might be surprised how much it says about your subject. Though it may not look like your reference, it may *feel* like your experience of it.

figure 12

Nancy Farrell
Composite Drawing from a Reference (improvisational version), 2008
Charcoal and pastel on paper
24 x 18 inches
(61 x 45.7 cm)
Courtesy of the Artist

figure 11

Eli Corbin
Composite Drawings from a Reference (improvisational and grid versions), 2008
Charcoal and pastel on paper
24 x 18 inches (61 x 45.7 cm)
Courtesy of the Artist

Jan Bailey is a well-respected poet and the author of three poetry collections. She continued to write until the death of her mother several years ago. After this pivotal event, she found herself with a serious case of writer's block at the age of 63 (figure 13).

"To be frank, I didn't want to write the usual loss-of-mother poems, and I found myself completely bored with my thoughts," she explains with a wry smile. She considered exploring visual arts instead of words, but she hesitated ... until she found a solution: "I was terrified of paint, brushes, and palettes, but there was nothing frightening about holding a pencil!"

figure 14

Jan Bailey
Up a Lazy River, 2007
Colored pencil on paper
11 x 7 inches (27.9 x 17.8 cm)
Courtesy of the Artist

figure 13

Jan Bailey
Writer's Block, 2008
Colored pencil on paper
6½ x 7½ inches (16.5 x 19 cm)
Courtesy of the Artist

The urge to create took a new direction and emerged in her passionate drawings of everyday items—a cat on a chair or a vase of flowers. These common objects were handy references for her vivid imagination. She calls her artwork "play" and gleefully describes how she often broke pencil points while pressing down hard on the paper to create areas of satisfyingly rich color (figures 14 and 15).

Originally from South Carolina, Jan has lived for many years on Monhegan Island, Maine—a tiny oasis of beauty 12 miles out to sea. The jewel-like palette of her works attests to her love of light and color. During the dark northern winter, she craves color, and through her work is able to tap into a warmer, brighter place.

—*Katherine Aimone*

AM I THINKING [WHEN I DRAW]? AM
I WRESTLING WITH MY THOUGHTS?
NOT MUCH. I DO KNOW THAT I AM
TAPPING INTO THE CHILD INSIDE,
AND IT FEELS DELICIOUS.

figure 15

Jan Bailey
The Coffee Hour, 2007
Colored pencil on paper
11 x 7 inches (27.9 x 17.8 cm)
Courtesy of the Artist

DRAWING

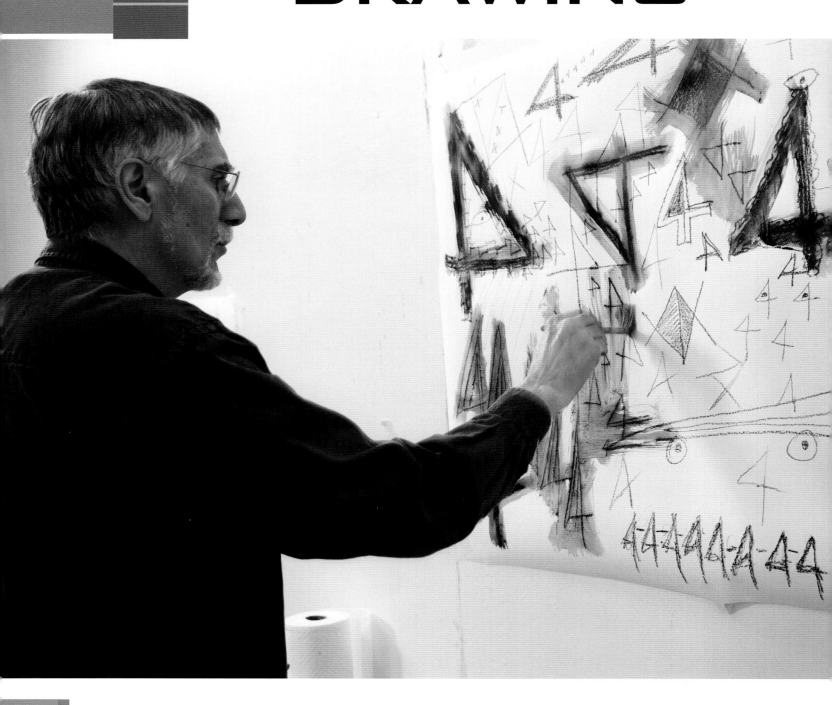

relationships

Part One of our conversation gave you a basic understanding of and some experience with drawing: what it is, what purposes it can serve, and what the process is like. Part Two introduced you to the visual elements at your disposal when you draw. Now, in Part Three, we're ready to discover how these elements work together to form drawing relationships that express things about ourselves and, in broader terms, about life itself. As in the earlier sections, you'll not only gain new and deeper theoretical insights, you'll take part in Play and Build challenges that will give you hands-on experiences in putting the theories into practice, making drawings you'll find both enjoyable and meaningful.

Specifically, Chapter 6 explores the familial relationship of repetitition. Chapter 7 examines a particular and dynamic kind of repetition: that of sequence or rhythm. Chapter 8 explores how equilibrium in drawing is a metaphor for balance in life. Chapter 9 looks at relationships of priority and hierarchy, another way of saying emphasis. Finally, Chapter 10 explores how foundational structures hold drawings together and how similar kinds of relationships serve as essential underpinnings for all of life. These are exciting relationships, so let's move right into Chapter 6.

Jim LaFerla creates a drawing based on the repetition of a "4" motif.

REPETITION

The most fundamental metaphorical structure you can employ in drawing is repetition. *Repetition* involves the recurring appearance or presence of some "thing," often referred to as a *motif*. In drawing, a motif can be any one of the variety of visual elements such as line, mark, shape, texture, tone, color, rhythmic cluster, directionality, and so on. Drawings that feature repetition of motif naturally hold together. The relationship is one of family. It relies on principles of similarity and likeness, and it fosters a sense of community.

figure 1

Jean Dubuffet
Footprints in the Sand, 1948
Ink on paper
7⅞ x 6¼ inches (20 x 15.9 cm)
Digital Image © The Museum of Modern Art / Licensed by
SCALA / Art Resource, NY
© 2008 Artists Rights Society (ARS), New York / ADAGP

ART IS THE CONCRETE REPRESENTATION OF OUR MOST SUBTLE FEELINGS.

Agnes Martin

When the myriad of characteristics and emotions *within a person* features a comfortable degree of predictability and uniformity, more often than not a sense of well-being is present. Further, when any group of people—a family, community, congregation, organization—contains members who are similar enough in interests, characteristics, frame of reference, and so on, a degree of unity and harmony naturally results. This kind of repetition and unified structuring occurs in nature on almost every conceivable level.

So here's the good news, and the moral of the story: When your drawings feature repetitive structuring, they'll be speaking indirectly and poetically about all these things! This will be the case whether your work is representational, symbolic, or nonobjective.

As an analogy, I often ask workshop artists to tell me what the essence of Beethoven's Fifth Symphony is. One or two people will invariably have the courage to hum out, "da-da-da dum, da-da-da dum." And I tell them, "Now *that's* a motif." Beethoven went on and on about "da-da-da dum" for 30 minutes, changing its character, creating variations in numerous ways, weaving things in and out of it, interspersing differing passages … but still working with and in response to his motif, a simple little four-note cluster! In drawing, you can use, or work with, visual motifs in the same way (figure 1).

Keep in mind that the principle of repetition can be worked with very simply and directly or with great complexity and depth. For example, your drawings can be structured to feature more than one motif. David Bates juxtaposed the repetition of three different visual motifs

in *Catalpa I* (figure 3): a leaf motif (moving in circular fashion around the space), an X-shaped floral motif (near the center of the drawing), and an elongated line motif (bottom left). Bear in mind, though, that for the repetition of more than one visual motif to succeed in a drawing, usually one needs to act as the dominant motif while the others play subordinate roles. In this drawing, Bates assigns the leading-actor role to the leaf motif, while the others play supporting roles.

Finally, a word of caution about visual motifs and how you can avoid a common pitfall in using them. In our context here, it's important that when you consider motifs you think *visually* rather than *conceptually*. For example, in a recent workshop I assigned the numeral 7 as the motif for the artists to work with. And I received the question: "Do we need to stick literally with the numeral 7, or for variety, can we use '4 + 3,' 'seven,' 'VII,' 'the number of notes in a scale,' and so on?" Good question. And the answer: Stick with the visual, a bar with a tail flowing backward at the top. Otherwise, you may make conceptual points, but conceptual repetition will not serve as the basis of structure in a drawing.

Conversely, things that don't seem the same conceptually may indeed work together as a visual motif. For example, in Morris Graves's *Bottles and Flowers* (figure 2), several vertical bottle forms and several short lines oriented on vertical diagonals join together to form a "vertical bar" motif.

Let's look at several drawings that offer us glimpses of superb uses of *repetition of motif*.

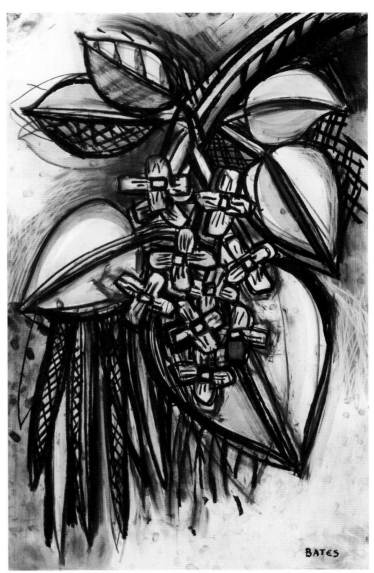

figure 3

David Bates
Catalpa I, 2003
Charcoal, watercolor on paper
41 x 26 inches (104.1 x 66 cm)
Courtesy of the James T. Dyke Collection
© David Bates

figure 4

Tony Smith
Untitled, 1953–55
Charcoal on paper

31½ x 39⅛ inchees
(80 x 99.4 cm)

Purchased with funds given by Agnes
Gund. (219.1996)
The Museum of Modern Art, New
York, NY, U.S.A.
Digital Image © The Museum of
Modern Art / Licensed by SCALA /
Art Resource, NY
© 2008 Estate of Tony Smith / Artists
Rights Society (ARS), New York

Architect, sculptor, and painter Tony Smith explores the circle as motif in intriguing ways in this untitled charcoal drawing (figure 4). All elements in this visual arrangement are members of the circle family, lending a strongly unified sense of community. Each is tonally quite similar. None of the entities are *perfect* circles, however. Each is organic and exhibits a slight irregularity—each is a distinct individual. Some are nearly circular, indicating very little movement. Others are more oval-like or more pronounced in irregularity, and serve as indicators of movement and direction in delicate and understated ways. The result is a drawing full of life and vibration.

Smith's exploration takes on an additional layer of richness by employing the circle as a familial *module*! Some circles, as units of expression, are combined with other circles to form congregate beings composed of two, three, four, or more (up to 12 in one case) circles held together by tonal connectors. As a result, the drawing embodies a much greater degree and depth of variety. The drawing has all it needs to hold together beautifully, while offering surprising varietal tensions that leave the viewer intrigued and satisfied. And all of this from playing with circles in charcoal—amazing!

For a largely self-taught artist, Elizabeth Layton (see Artist Profile, pages 70–71) works with repetition of motif in a very rich, complex, and sophisticated manner in *Every Which Way* (figure 5). Let's consider the ways in which she pulls this off.

At first glance you can see that Layton has organized her drawing around the repetition of a flower motif that is quasi-circular in nature. These forms appear over and over again throughout the drawing. And if that had been all she did to organize the drawing, it would have likely sufficed. But that only scratched the surface.

First, notice that some of the flowers are intense mid-tone blue in color while others are pale pink. Because of the intensity of the color, the blue flowers are clearly dominant and the pink ones subordinate. So visually, it's the repetition of the blue flowers that organizes the design. Look more closely and you'll see that there is a little curved shape of blue inside the watering can in the upper left corner of the image. It stands as another blue note, and it's about the same size as the blue floral forms. So, in a way, you might say that the drawing really revolves around the repetition of the mid-tone blue notes.

If that is the case, the pink flowers are a secondary and subordinate motif. Again, though, give the drawing further attention and you'll see that the shapes of the woman's arm (upper left), head, and hand (middle right) contain the same pale pink. So you *could* consider the repeated appearance of pale pink as the secondary motif.

Then, notice the repetition of the stripes in the woman's dress, echoed by the stripes in her hair—yet another secondary motif. Finally, see that there are three appearances of the intense red color—in the form of the watering can, a little flower in the woman's ear, and a

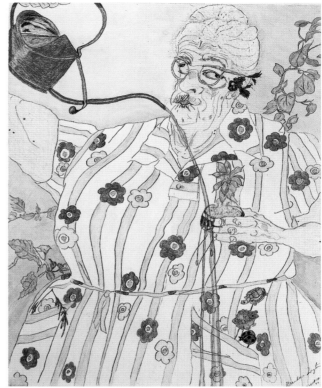

figure 5

Elizabeth Layton
Every Which Way, 1977
Colored pencil

22 x 28 inches
(55.9 x 71.1 cm)

Collection of the Lawrence Arts Center, Lawrence, Kansas. Gift of the Elizabeth Layton Foundation

ladybug by her dress pocket at the bottom right—a final motif that leads the eye around the drawing in a triangular movement.

Phew! That's an awful lot to consider in just one, apparently straightforward drawing. And it's so wonderful: There's no concrete and objective way to respond to a drawing like this, just a number of related possibilities, all revolving around repetition of motif. As a result, the drawing is continuously intriguing.

W hen you draw from life, you inevitably face the daunting task of abstracting: distilling, arranging, rearranging, exaggerating, and altering what you see in response to your visual experience. As we've noted, you are the unique filter through which experiences of the visual world pass to create a drawing that is uniquely and satisfyingly your own. One of the ways in which you can filter things is to recognize the repetition of a visual motif in your reference, embrace it, and emphasize it. Another way is to convert things in the reference into motif forms that recur in a clear and unifying way.

Amedeo Modigliani does some of each in the pencil drawing *Paul Guillaume* (figure 6). What's the motif here? That's right, the triangle (or more accurately, triangular and modified-triangular wedges). It's likely that some were present in the model when Modigliani observed. It's virtually certain that the artist exaggerated and reinforced the triangular, sharply pointed nature of these forms. He may have even invented one or two of them. No matter. As you can see and feel, repetition of this motif acts as a powerful unifier. Its presence can be sensed everywhere. Most centrally, Guillaume's head, collar, and shirt and tie—taken together—form one large incarnation of the triangular motif (with its pointed top facing downward). At the bottom on each side are two small, dark triangles; they are in turn flanked by two taller triangles, light in value—all are pointing up. On the left stands the darkest triangle in the drawing, pointing downward in response. Just below it to the left is another little triangle … and so it goes. Even the large negative shapes to the left and right of the figure hint at triangularity.

In this unified repetitive interpretation, notice the range of little elements that don't quite fit, and stand in contrast to the triangular nature of things— the rounded, organic shapes of the ears, the curvilinear lines of the eyebrows and the side of the nose. These furnish additional depth and variety.

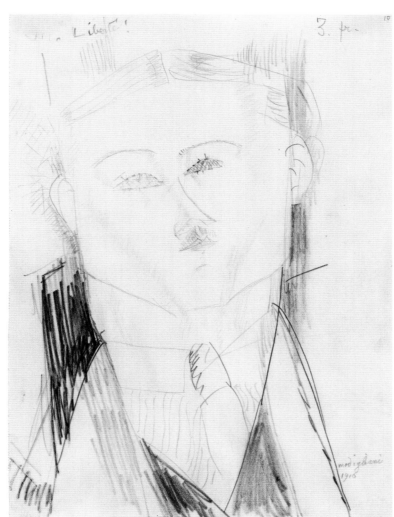

figure 6

Amedeo Modigliani
Paul Guillaume, 1916
Pencil on paper
13⅞ x 10⅜ inches (34 x 26.4 cm)
Digital Image © The Museum of Modern Art /
Licensed by SCALA / Art Resource, NY

PLAY 1 ▪ REPETITION OF A MOTIF

As we noted earlier, a visual motif can be almost anything: a shape, line, mark, color, bit of texture—the possibilities are vast. Shape and linear symbol are two common motif categories, and we'll focus on them here.

The challenge is straightforward: Simply fill your drawing surface with many incarnations of the same shape. Automatically, your drawing will hold together. Next, the trick is to make the drawing as richly satisfying as possible. This can be addressed in many ways. The one we'll use here is to vary the motif in different ways so that each motif is an individual taking part in a larger community.

For example, consider a drawing based on the repetition of an oval motif. To create variety, you can make the ovals bigger and smaller, fatter and thinner, whole or fragmentary. You can use fat and thin contour lines. Some ovals can be established as areas of tone, with a few being darker and others lighter. Or you can orient the ovals on a horizontal, with others being vertical or diagonal. The ways in which the ovals relate to one another can be a source of variation too. Some can be separate from the others, others can "kiss" or butt up against one another, and still others can overlap. Now it's your turn to make a drawing in this way.

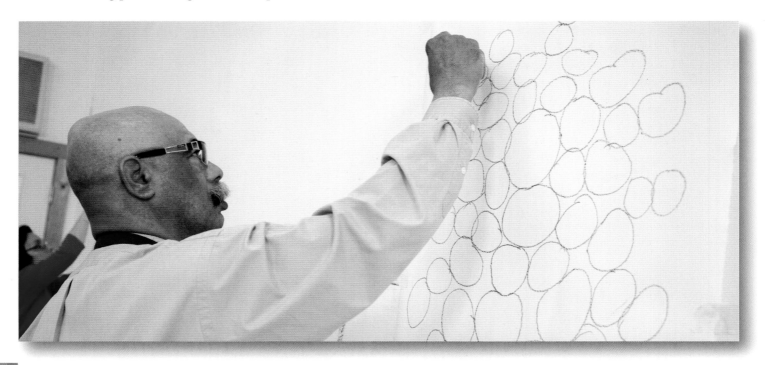

1 Begin by selecting a very simple, basic motif. Some shape possibilities include geometrics such as a circle, oval, triangle, and rectangle. For linear symbols you might use things such as the numerals 2, 3, 4, 5, 6/9, 7, and 8, and almost any letter, such as b/q, c, h, k, s, and so on.

2 Next, using drawing tools and a drawing surface of your choice, begin to draw a few incarnations of your chosen motif.

3 Pause for a moment (if you're working standing up, step back for just a moment). Take in the whole drawing space, and sense what each shape or symbol is doing and how it's relating to the others. As soon as you have an urge to respond in some way, do so. At this point, this will likely mean adding additional instances of the motif.

4 Continue adding, then observing and absorbing. At any time, you have the option to undo, cover up, or veil part of what you've done. If you're working with abrasion tools, a kneaded eraser will enable you do this. Or, if you're mixing abrasion tools with paint, you can use the paint to take things away.

5 Keep in mind that it's okay to introduce a few other elements here and there if you wish, as long as your original motif continues to have a very dominant, even overwhelming, presence. Jim LaFerla does this in his drawing based on the repetition of a "4" motif. Notice the little eyes (or symbols for eyes, that is) that appear intermittently. They give not only a sense of variety but a hint of humor as well.

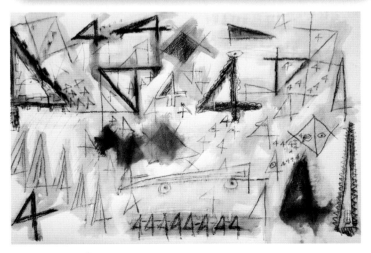

Jim LaFerla makes a drawing based on the repetition of a "4" motif; the finished drawing is above. Opposite page: Tim Proctor draws variations of a circle.

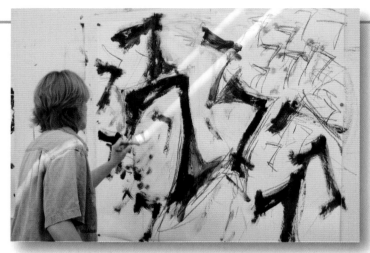

Beverly Munchel-Kievit repeats a "7" motif using mixed media; her finished drawing is below.

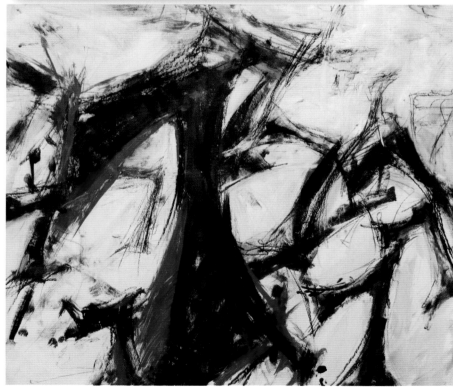

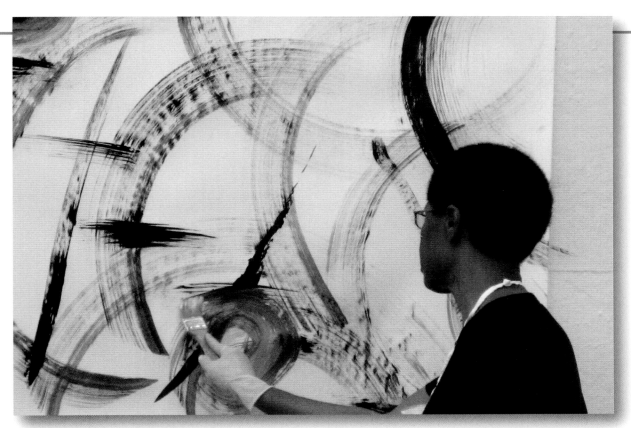

Gwen Magee develops her drawing of the letter "C." She uses a brush to obliterate some of her lines.

6 As you're working, you may notice a bonus phenomenon: overlapping motifs that give birth to new shapes. You can see this occurred for Beverly Munchel-Kievit in her "7" motif drawing on the opposite page. In the finished product, a range of new shapes—most often pointed half-ovals—have come into being. They repeat so often that they function as a secondary motif, and they lend breadth, richness, and variety to her mixed-media drawing.

7 Continue developing your drawing until you reach a satisfying resolution.

BUILD 1 ■ REPETITION OF MULTIPLE MOTIFS

To structure a drawing around the repetition of a motif, you don't have to decide in advance what the motif will be. If you have one in mind at the start, you change your mind during the drawing process. The Build exercise that follows will help you explore this territory.

In developing her drawing (figure 7 on page 123), Linda Sommer began without committing to any motif. Instead, she vacillated between repeating triangles and repeating rectangles, and kept working until a final motif asserted itself. In this case, a hybrid between the two original motifs emerged: a modified triangle, one with its apex cropped. With this new form asserting itself as the dominant element, any appearances of full-fledged triangles or rectangles became, in the end, exceptions or variations that lent breadth and tension to the drawing.

1 Begin by introducing two or more motifs into the drawing.

2 Put more in, take some out, emphasize some elements, de-emphasize others, and continue processing. Play, take chances, explore. You can't make a mistake here; there's not a right or wrong way to proceed.

3 At some point, one motif may become dominant; as you keep going, another may take the lead. Keep the juggling process going until you sense that your primary motif (or a hybrid) has emerged.

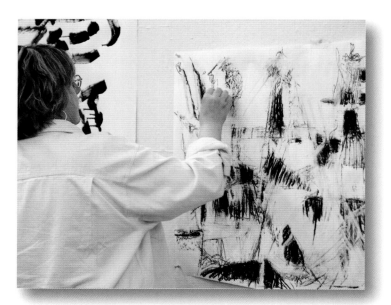

Linda Sommer discovers a new motif as she works with repeated triangles and rectangles.

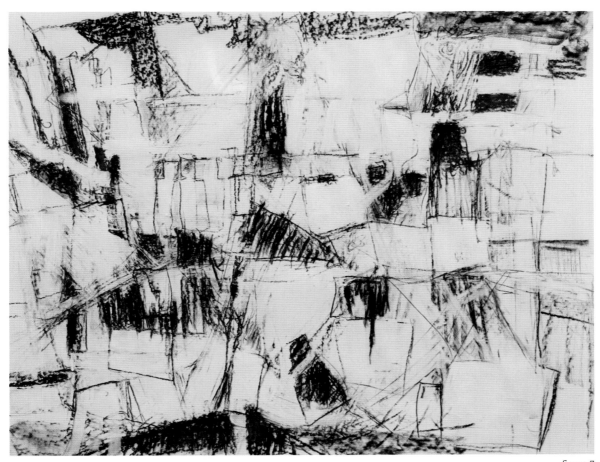

figure 7

Linda Sommer
Repetition of Multiple Motifs, 2007
Mixed drawing media on paper
42 x 48 inches (106.7 x 121.9 cm)
Courtesy of the Artist

BUILD 2 ▪ SHAPE MOTIF REPETITION

Now let's develop the repetition of a motif in a different way. Instead of working with nonobjective, "abstract" elements such as ovals or numerals, let's apply the idea to working from life, repeating one observed element numerous times in the same drawing. Take a look again at Jean Dubuffet's *Footprints in the Sand* (page 110).

1 Select drawing tools/media and a drawing support.

2 Next, choose a simple object to work from: a hat, an egg, a banana, a leaf … anything you'd like (in the examples shown here, the artists work with an oyster shell as reference).

3 Then, begin by making a contour drawing of this element anywhere you like on the drawing surface. Where you place the element is not crucial. It doesn't need to be an accurate rendering; just put one version out there.

4 Do this again and again. If you like, you can vary your visual relationship with the subject by turning it a bit, moving closer to it, or leaning to the side to get a slightly different view. If you'd like, you can make the repeats of the motif smaller and larger, fatter and thinner, and so on. Try clustering some together or overlapping others. Make your contour rendering as accurate or as interpretive as you like.

5 As you proceed, you have the option to take things out, veil them, or cover them up. Keep developing the drawing until it holds together well by virtue of repetition of motif, and you sense a satisfying resolution.

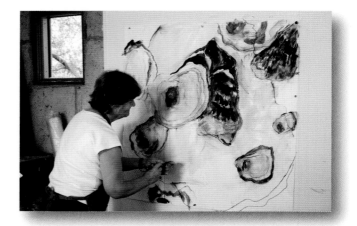

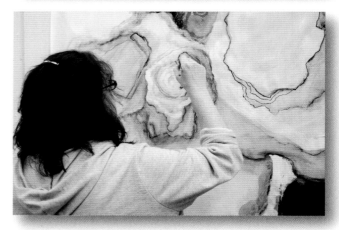

Regina Gudelis (top) and Charlotte Foust (bottom) work on drawings using an oyster shell as reference.

VARIATION

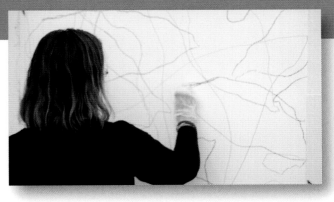

This variation is appropriate if you're interested and experienced in creating drawings from life. This exercise may furnish you with a new way to abstract from observation. Earlier in the chapter, we saw how Amedeo Modigliani (pages 116–117) used repetition of motif to organize his representational portrait of Paul Guillaume. In that drawing, the artist observed the repetition of a triangular motif in the subject and ran with it. He embraced it, exaggerated or clarified it, and perhaps even invented instances of it.

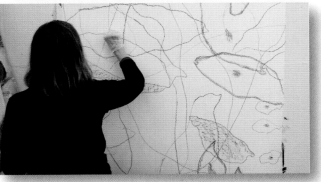

First, re-examine Modigliani's drawing as a refresher. Then, select a subject of your own—a corner of the room, a landscape vista, your sleeping cat, the contents of a wastepaper basket, a person posing—any subject will do. Spend time being still and observing. Can you see a motif of any kind that repeats? More than one? If so, you're all set to start drawing. If you haven't worked with this approach before, you may be surprised just how rewarding and expressive your drawing becomes.

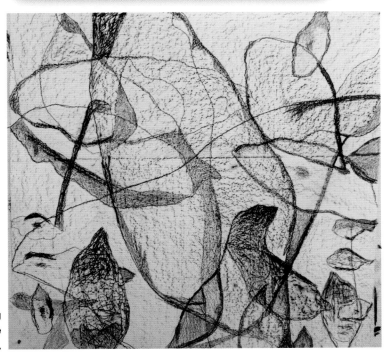

Charlene Thomas develops her drawing based on an oyster shell motif (above). The finished drawing (right) is fluid and elegant.

RHYTHM

Everything that is alive has rhythm. Rhythm permeates nature (even so-called inanimate objects display rhythmic qualities). It influences everything we do. So when a drawing displays rhythm—and especially when rhythm is a primary unifier or dominant *presence*—the drawing can be experienced as being *about* nature or life itself. The reference may be direct and descriptive. Or, as we've been repeatedly noting in our study, the reference may be indirect, poetic, and metaphorical.

figure 1

Marc Chagall
Dance of the Gypsies, 1942

Watercolor, wash, pencil, and ink on paper

10⅜ x 16 inches (26.4 x 40.6 cm)

Digital Image © The Museum of Modern Art / Licensed by SCALA / Art Resource, NY © 2008 Artists Rights Society (ARS), New York / ADAGP

We're all intimately familiar with rhythm—we're rhythmic beings. Our hearts beat rhythmically. We breathe in and out in rhythmic fashion. When we walk, our legs move forward alternately, *left right, left right*. In response, our arms usually swing back and forth the opposite way: the left arm moving back as the left leg moves forward, and so on. When we dance, our movements respond to rhythm. We often speak in rhythmic cadence. Writers and poets employ rhythm to structure their works.

The rest of nature, too, is *rhythmic, rhythmic, rhythmic*. Tides rise and fall, alternating between high and low, in a very regular and predictable pattern. The surf comes in and out, in and out, in a patterned manner. When you observe a mountain range, you often become aware of a rhythmic alternation between peaks and valleys, or higher points and low points—both inducing a sense of up and down, up and down (should you set out to draw a mountainous landscape, draw rhythms rather than mountains and you'll be amazed at the results you obtain). Younger mountain ranges exhibit pointy, angular shape motifs while older mountain ranges exhibit shape motifs that are softer and rounder.

In drawing, *rhythm* is a specific kind of repetition: one that is *sequential* in nature. It's a repeating pattern of things (the motif) and no-thing-ness. Put another way, visual rhythm consists of beats (the motif) and the intervals or spaces *between* the beats. Naturally, then, rhythms can be varied by changing the nature of the beats (varying the motif) or the nature of the intervals (varying the spacing or the amount of no-thing-ness between the beats). Sharon Reed's drawing (figure 2) is a powerful example of horizontal rhythm.

There is a direct parallel between rhythm in drawing and rhythm in music, and the analogy is illuminating.

figure 2

Sharon Reed
Horizontal Rhythm, 2008
Mixed drawing media on paper
30 x 42 inches (76.2 x 106.7 cm)
Courtesy of the Artist

Consider the four-beat musical sequence: one-two-three-four, one-two-three-four. We all know this one and are familiar with some of its variations. To get the idea, say the following *out loud*, and say the words in capitals *louder* than the word in small letters:

figure 3

- **o n e - t w o - t h r e e - f o u r ,
 o n e - t w o - t h r e e - f o u r**

- **O N E -t w o - t h r e e - f o u r ,
 O N E -two-three-four**

- **one-two-T H R E E -four,
 one-two-T H R E E -four**

You can hear the difference in emphasis or feeling, and, looking at the printed text, you can *see* the changes in emphasis too! Now, think of a drawing containing a sequence of four ovals, and visualize drawing them this way (as illustrated in figure 3):

- **same-size same-size same-size same-size, same-size same-size same-size same-size**

- **LARGER same-size same-size same-size, LARGER same-size same-size same-size**

- **same-size same-size LARGER same-size, same-size same-size LARGER same-size**

Keep in mind, of course, that instead of "larger," you could substitute smaller, fatter, thinner, and so on. And these are just a few and some of the simplest of possible variations!

Another analogy for anyone familiar with basic military training is the verbal marching orders barked by a drill sergeant—the four-beat sequence:

- **Left-right-left (space), left-right-left (space)**

The verbal "space" is a fourth (right) step that is implied. The drawing equivalent of this might be:

- **Small-oval big-oval small-oval (space where an absent big oval would fit)**

In working with rhythm, you automatically address issues of space, time, and motion. A shape motif (an oval, for example) occupies space; a sequence of *several* ovals consists of the space occupied by the ovals and the areas of no-thing-ness *between* the ovals. To experience such a rhythm takes time (you start by experiencing one oval and proceed through space from oval to oval and so on). And of course, these experiences of space and time lead to the experience of motion, or movement.

Rhythmic movement can occur in many different ways. The sections that follow detail some common ones.

HORIZONTAL

Both of the drawings presented on page 129 are based on horizontal movements of a vertical bar motif. Both, in fact, exhibit *two* sets of horizontal rhythmic movements.

The underpinning of Will Barnet's *Study for Early Spring* (figure 4) consists of a horizontal rhythmic movement of tall tree verticals. These run all the way (or nearly) from top to bottom. The intervals between the trees vary nicely; the "spacing" ranges from dense to relatively open. Then, interspersed between these tree notes runs the second horizontal rhythm of the shorter, vertical notes of the figures. The two rhythms simultaneously function in support of one another. It's worth noting, though, that in both horizontal rhythms the notes are invariably straight and vertical. As a result, the drawing

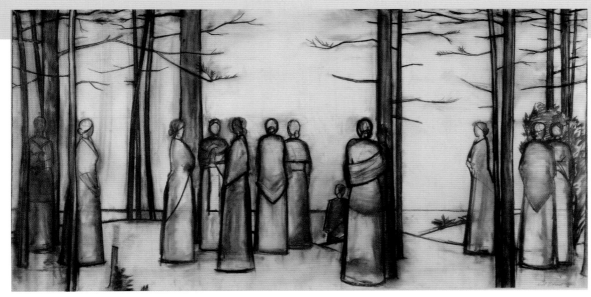

feels quite static and highly ordered. Finally, notice how on the limbs of each tree stand horizontal bars that create little counter-rhythms that move vertically.

Marcia Kocot and Tom Hatton's *21 September–29 September 2005* (figure 5) also features a horizontal rhythmic movement of repeating vertical lines. In this case, lines vary from fairly straight and placid to quite wavy and energetic. They are also very numerous and lend a feeling of great density and ambiguity—you can't always tell which line is which as they overlap and intertwine. The artists increased the complexity of the rhythm by splitting the drawing into two sections—a top bar and a slightly larger bottom bar. This change in scale creates a shift: It makes the rhythm in the bottom bar come forward or closer to us, phasing one rhythm against the other.

figure 5

Kocot and Hatton
21 September–29 September 2005, 2005
Ink on rag paper
15⅜ x 15⅜ inches (39 x 39 cm)
Private Collection, New York
© 2005 Kocot and Hatton

VERTICAL

The underpinning of Carroll Dunham's drawing (figure 6) is clearly a vertical movement of horizontal bars that vary from fixed to wavering in character. By the way, note the secondary rhythmic movement that flows in oval fashion—a nice rhythmic counterpart in response.

DIAGONAL

In *Cabbage Patch* (figure 7), Arthur Dove speaks of a dynamic, diagonal rhythm. The long diagonals move from the bottom left corner to the upper right. Then, in embellishment, curlicue, corkscrew lines between the long diagonals establish parallel diagonal rhythms in the left-hand two-thirds of the drawing, and opposite or counter movements in the right-hand third of the arrangement. Not only that, but the curlicue lines are also rhythmic in and of themselves, consisting of a sequence of one loop after another after another. The overall feeling is lively, jazzy, and playful.

You'll notice this same type of rhythm in Marc Chagall's *Dance of the Gypsies* (figure 1, page 126). That drawing features a main diagonal of figures plus a secondary diagonal sequence of three figures above it. Chagall left it open for us to experience the two rhythms as one, in which the eye would move up and down from one rhythm to the other ... very nice!

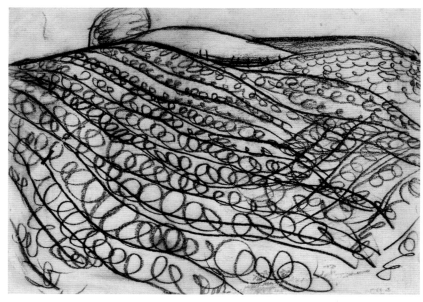

CIRCULAR/OVAL/ ELLIPTICAL

A looping rhythmic movement serves as the unifying thread in Chuck Holtzman's drawing *Seven Hundred* (figure 8). This sequence moves from one dark cluster to another and another. Most of the clusters, the motif, are modified circular areas as well. Generally, the intervals or spaces between the "notes" are fairly uniform and form a predictable pattern. However, the nature of the motif varies, forming a hierarchy within the sequence. For example, the strongest beat in the rhythm is the cluster of little circles to the left of center, just below the middle. This note is a dense grouping of sharply defined circles with punchy, hard edges; the cluster also contains crisp value contrasts that run from extreme white to extreme black. As an analogy, you might think of this as the *loudest* beat in the rhythm.

Another rhythmic sense of direction can be seen in Susan Jane Walp's *Study for Blueberries on a White Cloth* (figure 9). The unifying movement in this drawing comes in the form of a figure eight or ellipse. The white cloth gently loops in this manner, serving as an underlying support for the movement of the little circular notes of the blueberries that also form an ellipse.

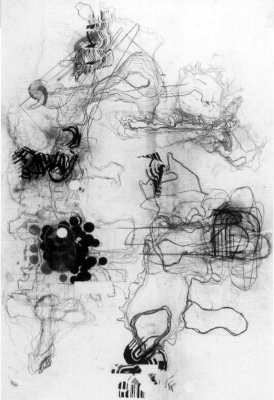

figure 8

Chuck Holtzman
Seven Hundred, 2006
Ink, charcoal on paper
69¾ x 44½ inches
(177.2 x 113 cm)
Courtesy of the James T. Dyke Collection

figure 9

Susan Jane Walp
Study for Blueberries on a White Cloth, 1997
Graphite, color pencil on toned paper
10¾ x 13 inches (27.3 x 33 cm)
Courtesy of the James T. Dyke Collection

Zigzag (Rocking)

Elsie Freund's watercolor *Dock at Hydra, Greece* (figure 10) is a pronounced and energetic example of a rocking or zigzag rhythm. At first glance, you can see that the drawing is built on a large "Z" movement. Closer inspection reveals that the entire drawing consists of a series of diagonal thrusts, alternating between *lower left to upper right* and *upper left to lower right*. The general principle is illustrated by figure 11. Freund's particular application of this principle is diagrammed in figure 12.

To get the feeling of this kind of rhythm—to really feel it, physically—I often suggest that artists do the following.

Clasp your hands together in front of you, a couple inches from your lower chest/upper abdomen, so that your two arms form one long horizontal that is parallel to the ground. Keep the two arms locked, but relaxed, in that position. Next, keeping your hands steady in the center in front of you, raise one elbow—for example, the left one. Your right elbow will automatically lower in unison. Hold that position for a second. Then, still keeping your hands steady and centered in front of you, raise the right elbow and the left will lower itself in unison. Hold that position. Keep alternating: hands steady, first the left

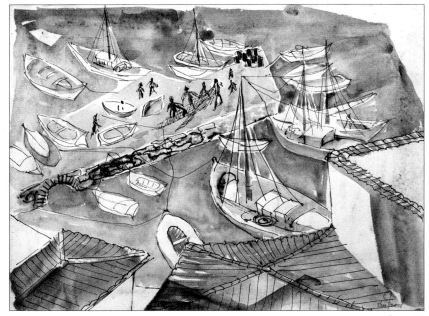

figure 10

figure 11

figure 12

Elsie Bates Freund
Dock at Hydra, Greece, 1960
Watercolor on paper
9 x 11¾ inches (22.9 x 29.8 cm)
Arkansas Arts Center Foundation Collection: Gift of the artist,
1997. 1997.037.001

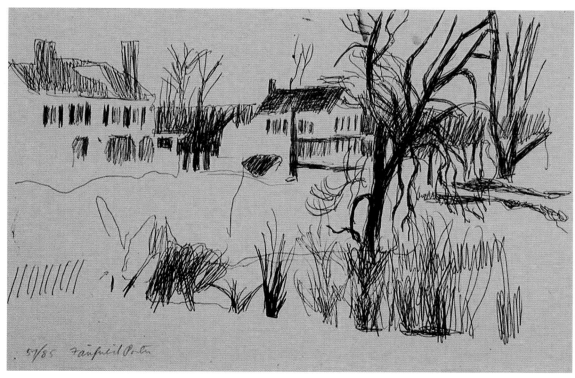

figure 13

Fairfield Porter
Snow Landscape,
1960–61
Lithograph

8⁹⁄₁₆ x 13 inches
(21.75 x 33 cm)
Courtesy of the Rochester
Memorial Art Gallery

elbow up, then the right, left elbow up, then the right, and so on. Feel what that's like? Can you sense in your body the kind of physical rocking in Freund's drawing?

Finally, in *Snow Landscape* (figure 13), Fairfield Porter combines the horizontal movement of verticals we observed earlier in drawings by Will Barnet and Kocot and Hatton (page 129) with the zigzag movements in the Freund drawing. The several interrelated horizontal rhythms of vertical bars are easy to discern. The rocking rhythm is more subtly felt underneath—a series of zigzagging diagonals, starting at the lower right and moving its way up through the drawing.

Let's take an in-depth look at three additional drawings in which rhythm serves as the unifying thread or as the subject of the drawing itself.

Jan Groth's untitled crayon drawing (figure 14) consists of visual rhythm, pure and simple—it's the subject of the work. The motif is a semi-vertical bar that varies subtly in both character and movement. The end product is elegant and beautiful.

Starting from the left, Groth's bars begin with perfectly vertical tops, feature dark and slightly bulging accents in the middle, and trail off in reverse-C motions at the bottom. The intervals here are fairly evenly spaced. As the left-to-right rhythm reaches the center of the drawing space, the dark bulges begin to break down, evolving into dark, shallow "C" movements. Just past the middle of the movement, the dark middle accents dissipate altogether, as do the reverse-C tails at the bottom. In the end, the right side of the movement consists of shorter bars at the top only. Intellectually it might seem that the rhythm grows weaker, but other linear forces maintain the energy: The remaining bar shifts to a diagonal orientation (creating just a bit more dyna-

mism), and the intervals between the bars get narrower and more compressed (creating a feeling of increased pressure and congestion).

The kind of rhythm created by Groth feels alive, in flux, organic. The linear rhythm and movements might refer literally or metaphorically to a ribcage, or to reeds and seaweed. Knowing that the artist's primary medium is tapestry, the drawing could be interpreted as a fragment of a loom or other weaving device. Perhaps Groth is influenced by all these factors. In any case, the drawing is clearly and eloquently about rhythmic energy.

figure 14

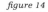

Jan Groth
Untitled, 1970
Crayon on paper

24⅝ x 34⅝ inches
(62.4 x 87.9 cm)

Digital Image © The Museum
of Modern Art / Licensed by SCALA / Art
Resource, NY
© 2008 Artists Rights Society (ARS), New York /
BONO, Oslo

LOOK AT THIS CARLOS ZINELLI

In contrast to Groth's drawing, which features delicate line and nuanced rhythmic movements, Carlo Zinelli treats us to lines and rhythms that are bold, direct, and assertive. If Groth's drawing is spare and elegant, Zinelli's is chock full of rhythmic gyration and density. His untitled drawing (figure 15) clearly features the same horizontal movements of vertical bars we found in Groth's piece, but there the similarity ends!

Zinelli's drawing is jazzy and vivacious. The lines, executed in tempera, are uniform and powerful (nothing subtle or nuanced here). The composition is grounded by two rhythmic rows of vertical figures and bows situated in the bottom of the drawing space. These together give the drawing a rock-solid foundation. Then, above these two rows, the lines go wild. Rhythm after rhythm after rhythm create one movement after another, all occurring in the same space simultaneously. The motif elements themselves become smaller and rigidly ordered, and they march across the surface in staccato fashion. While a few of the movements remain relatively horizontal, most take on a more assertive diagonal direction. These shorter sequences combine with a few singular diagonal forms (such as the large rifle in the upper left and the counter diagonal just above) to create in the drawing a powerful sense of tilting animation.

figure 15

Carlos Zinelli
Untitled, no date
Tempera on paper
Courtesy of the Anthony Petullo Collection of
Self-Taught and Outsider Art

Milton Avery's drawing *Very Old Orchard* (figure 16) is splendidly animated, in large part by a lively rocking rhythm that runs across the top of the space. This primary sequence is supported by a more predictable, even-keeled, subordinate rhythm of grass and shrub forms below. In musical terms, you might think of the upper rhythm as a line of melody, with the lower rhythm acting as the underlying bass line.

Take a moment to feel the rocking sensation of the trees as they tilt back and forth from left to right. This rhythm is neither simple nor obvious, and it's much easier to sense than to analyze or understand. As best as words can describe, here's how it works: Starting at the left, notice how the trunk of the first tree leans strongly to the left. Then its limbs, especially the top two, tilt back to the right. The thin top of the second tree's trunk gestures back to the left, while its lower trunk and limbs counter by rocking back to the right. This right tilt is reinforced by the bottom of the trunk of the third tree, which is quickly countered by the movement left in the middle of the trunk, only to be countered again by the sharply rightward diagonals of the limbs at the top. The linear gestures in the remaining trees can be interpreted to extend this zigzag tilting, back and forth, all the way to the right edge of the drawing.

Note the additional rhythmic vibrations at the bottom of each tree trunk, which Avery created through short little hatchings in brown. These serve as accents or embellishments to the rhythm. Finally, a series of highly varied lines and marks are used to create the "bass line" rhythm below.

FINDING THE WORDS

Now it's your turn to put Avery's rhythm into words. Ready? Describe the rhythmic movement by posing and answering questions, including the following:

- What is the first beat like, and how does Avery's arrangement of line and mark achieve that feeling?

- What is the nature of the interval or space that follows?

- What is the nature of the next beat in relation to the first (what does it feel like, and how does Avery's line and mark create this feeling)?

- How does the movement up and down, higher and lower, from one instance of the motif to another change the feeling of the rhythm?

Keep posing and answering these questions until you've achieved a satisfying (though necessarily incomplete) description.

Okay, then: enough talking for now. Let's put these understandings into action by making marks on paper to create your own rhythmic drawings.

figure 16

Milton Avery
Very Old Orchard, 1953
Watercolor on paper
22 x 30 inches (55.9 x 76.2 cm)
Courtesy of Knoedler & Company
© Milton Avery Trust / Artists Rights Society (ARS), New York

PLAY 1 ▪ RHYTHMIC REPETITION

Let's start working with rhythm in simple, basic terms. The motif will be a short, straight line, or bar. The movement will be horizontal.

1 Begin with several long horizontal drawing surfaces, ones that are significantly longer than they are tall. A superb size is 10 x 40 inches (25.4 x 101.6 cm). If you need to work smaller, a sheet of legal-size paper (11 x 14 inches [27.9 x 35.6 cm]) cut in half the long way creates two sheets that are 5½ x 14 inches (14 x 35.6 cm), which will do just fine. If you prefer, work on one large sheet of paper instead, and mark off the sheet into a series of long bands stacked vertically. In either event, if you're working large, hang your surfaces on the wall or lay them on the floor. If you're working on a smaller scale, attach the surfaces to a drawing board in front of you.

2 On the first drawing surface, using a sharpened graphite or charcoal pencil, draw a row of bars of equal size and equal weight from left to right. Make sure they are all vertical, and make the intervals *between* the bars equal in diameter as well, as Tacy Apostolik demonstrates at right. In theory, at this point, you'll have a perfectly even rhythm, with no variation whatsoever.

3 Now, begin to create interest, tension, and vibration by doing nothing more than changing the width and weight of the bars. Make some a bit fatter, others much fatter, and so on. In other cases, you might make the bar darker but not much, if any, wider. Remember, too, that you can use an eraser at any time to lighten a beat, or erase a beat altogether and redo.

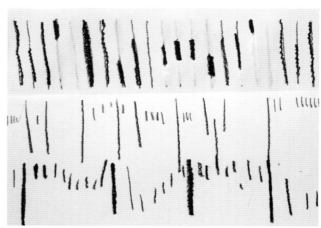

Tacy Apostolik works on her drawing that explores the horizontal rhythmic movement of a vertical bar motif (top); the finished piece follows (bottom).

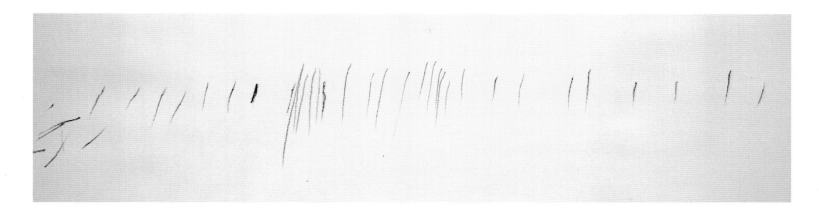

4 Continue working your linear rhythm until it satis-
fies you. Then stop and move on to the next piece of
paper or the next band on your large sheet of paper,
and repeat the exercise, creating a new resolution,
a variation on the theme.

5 Repeat the exercise as many times as you like.
When you're through, put all the drawings in front of
you. Take them in. Note the differences in feeling and
vibration.

VARIATION ONE

Repeat Play 1, but this time add to the ways in which
you vary the character of the rhythm by doing one,
two, or all of the following:

● Allow some of the bars to tilt *a bit* on a diagonal

● Make some of the bars longer, or taller, and others
shorter

● Vary the width of the spaces or intervals

You'll likely find this to be liberating. You're also likely
to create rhythms that are more lively and dynamic.
Lisa McLaughlin LaRose does these kinds of things
in her workshop drawing (figure 17). Notice how
her sequence begins dynamically with a number of
diagonals that point up and to the right, then levels
off with a number of very similar beats spaced quite
evenly. The last of these is darker than the rest and
acts as an accent note—the strongest single beat in
the rhythm. Then, after a nice little rest interval, the
rhythm takes off: A number of taller vertical lines
appear very quickly, one after another, forming a
cluster of beats. This is followed by more tall notes
leading into a second cluster, though not as dense
as the first. After this, the rhythm returns to shorter
bars that are more openly spaced. Again, think of
McLaughlin LaRose's rhythm in terms of breathing:
opening and closing, opening and closing; or airy and
dense, airy and dense.

figure 17

**Lisa McLaughlin
LaRose**
*Rhythmic
Repetition of
a Vertical Bar
Motif,* 2008
Charcoal on paper

10 x 40 inches
(25.4 x 101.7 cm)
Courtesy of the Artist

VARIATION TWO

Another way to extend the possibilities within this exercise is to allow yourself to vary the rhythm even more by altering the short bar/line motif itself by *bending it* so that it contains come curvilinear or angular gestural movements.

For examples, let's look at two workshop drawings. In the first (at right), Nancy Farrell uses paint to create thick/thin variations within each of the beats themselves, while elongating them at the same time. She also bends them into shallow angular gestures. Regarding the spacing of the rhythm, hers can be summarized as something like: beat-space-beat spaaaace beat-space-beat-space-beat-space-fraction of a beat spaaaaaaaace beat.

Kathy Casey takes this variation of the Play exercise in a different direction (below). The beats in her rhythm can be read or felt in a couple of ways simultaneously. At first glance, she

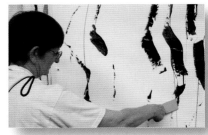

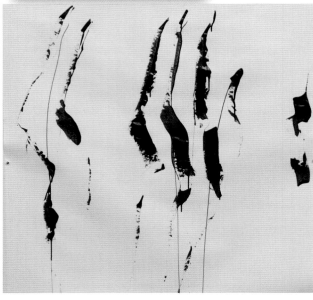

Nancy Farrell works on this variation; her finished drawing is pictured below.

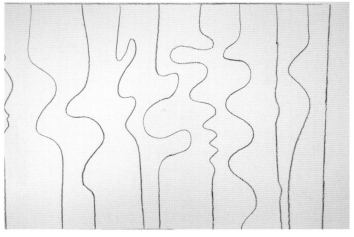

Kathy Casey develops her drawing of a rhythmic repetition of a vertical bar motif; the finished piece is at right.

presents us with a series of vertical lines of equal weight that become quite curvilinear. They wiggle their way across the space from left to right. In these terms, the rhythm becomes most dynamic just to the right of the middle (where the lines wiggle the most) and then quiets again before the finish. On the other hand, Casey's lines seem to want to be read in pairs that form shapes. Take any two of the lines along with the space between them and you've got an enclosed area, or shape. In turn, that shape can be read as positive (a thing) while the spaces to the left and right can be read as negative (no-thing). It's amazing what a series of lines can do!

VARIATION THREE

Yet another way to explore the possibilities within this exercise might be to a) feature several lines of rhythm in the same drawing, and b) explore using differing motifs in the different rhythms.

Don Silver does these things in the Play exercise, at right. Notice how the rhythm with the heaviest notes is placed at the bottom of the drawing, giving it a sense of groundedness, foundation, and stability. The middle row of rhythm consists of equilateral triangles; most of them are oriented so that their bottom edge is horizontal so that, by implication, they feel quite stable as well. At the same time, the apex of most of the triangles points upward and toward the top line of rhythm, which is the most varied and dynamic.

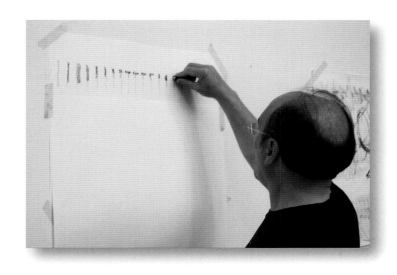

Don Silver demonstrates how several motifs of differing rhythms can be repeated to expressive effect; the finished drawing is shown at left.

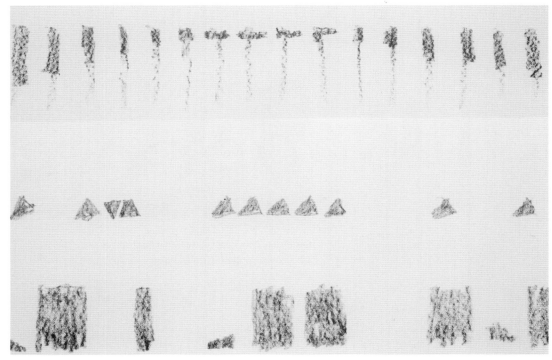

BUILD 1 ▪ HORIZONTAL RHYTHM
OF A VERTICAL LINE BAR MOTIF

After playing and playing, exploring possibilities of what a simple rhythm can do in so many variations, you likely have this idea of rhythm internalized pretty well. Now it's time to put your new understandings to use in a more open-ended way—by incorporating the idea of "in flux" that we've talked about and worked with in earlier Plays and Builds. The only ground rules here are:

• Stick with the vertical line/bar motif.

• Process the drawing by both putting things in and taking things out.

You'll be working in a more improvisational way, so stifle the controller and editor inside and simply let go!

1 Select and position a drawing surface to work on— the nature and size of this surface is up to you. The usual paper supports you've used up until now will work just fine. For this particular exercise, you might want to prime your paper first. If you do this drawing with dry abrasion tools, the priming will allow you to erase more easily. If you use paint, the priming will make the paper tougher so it stands up better to rubbing and scraping.

2 If you're going to work with unprimed paper, skip to step 5 now!

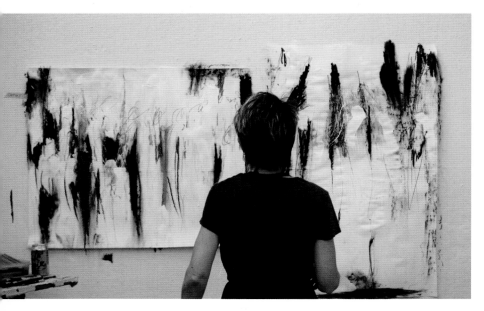

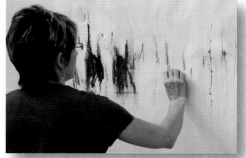

Catherine Hayden-Cooper develops a set of drawings that shows several stages of this exercise.

3 To prime paper, you'll need either acrylic gesso or acrylic medium (acrylic polymer emulsion) of any kind. In a pinch, you can prime paper with plain old acrylic, artist grade, or house paint.

4 Simply cover one side with the gesso/medium/paint. If the paper is light or even medium in weight, the priming will cause the paper to buckle. For the most part, it will flatten back out when the primer dries. Priming both sides will make it flatten out even more.

5 If you're working with dry abrasion tools, make sure you have an eraser handy—a kneaded eraser works especially well.

6 Now you're ready to start drawing.

7 Begin by sketching out a horizontal rhythmic movement of a vertical line/bar motif. Do this quickly, with very little, if any, planning or thinking. Just get it started. Your initial lines aren't crucial or precious. Most, if not all, will be erased, covered, or veiled in some manner.

8 Pause for just a moment to take in the rhythm you've generated. Feel it. Then, as soon as you have an urge to alter it, at all, in any way, do it.

9 Step back and repeat the same process over and over. Sometimes you'll add things, putting more in. At other times, you'll be erasing or covering marks. Keep this processing alive until you arrive at a rhythm you find compelling or satisfying—your rhythmic drawing is finished!

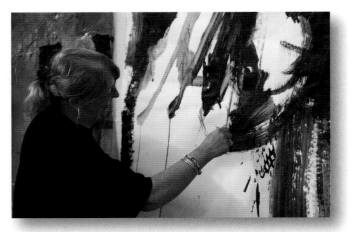

Louise Lachance Legault explores horizontal rhythm (above); her finished drawing is at left.

BUILD 2 ▪ RHYTHMIC DRAWING
WITH ONE MOTIF

Okay, it's up to you. You choose the materials and methods. The only two requirements here are:

• Organize your drawing around rhythm. Make use of rhythm itself as the subject of the drawing.

• Work with one motif only. It may be any shape, mark, or linear symbol.

Martha Mahoney does this beautifully in her workshop drawing (figure 18). She's embraced an oval motif that appears in a rich variety of forms. Some are joined together in clusters, either by overlapping or by lines that run from one to another. The intervals vary quite nicely as well. Note how the watery drips from the watercolor crayon lines serendipitously create a secondary rhythm of vertical lines that move horizontally across the drawing space. The overall movement is curvilinear and looping, the line quality light and fresh. As a result, the finished drawing feels lyrical and graceful.

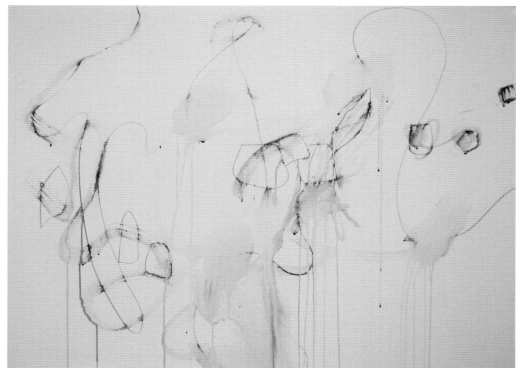

figure 18

Martha Mahoney
Rhythmic Drawing:
One Motif, 2008
Watercolor crayon
on paper
30 x 42 inches (76.2 x 106.7 cm)
Courtesy of the Artist

BUILD 3 ■ RHYTHMIC DRAWING
WITH SEVERAL MOTIFS

For your last challenge of this chapter, you're further liberated from restrictions. Here, you're encouraged to improvise and to keep things in flux. Here's your challenge:

1 Pick several motifs with which to work.

2 Arrange these motifs into a number of rhythmic sequences that move in a number of ways.

3 Put things in and take them out—keep the process alive.

4 Continue until your drawing and its variety of motifs and movements fit together to your liking— and you've got it!

A word of advice: As we saw in Chapter 6 (page 122), when you're working with more than one motif, it's usually most effective if you make one of them the primary motif and the others secondary and subordinate (just as in life, it's usually helpful and comforting to have priorities and hierarchies). This will hold true here. When you are working with more than one rhythmic movement, it often helps to combine two or more of them to form a larger, overall rhythm.

Judy Schwarz develops her drawing of several motifs; her finished piece appears on page 146.

Judy Schwarz explores rhythm in her workshop drawing (page 145). In the finished drawing (figure 19), you can see how the "C" or comma-shaped motif prevails, acting as a unifier. It's used as the beat element in several rhythms through the middle and top of the drawing. Then, a counter-rhythm—consisting of a repetition of a spiky/pointy shape motif—moves across the bottom and up the right side of the space. In doing this, Schwarz creates a dialogue between the curvilinear and the angular, the rounded and the pointy, to create a strong, dynamic piece of art.

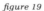

figure 19

Judy Schwarz
Rhythm: Several Movements, Several Motifs, 2007
Mixed drawing media on paper
34 x 44 inches (86.4 x 111.8 cm)
Courtesy of the Artist

Don Silver explores rhythm at right. In his workshop drawing, one rhythmic sequence leads to another and another to create one large, circular movement that engages the entire space (below). Start with the series of vertical bars on the bottom right. They lead your eye to the left and into the drawing space. The last bar tilts on a diagonal; the bottom left end of it points us to the start of a second rhythm consisting of a horseshoe-shaped motif that varies from light to dark. This leads the eye up to and across one more scribbly bar, and then to a third rhythm of S-shaped lines that curves, from left to right, across the top left corner of the drawing. That leads us to two more parallel linear rhythmic patterns, the top one of which curves right back down to our original starting place, the vertical bars in the bottom right—superb!

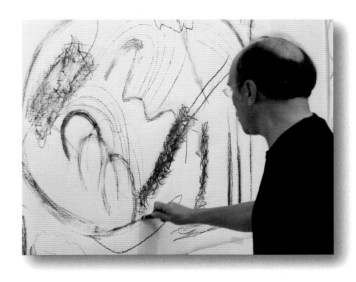

Don Silver works on an exercise exploring how one rhythmic sequence leads to another. His finished piece is at left.

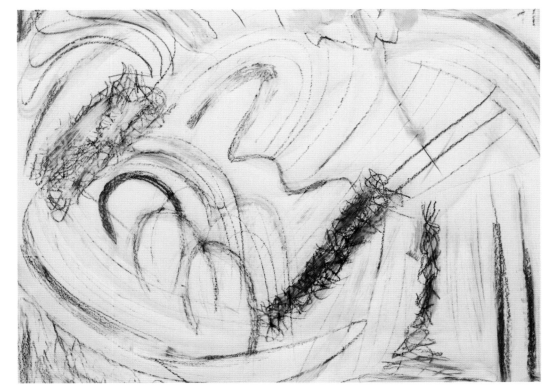

Bill Traylor was born into slavery on a plantation, near Benton, Alabama. After the Civil War, Bill continued to live on the plantation, but in 1939, he left because everyone of importance to him had moved on. Bill's wife had died and his nine grown children had moved away from the area, so he relocated to Montgomery.

He could not read or write, having never had an opportunity for a formal education. But at the age of 83, he took up drawing, and over a period of only a few years produced more than 1,800 drawings. Sitting on a wooden box creating his work in downtown Montgomery, Bill gained attention and was discovered—during the height of segregation in the deep South—by a white artist named Charles Shannon, who arranged for Bill's work to be shown at the New South Art Center in Montgomery in 1940.

Bill's drawings are sophisticated, even if naïve by conventional standards. His innate sense of design is strikingly illustrated in the untitled piece now in the collection of the High Museum in Atlanta, Georgia (figure 21). The piece's rhythmic rocking is created through a masterly use of diagonal lines and an overall triangular structure that cradles the seesawing movement. An unusual spatial sense, coupled with a unique vocabulary of shapes and symbols, underscores the authenticity of his direct approach (figure 20).

More than 60 years after his death, Bill Traylor is one of America's most recognized folk artists.

—Katherine Aimone

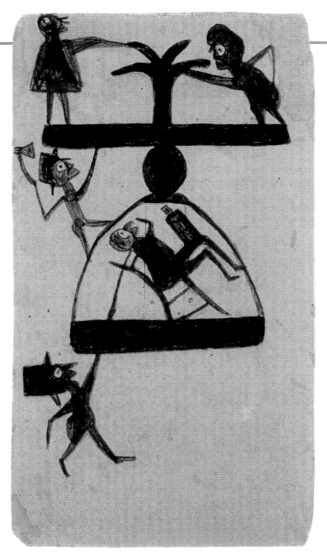

figure 20

Bill Traylor
Walnettos Figures Construction, 1939
Poster paint on cardboard

Courtesy of the Anthony Petullo Collection of Self-Taught and Outsider Art

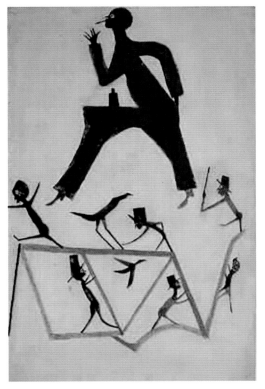

figure 21

Bill Traylor
Untitled, ca. 1939–1942
Tempera crayon and pencil on cardboard

High Museum of Art, Atlanta; Purchase with funds from Mrs. Lindsey Hopkins, Jr., Edith G. and Philip A. Rhodes, and the Members Guild, 1982.114

CHAPTER EIGHT

EQUILIBRIUM

All of nature revolves around—and is dependent on—the notion of equilibrium or balance. We rely on our sense of equilibrium all the time; it plays a role in virtually everything we experience (though we're not often aware of it). So, when drawings embody and address a sense of equilibrium, they speak poetically about nature, about life, about us.

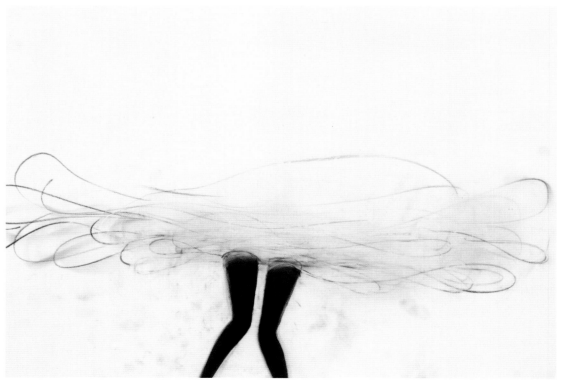

figure 1

Cathy Daley
Untitled, 2004–2005
Oil pastel on vellum
14 x 19½ inches
(35.6 x 48.5 cm)
Courtesy of the James T. Dyke
Collection

I STRIVE TO EXPRESS THE SPIRITUAL NATURE OF THE UNIVERSE.
PAINTING IS FOR ME A DYNAMIC BALANCE AND WHOLENESS OF LIFE;
IT IS MYSTERIOUS AND TRANSCENDENT, YET SOLID AND REAL.

Richard Pousette-Dart

In the broadest sense of the word, *equilibrium* in nature (and in drawing) can be understood as the unity that occurs when opposites or polarities come together. When this kind of synthesis happens, we say that things are "in balance." The traditional Chinese notion of yin and yang (figure 2) is a perfectly distilled expression of this idea. It puts forward the paradox that while polarities are expressions in *contrast and opposition*, they're also *indispensably joined together*. Each cannot exist—and is not fully complete—without the other.

Examples of polarities in nature are night and day, hot and cold, wet and dry. In terms of the human psyche and emotion, polarities include things such as pain and pleasure, hope and fear, love and hate.

figure 2

Naturally, drawings can be understood in these terms as well. Parallel and equivalent pairings in drawings include things such as light and dark, pure and dull, active and passive, congested and airy, busy and quiet, rough and smooth, top and bottom, inside and outside, front and back, left and right, and so on.

CREATING STABILITY & INSTABILITY

Put another way, equilibrium can also be understood as a series of weights and balances that interact, work together, or cancel one another out to establish a feeling of *stability*. For most of us, most of the time, this sense of stability is a desirable and necessary thing. At the same time, an element of *instability* or imbalance can lend life—and drawing—a feeling of excitement and tension. Indeed this polarity— stability and instability—will be our main focus throughout this chapter.

A balanced drawing feels settled, in place, on an even keel. It doesn't feel top- or bottom-heavy or lean too much to one side or the other. When you look at an empty sheet of drawing paper, you're looking at perfection. The space is perfectly stable, quiet, and passive. As soon as you make a mark on it, you run the risk of disturbing that equilibrium. In fact, anything you do that is not perfectly sym-metrical (more on symmetry shortly) will destabilize the system, throwing the drawing's balance out of whack. Then, for the rest of the drawing process, you end up juggling things in a variety of ways over time in an attempt to re-establish that equilibrium or near-equilibrium.

HIGH-WIRE ACT

This process of balancing in drawing is akin to walking on a high wire, balance beam, or curb without falling off. You start walking forward and, before long, you begin to lean to one side or another and your sense of equilibrium is threatened. Instantly, your body responds. For example, if your torso begins to lean or fall to the left, your right arm rises up into the air and your head leans to the right; those combined responses re-establish equilibrium. And there is no thinking involved; there is not enough time. The adjustments you make are intuitive: Your responses come from an inner intelligence in the body.

Another helpful analogy is to consider a room full of scales—you know, the old-fashioned kind, with two shelves, one on each side of a central fulcrum. Imagine that the right side of one scale is connected by a chain to the left side of a neighboring scale. That scale in turn is chain-linked to another and so on all the way around the room. Some of the chain links are longer than others. Now imagine putting a weight on one side of one

of the scales. What would happen? The entire room would be set into motion; one scale would tilt one way, another tilting the other way in response. Those linked by shorter chains would shift more pronouncedly. The system of scales would be out of balance. Then, assuming that full equilibrium is your goal, you would need to add small weights here, heavier weights there, remove others, and so on, until balance is restored.

As we've seen and experienced in previous chapters, the drawing process can work the same way. You start by introducing visual elements into the drawing. Each of these animate elements exerts its unique energy into the drawing. These energetic elements then form relationships with one another and with the drawing space they share. As the drawing develops, you emphasize some elements and de-emphasize others. You move some around in response, removing others altogether. You introduce new elements, and so on. In the process, relative equilibrium is often established, lost, found, re-established, or partially re-established until a final resolution comes about.

ACHIEVING EQUILIBRIUM THROUGH SYMMETRY & ASYMMETRY

Drawings can achieve equilibrium in two ways: through symmetry and asymmetry. Let's examine both.

SYMMETRICAL DRAWINGS

Symmetrical drawings achieve balance through mirror imaging. Most often, they feature a center line (or central axis) and identical elements in the same placements to each side. This is referred to as *bilateral symmetry*.

Human beings are intimately familiar with bilateral symmetry—we're built like that ourselves. We have a central axis and mirrored elements on each side (arms, legs, etc.).

Some drawings feature a mirroring of elements according to several axes simultaneously. There are even some that feature mirroring from all sides—top to bottom, side to side, corner to corner. This is referred to as *radial symmetry*. You can see a good example of this in Renie Breskin Adams's *Acrobatic Apricats* (figure 3).

BILATERAL SYMMETRY

But bilateral symmetry is the kind you'll likely see and work with the most, so we'll focus our energies on this kind of arrangement. Creating balance in your drawings using this kind of symmetry is a snap. All you need to do is draw a central axis, center elements on it, add something to one side, and place an identical thing in an analogous placement on the other. Continue mirroring until you feel like stopping, and you've created perfect symmetry, perfect equilibrium!

Perfect symmetry can be highly effective for some drawing purposes. For example, drawings that are designed to serve as objects of meditation, or as pure decoration, can benefit from the resulting lack of tension and surprise.

figure 3

Renie Breskin Adams
Acrobatic Apricats, 2007
Ink marker and electronic pen
5 x 5 inches (12.7 x 12.7 cm)
Collection of the Artist

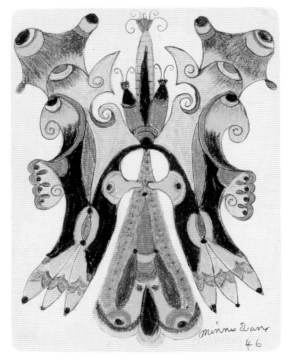

figure 4

Minnie Evans
Untitled (Butterfly Form), 1946
Pencil and crayon on paper
Courtesy of the Anthony Petullo Collection of Self-Taught and Outsider Art

TWEAKED SYMMETRY

Often, however, this kind of symmetry is regarded as being *too perfect*—so balanced that there is a shortage of visual tension, variety, and mystery. For many drawing purposes, perfect symmetry can seem too predicable, too easy to understand. So, most drawings intentionally employ some form of *imperfect* or *modified symmetry* instead. I call this "tweaked symmetry"—symmetry replete with subtle and not-so-subtle "flaws" and eccentricities. As we'll see here, there is a wide continuum that runs from perfect symmetry to subtly tweaked symmetry to substantially tweaked symmetry, where the mirror imaging is present *just enough* to serve as a unifying principle.

Minnie Evans's *Untitled (Butterfly Form),* figure 4, is an example of nearly perfect symmetry, with *very* subtle variations that give the drawing just enough variety and tension to keep our interest. Observe the drawing and sense these dynamics. The tension and handling is one-of-a-kind and personalized. You're following me, yes? All right. Now let's take your "seeing" skills up a notch.

Martin Ramirez tweaks his symmetry even more in *Courtyard (#208)* (figure 5). Here the train-like form at the top on the right isn't mirrored at all on the other side. Instead, Ramirez allows it to act as a pull to the right, and then he responds in unexpected ways. Notice the little figure on the central axis near the bottom? It looks and gestures to the left and a bit up, leading us to the lower of two animal forms on the left, which is a bit more sharply diagonal than its counterpart on the right side. This pull to the figure/animal pairing draws us to the bottom and left, offsetting the train's pull to the top and right. When you can observe these kinds of dynamics in a drawing, it develops your visual acuity and, as a result, enriches your appreciation of everything you see.

Cathy Daley's tweaked symmetry is more subtle, but just as substantial in her untitled drawing (figure 1 on page 150). Notice that the dancer's legs (the central axis) are moved off center, to the left. At the same time, the looping lines that represent a hoop skirt are higher and more hard-edged on the left than on the right. So what balances these left-heavy forces? Two things: First, the dancer's legs, from the knees down, form a triangular shape that leans and points on a diagonal, up and to the right; second, the very light contour line that forms the highest point of the skirt is to the right of center.

ASYMMETRICAL DRAWINGS

In contrast to symmetrical drawings, *asymmetrical drawings* are inherently full of tension and mystery. Thay are achieved by using differing visual forces in differing placements that relate to one another in such a way that equilibrium results. There is no mirroring around a central axis. Rather than finding ways to make things more interesting (as was often the case with symmetry), the challenge in asymmetrical drawings is to find equilibrium at all, and then in ways that are unique and inexplicable. The balancing can occur from side to side. Or it can be more amorphous than that, with no apparent structure at all.

As a transition from symmetry to asymmetry, Laurie Peters' *Sketchbook Page* (figure 6, page 156) furnishes a great example. Notice that there is still a central axis here. But instead of side-to-side mirroring, the arrangement features very different elements in non-mirroring placements that manage to achieve equilibrium anyway! The sums of the weights and placements on each side are equivalent. In some ways, the vessel shape, lower left, with looping lines at its top, is the strongest single force in the drawing. Not so obvious is the weight of the large blue looping movement on the right that implies a big open oval; it roughly offsets the left-hand vessel. And the rhythmic series of black wavy vertical lines on the left roughly equates in force to the combination of the black skeletal form, yellow vertical, and thin line with a single loop to the right.

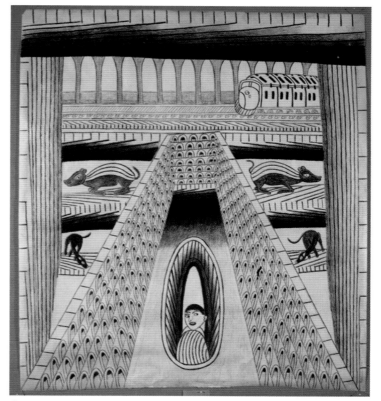

figure 5

Martin Ramirez
Courtyard (#208), 1954
Mixed media on paper
Courtesy of the Anthony Petullo Collection of Self-Taught and Outsider Art

figure 6

Laurie Peters
Sketchbook Page, 2002
Mixed media
8½ x 11 inches (21.6 x 27.9 cm)
Collection of the Artist

Most asymmetrical drawings, however, have no central axis. Instead, equilibrium is achieved in ways that are impossible to fully comprehend or explain. This kind of balance is simply felt—an intuitively satisfying state of affairs. Look at Morris Graves's *Animal* (figure 7), for example. Although nearly impossible to describe in words, the equilibrium in the drawing goes something like this: The largest shape in the drawing—the modified oval of the body—is just to the right of center, as are the legs, two of them dark, underneath. These forces combine to bestow significant weight to this right side of the space. This bottom-right push is countered by the pull of the dark and richly activated head, up and left.

Similar dynamics are at work in Judy Gilmer's *"Iron" Relic of my past* (figure 8), where the major vertical weight of the iron form that thrusts upward on the right is offset by the snaking wire leading to the plug on the lower left. Similarly, Martica Griffin's *Tofino 1* (figure 9) features a cluster of heavy forms on the upper right offset by a cup on the lower left.

Now let's look in depth at several drawings that address the issue of equilibrium in intriguingly successful ways.

figure 7

Morris Graves
Animal, 1954
Sumi ink on paper

18 x 24 inches (45.7 x 61 cm)

Arkansas Arts Center Foundation Collection: Purchase,
Fred W. Allsopp Memorial Acquisition Fund. 1984.018.002
© Robert and Desireé Yarber of the Morris Graves
Foundation

figure 8

Judy Gilmer
"Iron" Relic of my past, 2006
Black marker on vellum paper

16 x 12 inches (40.6 x 30.5 cm)

Collection of the Artist
Photographed by Judy Gilmer

figure 9

Martica Griffin
Tofino 1
Pastel on paper

16 x 24 inches (40.6 x 61 cm)

Courtesy of the Artist

Bob Grayson's untitled colored pencil drawing (figure 10) is a seemingly simple and straightforward example of symmetrical equilibrium. After all, there's a blue bowl in the center from left to right, situated on a central axis running vertically through a pair of blue tablecloth stripes just below. Two sets of stripes on the same cloth are mirrored on each side. Four pegs in the wall behind are paired two to each side as well … and that's that! The drawing is balanced as a result, eliciting feelings of tranquility and serenity.

In spite of all this stability, however, the drawing has just a bit of an "edge" to it, and a closer look reveals why. Grayson has "tweaked" the symmetry in a number of ways, introducing some "imperfections" that are actually quite purposeful, ones that lead the eye around the drawing in intriguing and unexpected ways.

First, notice that the central axis, and the bowl on it, are positioned just a touch to the left of center. Therefore, things begin to lean a tiny bit to that side. Next, notice that the lemon at the top left of the cluster in the bowl is an elongated oval that serves as a pointer, directing us to the upper left corner of the drawing. There you encounter the first in a series of posts positioned on the wall behind that form a rhythmic sequence from left to right. Look carefully and you'll see that this movement rises (tilts upward) ever so slightly as it moves from the first post on the left to the last post on the right. This movement takes us from the upper left corner across to the upper right corner where, lo and behold, the shadow cast by the last post points back down. This leads the eye to the point where the tabletop intersects with the right edge of the space. This back edge of the table directs us to the left where we meet up once again with the blue bowl—right where we started. In a very subtle way, the artist moves our eyes around the space in this beautiful, symmetrical arrangement.

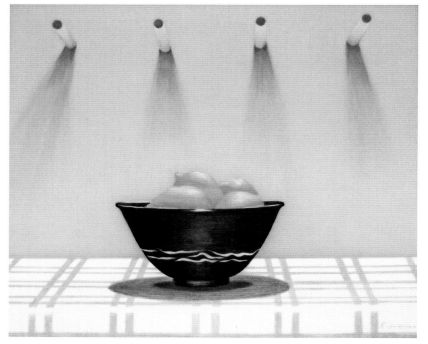

figure 10

Bob Grayson
Untitled
Colored pencil on paper
Courtesy of the Artist

Whereas Grayson's drawing was stable and tranquil, featuring some ever-so-slight tweaking of the symmetrical structure to induce nuanced tensions, Magdalena Abakanowicz's powerful drawing (figure 11) offers us a startling contrast. *Inside of Devious Tree I* is voluptuous and dynamic, full of motion, and completely in flux. It's nearly as lively as a symmetrical drawing can be. Thoroughly tweaked, its underlying symmetry nonetheless holds things together and furnishes a satisfying sense of equilibrium.

Abakanowicz's "tree" consists of a pair of vertical bars, situated roughly in the center of the space, mirroring an opening or fissure in the middle. This opening serves as the drawing's central axis. From there, a series of assertive linear movements, and the primary shapes they create, loosely mirror one another from side to side. Roughly in the middle from top to bottom is a large, curvilinear, organic shape that is split in two by the fissure; the two halves do the mirroring. There are also pairings of bulbous shapes from left to right at the bottom and at the top as well, superbly extending the feeling of mirroring throughout the design.

Symmetry aside, Abakanowicz's drawing feels *alive* because of the sense of flux she creates by veiling, erasing, and overlapping the charcoal lines. Linear movements and resulting shapes feel as if they are emerging and dissipating, coming in and out of being. As a result of all this processing, you're able to sense the hand of the artist—in this case, a strong and adventurous one. The end product is rich and compelling.

figure 11

Magdalena Abakanowicz
Inside of Devious Tree I, 1992
Charcoal on paper
39½ x 28¾ inches (100.3 x 73 cm)
Courtesy of the James T. Dyke Collection
© Magdalena Abakanowicz, courtesy, Malborough Gallery, New York

LOOK AT THIS SUSAN ROTHENBERG

Susan Rothenberg uses weighted line, combined with scale and density of form, to create an exquisite sense of equilibrium in *Axes* (figure 12), a textbook illustration of asymmetry at work. Rothenberg's drawing elicits feelings of elegance and grace through the delicate and sensitive nature of the lines she creates. In fact, subtle and nuanced variations in linear weight form the very nature of the weights and balances of the drawing.

Once again, asymmetry is impossible to *fully* explain or comprehend. Instead, it's a state of being that is felt or intuited. Analysis can at best give clues regarding how various visual forces work together to achieve this kind of equilibrium.

In the case of *Axes*, asymmetrical balance involves a dialogue between the left and right sides of the drawing—there is even a line to the left of center to signify the separation. The right side seemingly features most of the action. It contains the vast majority of the large horse form and three of its four legs. The elements on the right side are also exclusively diagonals; they're much more dynamic than the elements on the left that contain some horizontal and vertical movements. The right side is also much denser and more congested, resulting in a feeling of increased compression. So, with all these factors making the drawing weightier on the right, what keeps the drawing from feeling lopsided? That's right: The heavyweight, thick line that forms the left-side contour of the horse's head does the trick. Not only is this the thickest line in the entire drawing, it's also placed in the upper left-hand corner of the space, the place where the eye naturally goes to first. This makes the heavy line feel even more prominent and full of weight. It exerts plenty of pressure to lure us up and left, offsetting all that weight and energy on the right.

Okay, then. Now that you understand the issue of equilibrium and its applications and meaning in drawing, let's try your hand at it!

figure 12

Susan Rothenberg
Axes, 1976
Synthetic polymer paint, gesso, charcoal, and pencil on canvas
64⅝ x 104⅞ inches
(164.2 x 266.4 cm)

Digital Image © The Museum of Modern Art / Licensed by SCALA / Art Resource, NY © 2008 Susan Rothenberg / Artists Rights Society (ARS), New York

WORKSHOP

PLAY 1 ▪ BALANCING FROM SIDE TO SIDE

This challenge—and the variation that follows—calls on you to be a sensitive responder, to intuitively *feel* states of equilibrium and non-equilibrium in your drawing. You'll be balancing one element (or series of elements) on the left side of the space with another element (or series of elements) on the right. This process is seemingly so simple, yet it requires your full attention and awareness (in your body as well as mind). Remember, *thinking* alone will not lead you to a resolution.

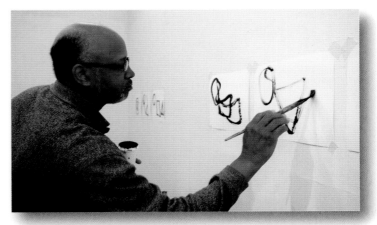

George Rice explores this challenge.

1 Choose a sheet of drawing paper—any size and quality will do—and a pencil, plus other drawing materials of your choice

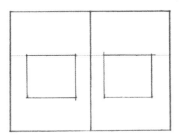

figure 13

(optional). A pencil or charcoal pencil along with an eraser or white and black paint will suffice. Next, very lightly, in pencil (so light you can barely see it), mark out the structure as shown in figure 13.

As you can see, this beginning structure is perfectly symmetrical: one rectangle to the left of center, another to the right. Each is exactly the same size and in exactly the same placement.

2 Now comes your part: Begin by putting one fairly large shape in the rectangle on the left—any shape you feel like, in any placement and orientation within the box that you like. Next, in response, put one or two small shapes in the rectangle on the right.

3 At this point, pause for a moment and sense (rather than analyze) the drawing's equilibrium. Does there seem to be a satisfying feeling of balance in the drawing? If so, stop here and move on to the next step in the challenge. Or, as will more likely be the case, does the equilibrium seem a bit off kilter? Does it lean too much to one side or the other? Does it seem top-heavy or side-heavy? Do you sense that the balance is not quite right in some intangible way? If so, then it's time to make a change or two. The possibilities are many.

4 To either side, you can add a shape, thicken a contour line, erase part of a contour line, fill a shape with tone, texturize an area, and so on. Remember, at any time, you can subtract as well as add by using an eraser or by covering things with charcoal or paint. Keep the process going until you arrive at a point where the equilibrium in the drawing is engaging and satisfying to you. Then, notice the corresponding inner equilibrium you feel as a result!

PLAY 1 ■ BALANCING FROM SIDE TO SIDE

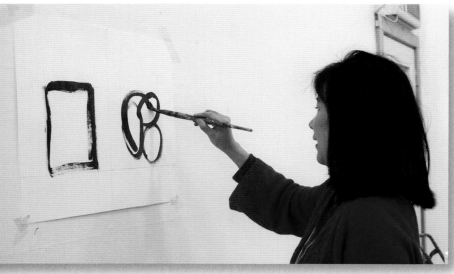

Annie Miller works on achieving balance from side to side.

VARIATION

1 Begin with the same or similar drawing surface and supplies you worked with on page 161. Now you'll do a very interesting variation of the previous challenge.

2 Start with the same structure as last time: two equal-sized rectangles, one on the left side and one on the right. Place the one on the left side in exactly the same position as it was last time. But this time, place the rectangle on the right side in a different position, any place you'd like. Two possibilities are shown in figures 14 and 15.

3 In the rectangle on the left side, place the same large element in the same placement as you did last time.

4 Now, in the rectangle on the right, respond by again placing a couple of smaller elements. Because the placement of your rectangular cluster to the right is different than last time, you'll have to respond in radically different ways in order to balance the drawing.

5 Again, step back, pause, and feel the weights and balances and implied directional movements. If needed, continue responding and keep the drawing going until you once again achieve a satisfying sense of equilibrium.

6 If you'd like, try yet another or several more variations of this exercise by starting with different given structures.

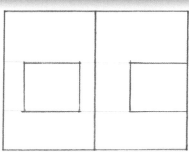

figure 14

figure 15

BUILD 1 ■ PAIR OF RELATED DRAWINGS

In this chapter we've seen how a variety of symmetrical and asymmetrical drawings work, and how satisfying the personal experience of equilibrium can be. Now, let's create a pair of drawings that put this principle to work. The drawings will be related; after you've finished, looking at the pairing will be quite illuminating.

SYMMETRICAL DRAWING

1 Choose two identical drawing surfaces (have both ready and available to work on). Use the same materials for both drawings: a pencil and one more additional abrasion tool are required; an eraser and/or white paint is recommended.

2 First you're going to create a composition with near-perfect symmetry. Then you'll tweak the symmetry to create a drawing that is both unified and full of interest and tension. Start by drawing a vertical line straight up and down in the very center of the space, dividing the drawing in half (see figure 16). This will furnish your symmetrical drawing's central axis, a sense of which will remain throughout and be present in the finished drawing.

3 Next, place a number of visual elements right on the central axis, centered on the axis. Make sure that one of these is fairly large in scale (between one-quarter and one-third the width of your drawing surface). An example of this can be seen in figure 17.

4 Now, introduce one visual element to one side of the axis, and then mirror it by placing an identical counterpart in an identical placement on the right side.

5 Add a few more elements on one side and mirror them with as much accuracy as possible on the other (figure 18).

6 Pause and take a look. You should now have a perfectly balanced drawing; its sense of equilibrium should be thorough and complete.

Put this drawing aside momentarily (but still within your view) while we begin to map out an asymmetrical variation.

figure 16

figure 17

figure 18

BUILD 1 ■ PAIR OF RELATED DRAWINGS

ASYMMETRICAL DRAWING

1 This time, start by drawing a vertical line straight up and down that is way off to one side of the space, dividing the drawing into two sections, one quite wide and the other relatively narrow (figure 19). You'll now have an asymmetrical underpinning.

2 Next, take the largest element in your first drawing (figure 17) and replicate it somewhere in the large section of this drawing.

3 Take some of the elements that lie right on the central axis in the first drawing and replicate them as best you can on the off-center axis in your new drawing.

At this point you'll have two drawing structures mapped out for you, something like the two examples you see in figures 18 and 20.

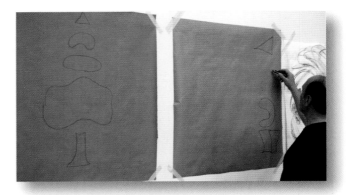

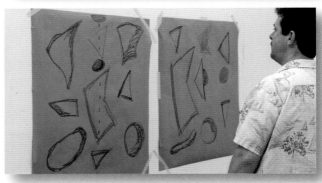

Top to bottom: Don Silver and Paul Adams develop their related pairings of asymmetrical drawings.

figure 19

figure 20

BACK TO SYMMETRICAL DRAWING

Okay, now let's return to the first drawing you did and explore how we might modify it to make it richer and more intriguing. This is the fun part: Enjoy the perfect symmetry you created, and then intentionally throw this perfection out of whack just a bit by altering one of the mirrored elements. Make it bigger or smaller, darker or lighter; add tone or texture to it; make it fragmentary by erasing or covering part of it—any alteration will do.

1 Next, respond by altering something on the other side of the drawing; in other words, make an adjustment to compensate. It won't take you long to get the hang of it. Make a bunch of alterations; change several elements.

2 Then take in the drawing as a whole and make appropriate adjustments in response. Keep this process going for as long as you like. You'll know when to stop when the drawing is richly satisfying and unified according to modified symmetry. Kathy Casey and Eli Corbin resolved their compositions as seen in figures 21 and 22.

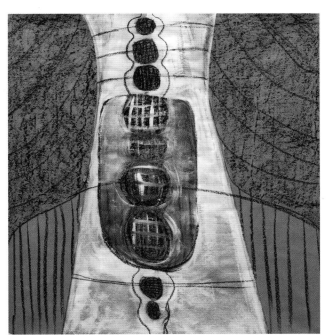

figure 21

Kathy Casey
Modified Symmetry, 2008
Mixed drawing media on brown craft paper
42 x 36 inches (106.7 x 91.4 cm)
Courtesy of the Artist

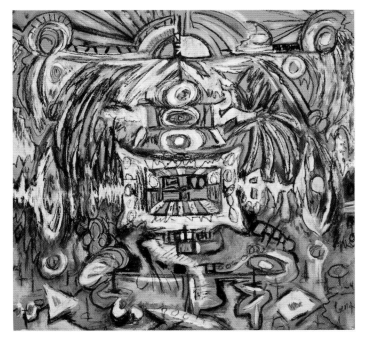

figure 22

Eli Corbin
Modified Symmetry, 2008
Mixed drawing media on brown craft paper
42 x 42 inches (106.7 x 106.7 cm)
Courtesy of the Artist

figure 23

Kathy Casey
*Asymmetrical
Drawing*, 2008

Mixed drawing media
on brown craft paper

Figure 27: 42 x 36 inches
(106.7 x 91.4 cm); figure 28:
42 x 32 inches
(106.7 x 81.3 cm)

Courtesy of the Artist

figure 24

Eli Corbin
*Asymmetrical
Drawing*, 2008

Mixed drawing media
on brown craft paper

42 x 42 inches
(106.7 x 106.7 cm)

Courtesy of the Artist

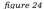

Eli Corbin develops her asymmetrical drawing.

BACK TO ASYMMETRICAL DRAWING

Now you're ready to return to the asymmetrical piece
in the pairing. By placing a few elements as you did,
according to my prescription, this drawing is probably
less than fully resolved. It's likely somewhat out of
balance and may be less than satisfying. So let's set the
drawing into motion.

1 First, add, subtract, and/or alter elements freely.
Make your first move based on your first urge; then
make another move in response, and so on.

2 Keep processing this drawing until the same
criteria we mentioned for the symmetrical drawing are
met: The drawing becomes both satisfying and unified
according to asymmetrical balance. Once again, see how
Kathy and Eli created their asymmetrical drawings
(figures 23 and 24).

Kathy Casey's finished symmetrical-asymmetrical pairing.

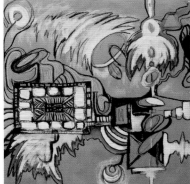

Eli Corbin's finished symmetrical-asymmetrical pairing.

When you're finished modifying both drawings, you will have a pair featuring common elements. The difference will be mainly in their arrangement. And because of the radical differences in the arrangement, you'll have radically different senses of equilibrium. Compare them; put your observations into words.

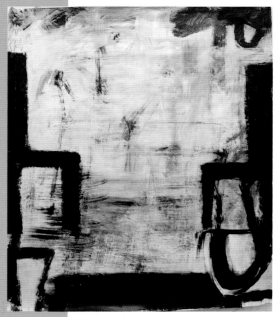

figure 23

Charlene Thomas
Two-chair Drawing, 2009
Charcoal and acrylic on paper
42 x 36 inches (107 x 91 cm)
Courtesy of the Artist

Charlene Thomas notes that she always did creative things, such as embroidery and flower arranging, while raising two daughters with her late husband, Jim Thomas. When her older daughter went off to college and majored in art, bringing home her work to share, Charlene's urge to draw strengthened. She began making small representational drawings of people and other subjects. Uncertain of what she was doing, however, Charlene felt she was floundering.

Then she took an art history course at a community college and it gave her much-needed fuel and direction. She saw works by master artists that she could relate to on a gut level, such as Matisse and Klee. Encouraged by a humanities professor at the college, Charlene decided to pursue a degree in art. In her early 50s, she enrolled at Stetson University in Deland, Florida.

"It was scary because I was older," she remembers. At one point she almost quit because the "I can't draw" voice began to dominate her thinking as she tried to do representational work. In fact, she was on her way to the registrar's office to withdraw from classes when one of the instructors stopped her. "Try this," he said. "Just cut loose and make a collage instead of drawing. Do a self-portrait. See what happens." Taking this simple step opened things up for her, and she continued her coursework, completing her degree in art in 1998.

Drawing is routine for her, and she carries a sketchbook with her wherever she goes. She also draws on old calendar pages, matchbooks, and index cards, constantly embracing the experimental and asking herself, "I wonder what would happen if I did this or that?" She is always "beginning" her work, always working from a fresh perspective.

Charlene delights in collaborating with other artists. To her, art is about sharing ordinary experience. She embraces the everyday as the stimulus for her work, never doubting that impulse, but responding to it in a loving way.

—*Katherine Aimone*

ONE DAY MY DAUGHTER LEANNE AND I WERE COMPARING ART, AND WE REALIZED WE WERE BOTH VERY SELF-CRITICAL. SO WE DECIDED TO TELL EACH OTHER WHAT WE LOVED ABOUT THE WORK, INSTEAD OF CRITICIZING IT.

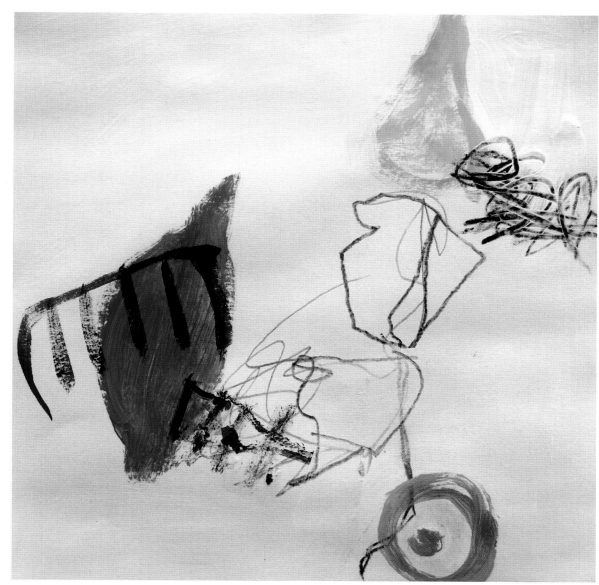

figure 24

Charlene Thomas
Serial Drawing, Set Two Image One, 2009
Mixed drawing media on paper
8 x 8 inches (20 x 20 cm)
Courtesy of the Artist

CHAPTER NINE

EMPHASIS

The previous chapter on equilibrium and this one on emphasis both deal with the arrangement of visual weights in drawing. Visual elements, no matter which ones you use or what they're like, have weight or presence. In the context of the entire drawing, visual elements are accorded varying degrees of emphasis according to their relative weight.

figure 1

Dyan Berk
Redleaf, 2008
Mylar, ink, colored gels
22 x 30 inches (55.9 x 76.2 cm)
Collection of the Artist

It's only through connection with intuitive or unconscious forces that we contact the fresh and new.

Terry Winters

VISUAL WEIGHT

Visual weight is the amount of pressure or assertion that an element exerts in the drawing. As an analogy, think of your skin as the drawing surface and imagine what different elements would feel like if placed on your skin, and you've got the idea.

Visual weight comes about, or is determined by, a number of factors, including the following.

CHARACTERISTICS OF THE VISUAL ELEMENT

Some visual weight is inherent in the characteristics of the visual element itself. For example, consider line: All else being equal, darker lines have more weight than light ones, thick lines more than thin. With regard to shape—choose an oval—all else being equal, a big oval exerts more pressure than a small one, a dark oval more than a lighter one, a hard-edged oval more than a soft-edged one, an intensely colored oval more than a dull gray one, one with complex contours more than one with simple contours, and so on. Texture? All things being equal, a passage of highly agitated texture exerts more pressure than a relatively smooth one, and a densely textured area more than a sparsely textured one.

RELATIONAL

A second determinant of an element's visual weight is *relational*. That is, the weight of an element is often determined or at least affected by *the company it keeps*. For example, a large, black oval will seem less weighty if it's surrounded by other large black ovals than it will if surrounded by small, light gray ovals. Think of a person's voice as an analogy: A screaming voice in a room full of screaming people would still be loud (or weighty) but not nearly as noticeable (or as seemingly powerful or assertive) as in a room full of whisperers.

Another relational way in which an element's weight or presence is enhanced is when other elements in the drawing point to it. We'll see this phenomenon at work later in the chapter.

ORIENTATION

In earlier chapters, we alluded to another factor that determines weight or pressure when we discussed the notion of *orientation*. We learned that any visual element is more dynamic (exerts more pressure or carries more weight) when it's placed on a diagonal, somewhat less when vertical, and even less when oriented as a horizontal.

THE DYNAMICS OF THE DRAWING SPACE

When you go to an art supply store or online to get surfaces to draw on, what do you usually find? Nearly always, you'll find surfaces that are flat and smooth; passive (empty); more often than not white or neutral in color; and rectangular, or occasionally square. These attributes are little more than commonly accepted conventions. After all, you might, and some people do, draw on surfaces that are three-dimensional or full of visual elements (Franz Kline was fond of drawing on telephone book pages), intensely colored, or irregular in shape (such as the works of Elizabeth Murray). Most of the time, though, drawing surfaces are passive rectangles. So it's a great idea and very helpful to understand the dynamics of the rectangle you work in. Some highlights follow.

PLACEMENT

Visual weight is determined and influenced by another factor, often overlooked: *Visual weight is always affected, and partially determined by, the element's placement in the drawing space*. Many artists have little awareness of this; others mistakenly minimize its importance.

To fully comprehend this—and to use that understanding to create more effective and expressive drawings—you need to understand the nature of the design space itself. From this new awareness, you'll learn how the placement of an element helps to determine its degree of prominence, or weight. So, before moving on to the rest of the material in this chapter, consider the following brief survey of the dynamics of the drawing space.

TOP BEFORE BOTTOM

Elements placed near the top of a drawing become more prominent simply by being there. All else being equal, we pay attention to them first. This is partially because of an imagined sense of gravity: Something near the top is more likely to feel as if it may spin into motion and fall. On the other hand, something placed at or near the bottom feels more grounded and supported, less likely to go in motion, and therefore less dynamic. As an analogy, think of the bottom edge of the drawing as akin to the ground plane in a landscape, the floor in an interior, the tabletop in a still life, and you've got the idea. To further understand this polarity between top and bottom, refer to figure 3.

Left Before Right

Everything being equal, when we look at a drawing, our eyes go to the left side before the right (figure 4). Naturally, then, visual elements gain in prominence and weight when placed on the left side of the space. Many attribute this phenomenon to the fact that, in western culture, we are trained to read from left to right. Others disagree, arguing that this tendency is universal. Regardless, this is how we experience things, so you'll want to keep this in mind when you draw.

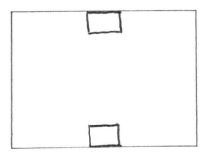

figure 3

Top Left Before Bottom Right

Combine the previous two principles and you arrive at this third one: The eye goes to the top left of the space before the bottom right. Specifically, all else being equal, we begin our experience of a drawing in the upper left portion of the space and conclude it in the bottom right (figure 5). Ironically, this bestows a special quality to the bottom right placement as well. Look at a batch of print advertisements and you'll see that a logo, slogan, contact information, or other important information is often placed there so that viewers leave the advertisement with that element or information as their last impression.

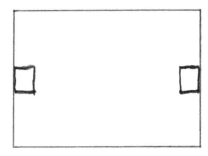

figure 4

These principles—and the ones that follow—hold true only when the two elements being placed in relation to one another are identical or similar in weight. That is, any of these principles can be countered or overturned by differences in the relative weights of the elements themselves. Hold on, you'll quickly understand this.

figure 5

figure 6

figure 7

figure 8

In figure 6, notice how your eye goes to the rectangle on the right before the one on the left—that's because of its relative diagonality. Then in figure 7, notice that the emphasis is back to the rectangle on the left because its highly textured surface outweighs its counterpart's diagonal nature. This kind of juggling back and forth is often an integral part of the drawing process.

THE CENTER

As you learned in the previous chapter on equilibrium, the center of a drawing space (figure 8) plays an indispensable role in symmetrical balance. In symmetrical drawings, a central axis runs right through the center. In *radial symmetry*, a visual element is placed dead center in the drawing space, and things work out beautifully. But in asymmetrical drawings (the kind of arrangement that most of us work with most of the time), the center, while certainly prominent, is most often a dead spot.

Accordingly, artists most often try to keep things out of this dead center location. Why? The eye and the body feel more comfortable when there is a visual hierarchy; they feel more comfortable when they can sense they're nearer to one thing and farther from another. Specifically, they like to feel closer to the top and farther from the bottom, or the other way around. Similarly, they like to feel nearer to the left and farther from the right, or vice versa. By comparison, dead center feels disorienting; or, put another way, it feels *non*-oriented!

JUST OFF CENTER

In contrast, placement of an element *just off center* is very comfortable (figure 9). It has all the benefits of being in the middle of things (prominence) with none of the drawbacks of being dead center. In traditional Western drawing, artists often situated their most important element or elements in these placements, as shown in figure 9:

● up and to the left of center

● up and to the right of center

● down and to the left of center

● down and to the right of center

In traditional portraits, for example, the subject's head would often be positioned up and to one side of center, with other important elements (such as an elbow, hand, or something held in a hand) down and to one or both sides of center. Interestingly, the areas outside the figure, often referred to as the background, were usually considered to be relatively unimportant.

ON THE EDGE

In response to these traditional figure-ground assumptions, modern artists considered the entire drawing space to be important. The distinction between *figure* and *ground* (or between the "important elements" on one hand and the "leftovers" on the other) was often de-emphasized and sometimes done away with altogether. As a result, the outside edges of the drawing space became new territory for emphasis. (Notice how modern drawings are more often "floated" in frames so that the edges show, as opposed to traditional matting and framing that covered the edges of the drawing.)

Modern artists discovered that the edge was not only new territory for placement, but dynamic new territory! They discovered that whenever a visual element is placed *on the edge* (figure 10), it immediately gains power, prominence, and weight. This happens because whenever you engage an edge, you're exploring the defining limits of the space, challenging its very parameters. Elements on the edge imply the possibility that the narrative extends beyond these limits.

figure 9

figure 10

Consequently, drawings that emphasize on-the-edge place-
ments often achieve a sense of monumentality, grandness
in scale. As an analogy, regarding our own lives, consider
the phrase "living on the edge." What sorts of things
does that phrase imply? That's right—venturing outside
one's comfort zone, thinking that the sky's the limit …
reaching for the stars … grabbing for the gusto, and so
on. Consider that, more often than not, you're acting in
that kind of spirit when you engage the edge in drawing.

figure 11

NEAR THE EDGE

Knowing what you now know about the top, bot-
tom, left, right, center, near center, and outside
edge, what do you think the dynamics of being far
from center but not on the edge might be? That's
right: the placements shown in figure 11 are rela-
tively weak. The one higher and to the right is stronger
that the lower ones. The shape not centered at the
bottom can be considered to be in "no-man's-land."

figure 12

THE CORNERS

Finally, rectangular drawing spaces have corners, and
corner placement comes with its own dynamics as well.
Elements placed in the corner are subject to similar
dynamics as elements placed in the center. In other
words, the eye and the body don't like to be stuck right
smack in the corner (figure 12). Why? Again, the answer
is because placement there is disorienting. The eye and
the body would much prefer to be nearer one edge of the
corner than the other (figure 13). In these placements,
the viewer can feel closer to and more connected with
one edge than the other. The resulting hierarchy of ori-
entation is comforting.

figure 13

Now that you're equipped with an understanding of how
the dynamics of the rectangle work, let's get on to our
discussion of how emphasis is used in drawing and what
kinds of meaning are derived from its use.

HIERARCHY OF EMPHASIS

Life is organized according to a series of hierarchies, emphases, and priorities. A healthy human body dispenses nutrients and antibodies according to a hierarchy and specificity of need. An emotionally healthy human engages in relationships and communities that best serve his or her psychological and social needs (neurotic and psychotic people often do the opposite). Plants reflexively position themselves, and orient their growth, in ways that give them access to light, warmth, and shelter to maximize their chances of survival.

Drawings, too, can be structured according to hierarchies. When you draw, you have the ability to move the eye around a space from one place to another to another, and so on. More specifically, you move the eye from weight to weight to weight—put another way, from point of emphasis to point of emphasis.

Most often, arranging a drawing this way means working with a *focal point*. This point, or area, is the most powerful element or placement in the drawing. It's the element or area that the eye is drawn to first. According to this structural approach, the artist then creates a hierarchy of emphasis points or placements—from the focal point to and through a series of prominent secondary points—and uses this hierarchy to move the eye around the drawing space. When you do these things in drawing, you're acting like a choreographer, leading animate entities around in space!

For those of you familiar with how traditional Western music is arranged, the focal point in drawing is analogous to a *tonic*—the most fundamental note in the scale or key in which the music is written. When you experi-

ence a melody as it moves through a piece of music written in the key of C, for example, whenever the melodic sequence arrives at the tonic note, C, the body feels comfortable, at home, at rest. The melodic movement then ventures off on a journey, only to periodically return to the primary note as a place of familiarity and stability.

In drawing, things work in similar ways. The most prominent element-placement in the drawing is the focal area—the place where the eye goes first. From

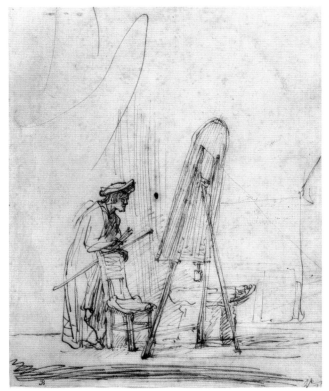

figure 14

Rembrandt Harmenszoon van Rijn
An Artist in his Studio, circa 1632–1633
Pen and brown ink
8¹/₁₆ x 6¹¹/₁₆ inches
(20.5 x 17 cm)
The J. Paul Getty Museum, Los Angeles, CA

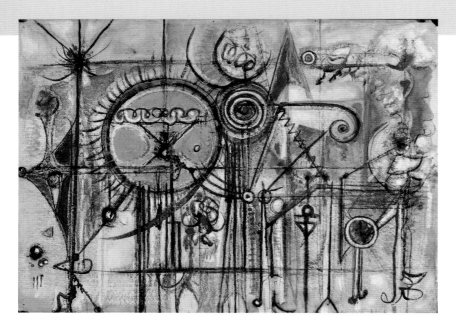

figure 15

Richard Pousette-Dart
Quartet #13,
1950
Mixed media on
paper
22½ x 30⅞ inches
(57.1 x 78.4 cm)
Arkansas Arts Center
Foundation Collection:
Purchase, Tabriz Fund.
1994.036
© 2008 Estate of Richard
Pousette-Dart / Artists
Rights Society (ARS),
New York

there, the viewer is directed to journey about the drawing from point to point to point, from weight to weight to weight. During this experience, anytime the viewer wishes or needs to pause or rest, the focal point will be the place to go. From there the viewer can venture out again to further experience the drawing.

How It's Done

Let's survey a number of ways in which this can work, taking our cues from some wonderful drawings.

Single Dense Cluster of Dark Lines

Rembrandt van Rijn was a virtuoso draftsman and a master at working with the principle of hierarchy of emphasis. In *An Artist in his Studio* (figure 14, page 177) Rembrandt uses a single dense cluster of dark lines to establish the drawing's primary focus—the head and front of the chest of the artist. This focal area is traditionally and comfortably placed, just below and left of center. From there, the artist's gaze and three directional pointers—the stick in the artist's hand and the two legs of his easel—lead the eye to the large canvas

shape, barely to the right of center. Then, a little curved element behind the easel to the lower right has some weight of its own; its curve then points us up to the little line at the right edge of the space, just below middle. A couple of loops near the top and left make sure we visit that region of the drawing, and some dense lines do the same for the very bottom of the space.

Color

Dyan Berk uses color—in this case, a vibrant, warm red—to establish primary emphasis in the complex, organic shape in *Redleaf* (figure 1 on page 170). There's no doubt this is the focal area. From here, the viewer has a number of secondary emphasis points to follow. The complex squiggly shape in the upper left corner is a powerful presence. From the red focal point, we can also easily move to the organic shape that adjoins it to the upper right. Extending from that shape is a long line moving downward that forms part of the contour of another complex wiggly shape, bottom center. To the right, some vertical lines lead us up to a cross-hatched oval, which points us right back to the red focal area. There we can pause before venturing out through the drawing once again, perhaps meandering through the rhythm of wavy bars just below.

Contrast in Scale and Color

Richard Pousette-Dart uses contrast in scale and color to establish a primary emphasis in *Quartet #13* (figure 15). In a drawing full of circles and circular movements, the most prominent one is again placed in a comfortable location just above and to the left of center. It's the biggest circle in the drawing, dwarfing the remaining members of the circle family. It gains even more weight from the warm and relatively pure color it contains. Its dark contour line emphasizes it even more. From here, the eye is free to visit an array of additional pressure points: the dark cluster of concentric circles that abuts it

to the right, the small dark blue circle with hard edges that floats in a relative void at the bottom right, the dark blue triangular shape with slightly rounded edges that engages the left edge near the middle, and so on.

CONTRASTING LINEAR WEIGHT

Contrasting linear weight is often used to establish hierarchy of emphasis as well. Oscar Bluemner explores possibilities in this regard in *Paterson* (figure 2 on page 172). In it, you can feel a cascading rhythm of pointy rooftops that moves from the upper left corner to the bottom right. As a counter, and to achieve equilibrium as well, Bluemner pulls us up and away from the rhythm to the heavy contour lines in the upper right-hand corner. Combined with the intensity of the blue color above them, these thick, dark lines exert a great deal of pressure, and serve as the focal point for the drawing.

As an aside, notice the little triangle at the bottom edge to the right of center? It serves as a little foundational wedge that supports all the weight above. Now, for fun, turn the book upside down and look at the drawing. What happens? Indeed, because the heavy contour lines and intense blue color are on the bottom of the space, they become less prominent and feel comfortably grounded. And what is the focal point now? That's right, that same little triangular wedge that now gains *oomph* by engaging the *top* edge!

CONTRAST IN DENSITY

Jordan Wolfson uses contrast in density, changes in linear weight, and the power of the outside edge to establish hierarchy of emphasis in *Interior with Chairs, 2.2.05* (figure 16). Notice how delicate and nuanced changes in density create increased feelings of pressure and weight. The focal area in the drawing is in a gently curving passage above and to the right of the middle. Here the surface is highly saturated with line and mark. Small clusters of density appear elsewhere and give the draw-

figure 16

Jordan Wolfson
Interior with Chairs, 2.2.05, 2005
Pencil on paper

25 x 22 inches
(63.5 x 55.9 cm)

Courtesy of the James T. Dyke Collection

ing a wonderful sense of vibration. The heavyweight contour line that defines one arm of a chair creates a powerful weight on the left, above middle. Then a horizontal sequence of vertical lines pulls us to the top edge and across to the right. The one farthest to the right combines with another line to form a square in the upper right corner. Finally, one leg of a folding chair engages the bottom edge near the center and encourages the eye to visit that area of the drawing too.

figure 17

Giacomo Balla
*Mercury Passing in
Front of the Sun,*
1914

Pencil and gouache
on paper

16½ x 11¾ inches
(41.9 x 29.8 cm)

Digital Image © The Museum
of Modern Art / Licensed by
SCALA / Art Resource, NY
© 2008 Artists Rights Society
(ARS), New York / SIAE, Rome

figure 18

Eve Aschheim
Guess Back It, 2006

Gesso, black gesso,
ink, and graphite on
Duralese mylar

14 x 11 inches
(35.6 x 27.9 cm)

Courtesy of Lori Bookstein
Gallery
Photograph by Farzad Owrang

There's little doubt where the focal area is in futurist artist Giacomo Balla's *Mercury Passing in Front of the Sun* (figure 17). That largest of the two perfectly geometrical circles just above and ever so slightly to the right of the middle fits the bill. It conveys a great deal of weight, pressure, and emphasis for a complex variety of reasons: It's the largest fully intact circle in the drawing; it overlaps a smaller circle, pushing itself forward; numerous long, straight lines point right to it (some cross right over it; others run right into and join with the circle's outside contour); its light interior is surrounded by contrasting darkness; and so on. From there, notice how the other prominent pressure points come in the form of triangular points and linear intersections, "X marks the spot" occurrences found throughout the drawing.

COMPETING PRESSURE POINTS

Occasionally, you can have two pressure points that vie for primacy, as is the case in Renie Breskin Adams's *Sketch for Animal Act* (figure 19). Here, the head (and particularly the large eyes) of the four-legged creature on the left grabs our attention—after all, it's comfortably placed and it's a recognizable face, to which we're naturally drawn. On the other hand, we have a splotch of intense red, below and right of center, that calls to us as well. We very easily travel back and forth between the two, and it doesn't really matter which one you start with. In either event, you'll get to the eyes soon enough, and they look back in the direction of the red so you'll get there next. From there, the body of the creature in the bottom right points us up to the rhythmic movement of the little blue circles. Next, dashing yellowish diagonals lead us up to a massive area of that color weight in the upper left. More dashing diagonals lead us down the left side to the rhythm of little aqua-colored shoes that direct us back to our starting area—very nice indeed!

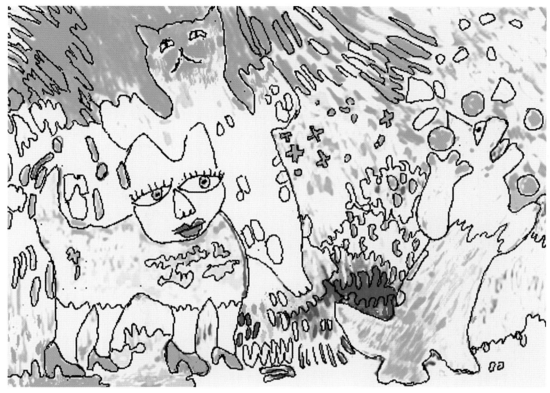

figure 19

Renie Breskin Adams
Sketch for Animal Act, 2007
Electronic pen
5⅛ x 7 inches (13 x 17.8 cm)
Collection of the Artist

THE OUTSIDE EDGE

Eve Aschheim explores adventurous and unorthodox possibilities regarding hierarchy of emphasis in *Guess Back It* (figure 18, previous page). Here, she employs both the inherent power of the edge and the directional power of line to create a most satisfying drawing. The first thing that's obvious about the arrangement is that all of its weighty elements are placed on the outside edge. These pull us to, and by implication even beyond, the drawing's parameters. This elicits feelings of openness and monumentality.

Aschheim also moves the eye around the space beautifully. The most prominent element is the intense blue line that engages the edge on the right, above middle.

The cluster of lines in the bottom right corner comes next, followed by the small angular cluster of lines on the lower left edge. We go from point to point to point in a fluid, triangular movement. Then, notice how almost every major linear movement in the drawing points to another: The long linear movement in the bottom right points right up to the faint diagonal on the upper left; this in turn points to a faint triangle in the upper right. Finally the blue line that is our focal point, though becoming very faint, is the only line to traverse the entire space, reinforcing its prominence.

Abstract expressionist Joan Mitchell's *Untitled (It's Hard to Get This)* pastel drawing (figure 20) is a classic example of hierarchy of emphasis at work. It shows of how this structural principle works, and it's a great example of her work, too.

A single, frenzied cluster of dynamic, gestural (even automatic, perhaps) line beautifully activates the space above center. This area is also the only place in the drawing where you'll find some thin, blue line, and we're drawn right to it! Overall, it's clearly the area of primary weight and focus.

This cluster merges with a large dark brown quasi-rectangle just above. This shape is prominent because it's both the largest and darkest element in the drawing. It's also the first of three second-tier weights that move around the space in triangular fashion to "frame" the focal area. The second of the three is the reddish-brown rectangle oriented vertically on the right edge, at and below the middle. Not quite as large as its dark brown counterpart above, this passage receives its weight both from its relatively large scale and from its color—still quite dark, and a richer color featuring a great deal of redness. The third element in the "frame" is the paler, transparent, mid-tone red/pink shape of the left edge. It's still darker than the background, noticeably red-pink.

Finally, bits of typewritten text are collaged or transferred onto the drawing surface. They serve to activate the open areas of the drawing surface while creating additional visual vibration. They also hint at a narrative underpinning to the drawing, one that seems stream-of-consciousness in nature.

figure 20

Joan Mitchell
Untitled (It's Hard to Get This),
circa 1975
Pastel on paper
14 x 9¼ inches (35.6 x 23.5 cm)
Courtesy of the James T. Dyke Collection
All Works by Joan Mitchell © The Estate
of Joan Mitchell

Richard Diebenkorn establishes a focal point in a somewhat unorthodox placement in *Untitled (The Ocean Park Series)*, figure 21. But there are alwayas exceptions to every rule. In this case, the drawing benefits from this unusual placement, acquiring an unusual and intriguing sense of tension.

As we noted earlier, just off center is a common and very comfortable placement, while the outside edge is a very powerful and prominent placement. On the other hand, far from center, but not on the edge, is usually a bit of an awkward placement; we described it as a no-man's-land.

Diebenkorn uses the principle of intersection to establish weight in the upper right, where two curvilinear movements meet. Curvilinear movements are rare in this drawing (the only other prominent one is in the upper left), so when two intersect and overlap, the feeling is powerful and energetic; the end product becomes the focal point of the drawing. A vertical line running down from this area again engages in intersection, meeting up with two other lines near the bottom and right of center. This forms a powerful, secondary pressure point. These three lines also join together with the outside edges to act as shape-makers, creating a tall column to the right, an angled block on the lower left, and a complex modified rectangle up and to the left. Next, taking a cue from the directional force of a diagonal line on the lower left, we are encouraged to travel up a vertical line to that other curvy movement in the upper left corner, and enjoy. From there, converging lines move out to the right and complete the cycle by leading us back to the primary area of focus.

By the way, in addition to this hierarchical structure, the drawing features two additional organizing principles worth noting. First, the surface exhibits a great deal of flux, of asserting and obliterating. This makes the drawing feel very much alive. Second, notice the network of horizontal and vertical lines, some prominently on top, others seemingly submerged. These form an underlying grid—another way in which drawings can be structured (see more on this in chapter 10, page 192). The multifaceted nature of the arrangement's structure makes this drawing feel strong and deeply compelling.

figure 21

Richard Diebenkorn
Untitled (The Ocean Park Series), 1972
Gouache on paper
27¾ x 18¼ inches
(70.5 x 46.3 cm)
Arkansas Arts Center Foundation
Collection: Purchase, Tabriz Fund
and Museum Purchase Plan of the
NEA. 1974.011.005
© The Estate of Richard
Diebenkorn

Take a close look at Mary Teichman's highly accomplished pencil drawing, *Sewing Machine* (figure 22), and compare it to the Diebenkorn drawing we just discussed. In spite of the difference in style and purpose, the Teichman and Diebenkorn drawings are kindred spirits regarding their respective approaches to hierarchy of emphasis. One is nonobjective and the other is highly descriptive, but they both feature focal points in similar unorthodox placements, and both rely on pressure points on the outside edge to make their drawings work.

In *Sewing Machine* we're immediately drawn to the upper-right quadrant of the space; specifically, to the three little spherical objects (balls of yarn? apples?) on a tabletop, clustered around a wine glass. We're drawn to them by the weight of their dark value. More fundamentally, we're also drawn to the entire cluster of objects on the tabletop in the upper right because it's framed and supported by the large area of darkness underneath and by the top and side of the drawing surface. Taken as a whole, this area is located higher than a comfortable just-off-center placement but not quite high enough to establish an on-the-edge placement. Teichman shows us that, in the hands of a master draftsperson, this unorthodox placement not only works but also adds exciting tension at the same time! How the hierarchy of emphasis flows is explained next.

Starting with the three dark spherical objects, a tiny implement on the tabletop points diagonally up and to the base of the sewing machine. The main vertical of the machine body points us up to a pair of concentric circles—another machine part—that serves as a secondary pressure point. Then, the horizontal body of the machine points us on a diagonal up and left, leading us by implication to the place where a series of verticals (curtains) engage the top edge—a third power point. These verticals direct us downward to an elongated bar that leads on a slight diagonal to the drawing's bottom left corner. There, moving to the right is a faint rhythmic sequence that moves on a diagonal up and to the right until we meet up with the powerful, dark vertical column of the table's base. Of course, that points up to the tabletop again, where we return to our point of origin.

figure 22

Mary Teichman
Sewing Machine, 1979
Pencil
11 x 17 inches (27.9 x 43.2 cm)
Collection of the Artist

PLAY 1 ■ HIERARCHY OF EMPHASIS

Here's a chance to play with the concept of hierarchy of emphasis, executing a pair of drawings within a "controlled environment" (remember, there is a lot of freedom to be gleaned from having a given structure in which to work). Here are your limitations: You'll be using straight lines only, and you'll be working with the same arrangement of lines in both drawings.

For this challenge, you'll need a medium to hard pencil (HB will work fine), a pencil sharpener, a kneaded eraser, a charcoal pencil, any other black, dry abrasion tools you'd like to add, and a straightedge of some sort (a ruler will work just fine). You'll also need access to a photocopy machine, or a scanner and printer, and three sheets of paper that will work in the duplicating machine. Get the largest size of paper your machine will handle: 8½ x 11 inches (21.6 x 27.9 cm) works great, but 8½ x 14 inches (21.6 x 35.6 cm) or 11 x 17 inches (27.9 x 43.2 cm) is even better.

For an overall approach to drawing, you're encouraged to refer to Eve Aschheim's drawings (*Title, Title,* on page 57, *Rung Without a Ladder,* on page 58, *Plural Blur,* on page 59, *Industrial Strength,* on page 59) for inspiration, as this exercise follows in their spirit. Here's what you'll do:

STRAIGHT LINES

1 Start out with three pieces of your photocopy or printer paper. On each, using a pencil and straightedge, fill the drawing surface with a bunch of short, straight lines (mostly varying from ½ inch [1.3 cm] to 3 or 4 inches [7.6 or 10.2 cm] in length). Make the lines uniformly light in weight. Draw some horizontal, some vertical, and others diagonal. Make sure that some lines engage the outside edge of the drawing space while others do not. When you're done, you should have something akin to what you see in figure 23.

figure 23

Ed Mazur
Workshop
Drawings, 2008
Charcoal on paper
Each: 14 x 11 inches (35.6 x 27.9 cm)
Courtesy of the Artist

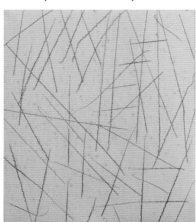 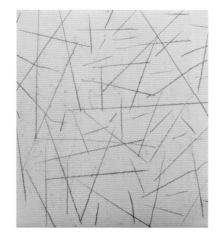 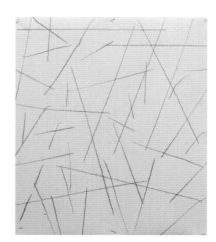

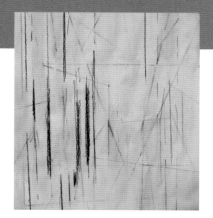

2 Now, select one of the three drawings, the one you find most intriguing, and make three copies using the photocopy machine or a scanner and printer. While you're at it, you might want to make a couple of extra copies in case you want to create additional variations of this drawing on your own when you're finished with the first two.

3 You now have three identical drawings in front of you. Save one copy as is to compare with the two variations you're about to create.

VARIATION 1

EMPHASIS JUST OFF CENTER

1 On the first of the two remaining drawings, create an arrangement that features a focal emphasis in a just-off-center placement, and a hierarchy of emphasis in response. You can create emphasis here in only one of three ways:

- Change the weight of the line itself, making it thicker or thinner, darker or lighter.

- Embrace the weight of the relative scale (bigger versus smaller, longer versus shorter) of line in the original drawing.

- Explore the relative power of the diagonal, the horizontal, and the vertical in the original drawing.

2 You can begin by selecting a focal point and work from there. Or you can start with no focal point in mind and determine your primary emphasis point as you go.

3 Continue processing the drawing, one step at a time, each step in response to the development of the drawing as a whole. Use the charcoal pencil to make some lines thicker or darker. Use the kneaded eraser to lighten up some of them again.

4 Keep the drawing going until you have achieved a hierarchy of emphasis that moves the eye around the drawing in an interesting and satisfying way. Figures 24 and 25 serve as examples.

VARIATION 2

EMPHASIS ON THE OUTSIDE EDGE

1 Take your second photocopy and develop a drawing in the same manner, this time creating a focal area somewhere on the outside edge of the space. In other words, you'll be having your most powerful element engage the outside edge somewhere—any location on any of the four edges will do.

2 Again, you can decide in advance where this outside edge placement will be, or you can decide as you go along.

3 Continue to process until a successful hierarchy in emphasis unifies the drawing in a satisfying way (recall Eve Aschheim's *Guess Back It*, page 180, as a superb example).

figure 24 (top left)

Beverly Munchel-Kievit
Workshop
Drawing, 2008
Charcoal and white paint on paper
14 x 11 inches
(35.6 x 27.9 cm)
Courtesy of the Artist

figure 25 (top right)

Fran Gardner
Workshop
Drawing, 2008
Charcoal and white paint on paper
14 x 11 inches
(35.6 x 27.9 cm)
Courtesy of the Artist

BUILD 1 ▪ HIERARCHY OF EMPHASIS

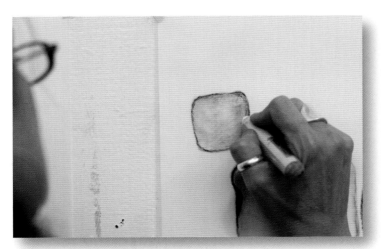

Kathy Casey makes the shape she will repeat to create her three drawings, shown below.

Here's an exercise similar to the last Play challenge, only this one has you working with a shape motif, and allows you the freedom to place strong emphasis points anywhere you'd like in the drawing. The tools and materials required are the same as in the Play on page 186, as are most of the procedures.

COMMUNITY OF SHAPE

1 Using a sharpened, relatively hard pencil that will allow you to make a consistently light line throughout this first step, engage your first piece of paper with a community of many incarnations of one shape, repeated over and over again in many variations. Create these shapes using contour lines only—don't fill them with tone or texture. Do make them larger, smaller, fatter, thinner; orient them in different ways, placing them wherever you'd like.

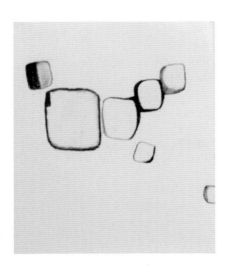

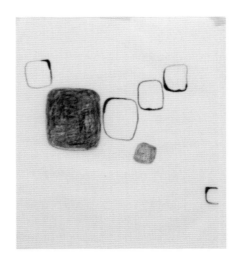

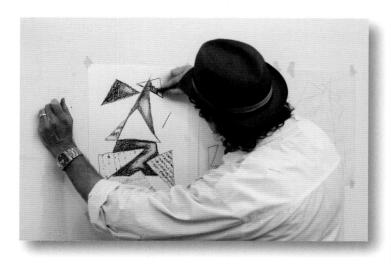

2 Again, make several copies of the original drawing.

3 Put all three drawing surfaces up on the wall or, if necessary, on a board in front of you.

4 Now, using the dynamics already present in the original, develop three variations of the same drawing by changing the weight of the contour lines only. It's recommended that you work on all three drawings at the same time, moving from one to another.

5 As the drawings proceed, develop a different hierarchy of emphasis in each. If you wish, you may begin to fill in some shapes with tone or texture. Keep them all going until you have three satisfying versions—that is, until all three move the eye around the space from point to point to point in satisfying ways (see examples by workshop artists Kathy Casey and Donny Floyd for inspiration).

Donny Floyd develops one of his drawings that illustrates different hierarchies of emphasis (top left); the finished drawing appears above.

ARTIST PROFILE

SAM GRUBER

1907–1996

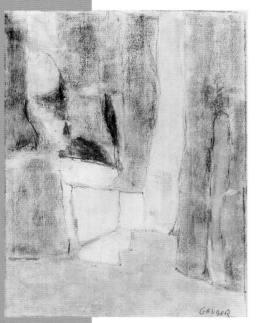

figure 14

Sam Gruber
Untitled
Pastel
17½ x 23 inches
(44.5 x 58 cm)
Courtesy of the Artist's Estate

Sam Gruber owned and operated an employment agency in Manhattan for many years. He finally sold it in 1967, when he was 60. He had begun playing the cello when he was 40 and was glad to be able to devote more time to his music during this period of his life. But, according to May (his widow), Sam felt like he could never "catch up" with other musicians, because he had begun playing so late.

He tried joining various amateur groups, but was not terribly successful. Being the resourceful man he was, he decided to start his own group in 1972—a kind of music camp for adults. He and May hired a director and staff, first-rate players, and they slated a time period to play and perform during a two-week period at New Hampshire's Saint Anselms College.

On the first day of rehearsal, Sam approached the hired director and asked where he might be placed to play his cello with the group. The director's reply greatly disappointed him: "Well, we're putting the wives and those who have accompanied the musicians in an art studio with a teacher, Seena Donneson, so why don't you go over there?"

He reluctantly parked his cello in a corner of the studio and went to the class, where he began to draw with pastels, per Seena's instruction. Pleased with what Sam created, she encouraged him to draw. Over the years, Sam drew and painted with passion, showed his work, and sold a number of pieces to raise money for the many causes he cared about.

During the 1980s, when Sam was still drawing as well as painting, his nephew, Jeffrey Gruber, visited him during a family gathering. Jeffrey, a painter, recalls Sam talking about his work: "You are trying to achieve some artistic goal in your painting, to prove something, but I don't do that or have that goal in mind. My artwork comes from spontaneous feeling and love of the process."

Sam's drawings are indeed testimony to his sensitivity, innate talent, and joy in producing the work (figures 14 and 15). His abstract compositions, created spontaneously and without concern about "success," flow with ease, like the music he longed to perfect.

— *Katherine Aimone*

190

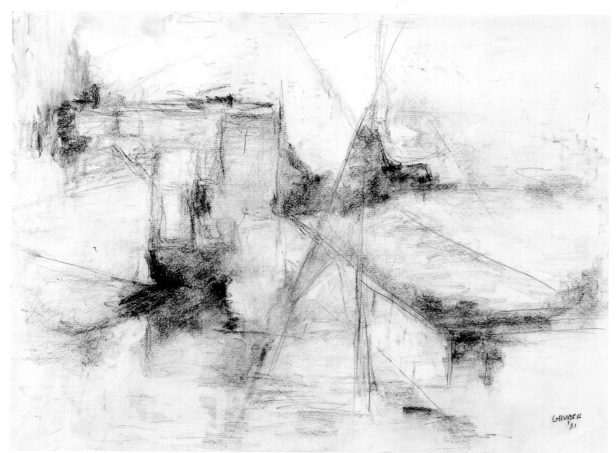

figure 15

Sam Gruber
Untitled
Pencil drawing

17 x 23 inches
(43 x 58 cm)
Courtesy of the Artist's Estate

CHAPTER TEN

FOUNDATIONAL STRUCTURE

In Chapters 6 through 9, we explored how different kinds of visual structures hold drawings together in unified and coherent ways. We've seen how elements of repetition and rhythm, and systems of equilibrium and emphasis, can serve this purpose. Now we'll conclude our exploration by examining how a series of underlying shapes can give drawings the foundational structure they need to hold together in richly satisfying ways.

figure 1

Lyonel Feininger
Paris Façade III, 1953
Watercolor, ink on paper

18½ x 11½ inches
(47 x 29.2 cm)

© 2008 Artists Rights Society (ARS),
New York / VG Bildkunst, Bonn
Courtesy of the James T. Dyke
Collection

Foundational structure occurs when a series of shapes join to cover (or engage) the entire drawing space, holding the space together in rock-solid fashion. They form a kind of interlocking jigsaw puzzle that acts as a foundation for the rest of the drawing. You might think of it as a drawing beneath the drawing. A foundational structure can be obvious or implied. In either case, it can furnish a drawing with clarity and coherency.

In the visual arts, foundational structures come in two varieties: *the grid* and *large underlying shapes*. We'll explore them both in the following pages.

THE GRID

In drawing workshops, whenever participants are asked to explore working in a grid, the reaction is more often than not one of reluctance; occasionally, the response is dread! Participants say things like, "Oh no ... that sounds so confining and inhibiting," and "I want to be free to express myself." The challenge is to demonstrate how the opposite is true—how working within a grid can be liberating instead.

Loosely speaking, you all know what a grid is: the division of space into an orderly series of compartments. Most commonly, this division is achieved through an evenly spaced series of vertical lines countered by an orderly and evenly spaced series of horizontal lines. These verticals and horizontals crisscross one another to form rows of rectangular or square compartments. Once this is done, the entire drawing surface is organized (figure 2).

Compositional coherency is a given, right from the start. Within that framework, you're free to do all kinds of things: Use the compartments as containers, make different kinds of connections between the compartments, join compartments together to make larger compartments or spaces, veil or cover up parts of the grid ... all these possibilities make a grid a truly liberating experience! And if, at some point, you alter the grid so much that it begins to lose its ability to organize the drawing, you can restore as much of the grid as you need.

figure 2

ORDERLY & DISORDERLY

Keep in mind that grids can be more or less orderly; there are many variations in grid character and type. Intervals from one vertical or horizontal to the next can vary in width; when this happens the nature and size of the compartments take on greater variety. Lines of division can occur on diagonals rather than verticals and horizontals; then the grid becomes inherently more dynamic. The lines of division can even become irregular or wavy. In all cases, however, the grid structure can serve as an effective foundation for a drawing. Figures 3 and 4 illustrate this clearly.

THE FUNCTION OF GRIDS

Grids function beautifully to serve a wide range of drawing purposes. Let's survey a few.

Highly utilitarian drawings such as calendars, ledger sheets in accounting, maps showing latitude and longitude, and so on rely on the framework of a grid to convey information, to tell their stories clearly and effectively.

Drawings with literary narratives, developed in a loose stream-of-consciousness manner, benefit from a gridded framework as well. In Renie Breskin Adams's *Bird Watching* (figure 5), a grid separates the "watchers" from the "watched." Adams's cats are confined to compartments above, while her birds are contained in two larger compartments below. The narrative consists of the dialogue between compartments, and the mixed-media drawing holds together beautifully!

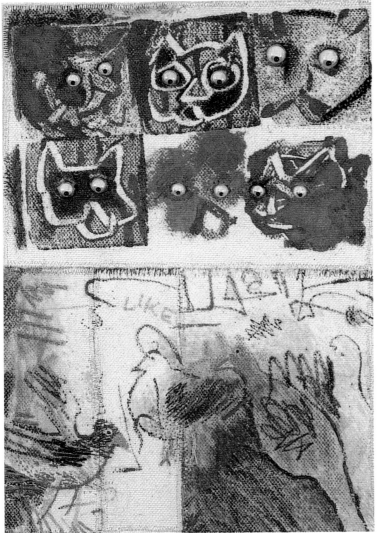

figure 5

Renie Breskin Adams
Bird Watching, 1995
Paint, pencil, embroidery,
and plastic eyes
7 x 5 inches (17.8 x 12.7 cm)
Courtesy of the Artist

Drawings done from observation, even highly representational ones, often rely on and feature underlying grids. Look at Lyonel Feininger's *Paris Façade III*, figure 1 on page 192. Feininger embraces the built-in gridlike qualities found in architectural elements and extends them to furnish compositional clarity. Notice how the foundational framework serves this purpose splendidly in spite of the lost-and-found nature of, and the diagonal variations within, the grid. In fact, these "imperfections and eccentricities" give the drawing added dynamism and an intriguing sense of mystery.

Finally, drawings verging on the nonrepresentational, as well as those that are completely nonobjective, often employ grids. Will Barnet's *Province by the Sea* (figure 6) indirectly refers to and evokes nature—organic shapes, ocean-blue color, horizontals. These poetic elements are harnessed together by a grid that lies "underneath."

figure 3

figure 4

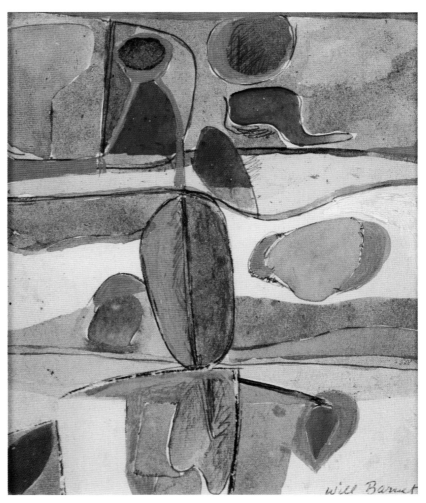

figure 6

Will Barnet
Province by the Sea, 1957
Pencil and watercolor on board

6 x 5 inches (15.2 x 12.7 cm)

The drawing by Ellsworth Kelly (figure 7) is both lively and unified. According to Kelly, the drawing "happened" serendipitously. Following in the footsteps of Dada artists such as Jean Arp and composers of chance music such as John Cage, he explored the creative process by deliberately embracing elements of chance.

As the title indicates, Kelly executed this drawing in three steps. First he drew a series of lines in ink on paper, then he cut the sheet into 49 equal-sized squares, and finally he put the pieces back together in a random fashion. If this drawing "just happened," why does it work so well?

Part of the answer is that Kelly's hand—the expressive quality of his line—is consistent. His lines are confident, direct, and sensitively executed. They're also predominately straight, and those that aren't gently curve. The weight of Kelly's line is consistent as well, with only subtle variations. All these constancies unify the drawing.

However, it's the gridded arrangement that is the ultimate unifier. We read the drawing as a series of equal-sized units, each containing as few as one, as many as five, but most often two to four lines (and in a few instances, dots or dashes). Next, we begin to read these units in aggregate rows, both vertical and horizontal, with each row telling a story of its own. Some of these rows form rhythmic patterns that are appealing, animating, and unifying.

So, in spite of giving over some artistic control in favor of chance events, an artist such as Kelly can produce work that holds together beautifully because of the consistent presence of the artist's hand and the inherent coherency of his chosen foundational structure.

figure 7

Ellsworth Kelly
*Brushstrokes Cut into Forty-Nine
Squares and Arranged by Chance,* 1951
Cut-and-pasted paper and ink
13¾ x 14 inches (34.9 x 35.6 cm)
Digital Image © The Museum of Modern Art / Licensed by
SCALA / Art Resource, NY
© Ellsworth Kelly

LOOK AT THIS REMBRANDT

What works in Modernist, non-objective drawings like Kelly's piece has always worked in traditional descriptive drawings as well. Rembrandt van Rijn's *Jeroboam Interrupted by the Prophet* (figure 8) is a fine example. While completely different in process and subject, the Kelly and Rembrandt drawings are kindred spirits in terms of their foundational structure. Let's see how this works.

Spend a moment or two taking in the Rembrandt drawing. Look past the recognizable elements and the literary storyline. Experience the grid that serves as the drawing's foundation. Sense horizontals wherever you can, both the obvious ones and those that are implied.

Figure 9 illustrates the myriad of horizontals you might have discovered. Now do the same in sensing vertical linear movements, and compare what you experience with what you see in figure 10. Then combine the two sets of crisscrossing lines, and you'll arrive at Rembrandt's foundational structure—the grid shown in figure 11 or a simplified version in figure 12. Amazing. Its structure is as thorough and effective as Kelly's.

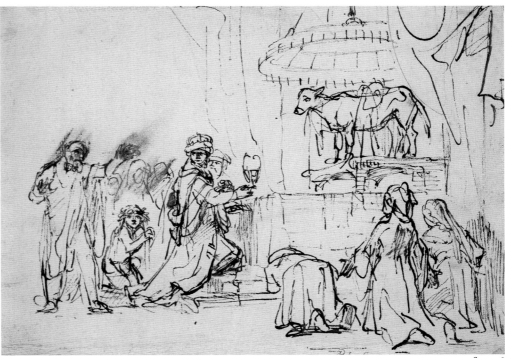

figure 8

Rembrandt Harmenszoon van Rijn
Jeroboam Interrupted by the Prophet, circa 1648–1652
Brown ink on paper
7 x 9¼ inches (17.8 x 23.5 cm)
Arkansas Arts Center Foundation Collection: Purchase, Fred W. Allsopp Memorial Acquisition Fund. 1984.019.002

figure 9

figure 10

figure 11

figure 12

PLAY 1 ▪ PLAYING WITH A GRID

Let's start by working with a grid as foundational structure. We'll follow Ellsworth Kelly's lead (page 196) in the way we draw and compose. First you'll do a drawing, then you'll deconstruct, or cut up, your drawing into a bunch of little squares, and finally you'll reconstruct the drawing pieces to make a new drawing featuring a gridded structure.

For this challenge, you'll need the following: access to a photocopy machine or a printer/scanner; six sheets of 8½ x 11-inch (21.6 x 27.9 cm) photocopy paper; a hard pencil and pencil sharpener; a ruler and scissors; a relatively soft drawing tool that won't smear when dry (pen and ink, acrylic paint and thin brush, a soft pencil, a soft felt tip pen, or a broad marker all work well); and adhesive to collage with (a glue stick, acrylic spray adhesive, or a water-based adhesive such as acrylic medium).

1 Position one sheet of the photocopy paper in a horizontal orientation, to be used as your drawing surface.

2 With the sharpened hard pencil, draw a horizontal line ½ inch (1.3 cm) down from the top, and a vertical line 3 inches (7.6 cm) in from the right side. When you've done this, you'll have created an 8-inch (20.3 cm) square inside the 8½ x 11-inch (21.6 x 27.9 cm) sheet, as shown in figure 13. In steps 3 to 8 to follow, consider your newly drawn 8-inch (20.3 cm) square area as your drawing space.

3 With your chosen soft drawing tool, start near the top of the paper, and draw a horizontal line that runs from the left edge all the way to the right edge of the 8-inch (20.3 cm) square drawing surface. Don't aim for perfection! Your line can curve or wiggle a bit, have a bump or two, as long as its voyage from left to right remains predominately horizontal. Allow your line to vary in weight if you like.

4 Just below that line, draw a second roughly horizontal line, one that again runs all the way from the left edge to the right. Let this line have moderate variations, too.

5 Continue moving down the drawing surface, making five additional lines in the same way until you've filled the drawing surface with horizontals.

6 If your drawing medium was wet, allow the lines to fully dry.

7 Using a sharpened hard pencil and a ruler, overlay a grid of very light vertical lines spaced 1 inch (2.5 cm) apart. You'll end up with a drawing space full of 1-inch (2.5 cm) squares. You'll have eight rows up and down, and eight rows across, as illustrated in figure 14.

figure 13

figure 14

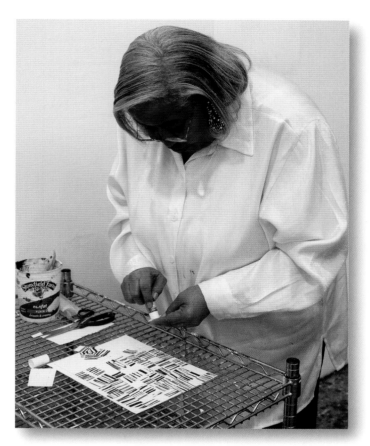

figure 15

figure 16

8 Make three or more copies of the drawing with the gridded overlay using the photocopy machine or the scanner/printer.

9 Next, cut off the excess ½ inch (1.3 cm) at the top of the paper and the 3-inch (7.6 cm) excess on the right side.

10 Cut up your 8-inch (20.3 cm) square drawing into 64 squares, each 1 inch (2.5 cm) in size, using the overlying grid as your guide.

11 Cut down another sheet of photocopy paper to an 8-inch (20.3 cm) square, and once again draw a grid of light 1-inch (2.5 cm) squares on it, so that it looks like figure 16.

figure 17

WORKSHOP

PLAY 1 ■ PLAYING WITH A GRID

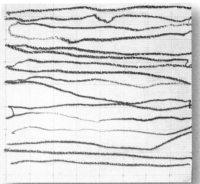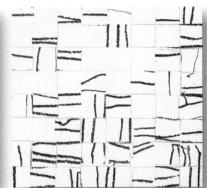

Nancy Rice (page 199) and Judy Alvarez (left) arrange cut components. Nancy's original and finished work are shown on page 199; Judy's are above.

12 Make a couple of photocopies of this gridded 8-inch (20.3 cm) square surface for future use.

13 Now you're ready to reconstruct your drawing. Begin arranging your little cut squares by placing them into your gridded 8-inch (20.3 cm) square paper. Play with them, moving them around a bit if you like. Or simply start pasting them into the grid, one after another, as Judy Alvarez above is doing here.

14 Continue until the grid is at least halfway filled in.

15 Stop and assess the drawing. Feel the arrangement. Then begin filling in additional squares based on what you feel the drawing needs.

16 Continue until the new arrangement is complete.

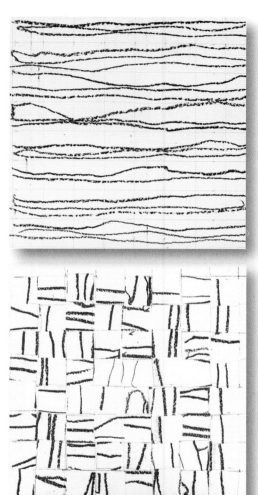

17 Repeat this Play exercise from step 8 at least one more time. Then compare the two or three reconstructed drawings you have in front of you. Take note of the comparative ways in which the drawings hold together, studying how the gridded foundational structure works as a liberating and unifying principle. How are these drawings similar? How are they different? How does each appeal to you and why?

George Rice cuts his paper along the grid lines (top left). His original and finished work is shown above.

WORKSHOP

BUILD 1 ▪ WORKING WITH A GRID

Here's your chance to organize drawings using a grid as foundation in two different ways, each representing contrasting approaches to art making. One—starting with a given grid and drawing in and out of it—offers a planned approach. The other—starting with automatic drawing and then discovering or arriving at a grid as you go along—is improvisational. Both are valid and effective approaches, and I suggest you try them.

For this challenge, you'll need the following: two paper drawing surfaces of your choice, identical in size and orientation; a hard pencil; a ruler; and an additional drawing medium (or a combination of materials that will let you assert and erase, such as charcoal and a kneaded eraser, watercolor crayon/s and white paint, graphite stick and white paint ... or combinations of all of these).

Note: You may opt to prime your drawing surface by first applying a coat of acrylic gesso, acrylic medium, or acrylic paint.

1 Place both drawing surfaces on a surface or wall in front of you, side by side.

2 On one of your drawing surfaces (call this one Drawing A), using a hard pencil and a ruler, compose a grid of equally spaced, straight horizontals and equally spaced, straight verticals.

3 On the other drawing surface (call this one Drawing B), quickly and without thinking, execute an automatic drawing such as you did in chapter 2. If you like, refer to pages 28–33 to refresh your memory.

4 You now have your starting places for the two drawings that explore a grid.

DRAWING A: STARTING WITH A GRID

1 In Drawing A, begin by doing some automatic drawing onto the gridded surface. Make sure to look at the drawing surface while you draw. Allow the automatic drawing to freely traverse the grid.

2 Next, look for places where the gridded movements and the automatic drawing movements begin to coincide or hint at joining together. Using your drawing media, experiment with making these connections stronger. Cover up areas, if necessary, to emphasize horizontal and vertical movements.

3 Now, begin to process the surface by putting in the grid and taking some of it away. Put in and take away, altering the grid if you wish; then assess the drawing again.

4 Continue to develop the drawing until you feel satisfied and perceive it to be organized, even in a subtle way, by the grid as foundational structure.

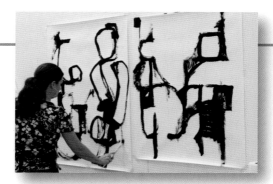

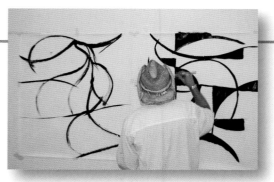

Kathy Casey develops her two drawings for the challenge; below is her finished drawing A.

Donny Floyd works on his two drawings for the Build 1 challenge; below is his finished drawing B.

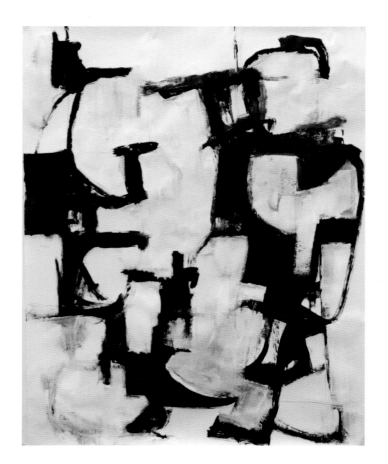

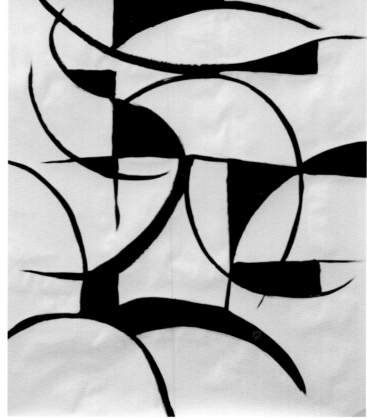

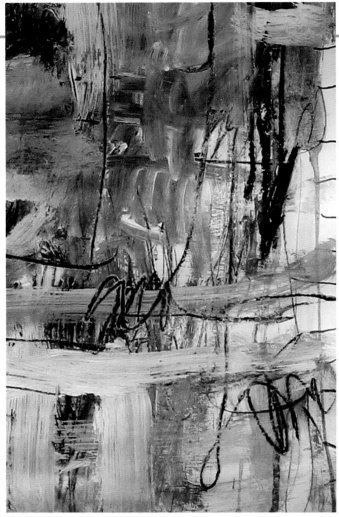

figure 18

Charlotte Foust
Working in and out of a Grid,
Drawing A (left) and Drawing B (right), 2007
Mixed media on paper
Both Courtesy of the Artist

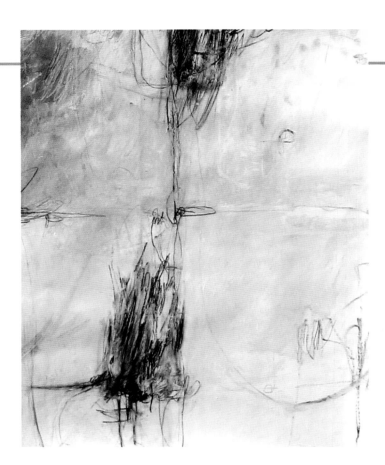

DRAWING B:
DEVELOPING A GRID

In Drawing B, you'll do the reverse of what you did
with Drawing A.

1 To begin Drawing B, take some time to contemplate
the automatic drawing you produced. Sense it, feel it.
Look for places and movements that suggest horizontals
and/or verticals. With your drawing medium, mark
some indications of a few of these.

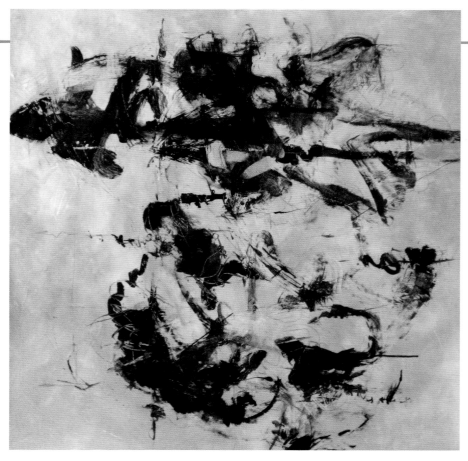

figure 19

Antoinette Slick
Working in and out of a Grid,
Drawing B, 2007
Mixed media on paper
Courtesy of the Artist

2 Next, sense the newly forming connections
between your automatic drawing and the hints of a grid
that are beginning to emerge from the horizontals and
verticals. Remember, you have the option of erasing, or
covering with paint, some of the automatic elements to
establish the grid more forcefully.

3 Continue the process of alternately establishing
gridlike structuring and taking some away. Put in and
take away, altering the grid if you wish; then assess the
drawing once more.

4 Continue to develop the drawing until you're
satisfied that it feels organized, however subtly, by the
grid as foundational structure.

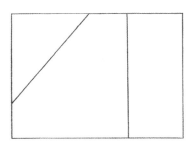

figure 20

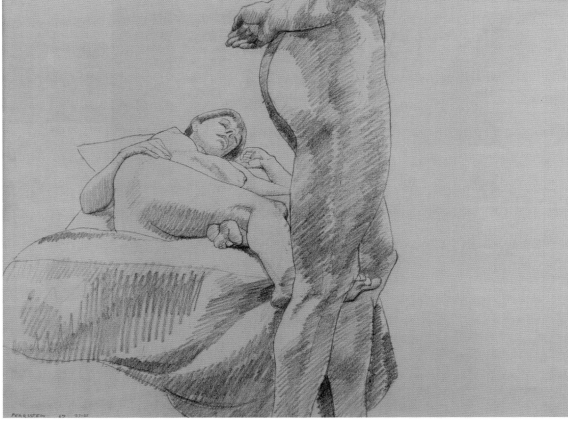

figure 21

Philip Pearlstein
Two Models, 1960
Graphite on paper

11 x 16 inches
(28 x 40.6 cm)

Collection of Adam Reich
and Clare Walker, NY
© Philip Pearlstein

LARGE UNDERLYING SHAPES

A second way to organize a drawing with foundational framework is to use a small grouping of large underlying shapes as a sub-structure. As was the case with the grid, *large underlying shapes* interlock to form a jigsaw puzzle-like arrangement that forms a foundation for the drawing. These shapes engage or cover the entire drawing surface to unify it. Keep in mind that three, four, or five shapes—and even as many as six or seven—can work together to accomplish structural clarity. Many more than that and you're likely to lose the coherency that this principle offers.

In the Renaissance, artists often relied on this kind of structuring. Many traditional presentations of the Madonna and Child employed three interlocking triangles. One large triangle, with its base at the bottom of the drawing and its apex at the top of the space, would contain the mother and child—the primary narrative and visual elements. Then, the "leftover" areas to the left and the right took the form of triangles as well, with their bases at the top of the drawing and their apexes at the bottom. These secondary triangles also contained

figure 22

Pat Williams
Kairos, 2005
Colored pencil
11¼ x 6 inches (28.6 x 15.2 cm)
Courtesy of the Artist

visual and narrative elements. This simple, clear, three-triangle underpinning held such drawings together beautifully.

Contemporary artist Philip Pearlstein uses a similar approach in his highly representational drawing *Two Models* (figure 21). Again, three big shapes underlie the drawing. One large triangle contains not just the primary narrative and visual elements; in this case, it contains *all* of them! In it we find a vertical figure, the right side of which forms the right side of the large underlying triangle; and a reclining figure at rest on a bed or couch, the outside contours of which form the left side of the large triangle. The bottom left side of the drawing space forms the third side of the main triangle. Then to the outside of this primary triangle are two absolutely passive and empty spaces—a rectangle to the right, and a smaller triangle, top left (figure 20).

Contemporary fiber artist Pat Williams employed three large shapes in composing her dreamlike narrative, *Kairos* (figure 22). Notice how the three triangles with

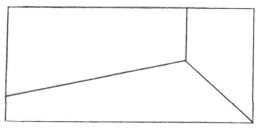

figure 23

cropped tops lock the space together, as shown in figure 23. Then, observe how the artist continued to develop the drawing's design. For example, each modified triangle contains, or frames, one large modified oval—the window on the upper left, the doorway to the right, and the cropped tabletop at the bottom. Your eye is drawn from one to another to the third. Notice too how the daisies and daisy petals take you on a delightful rhythmic movement that threads its way through the space—from the window in the upper left, across the table and then the floor, culminating in the landscape outside the doorway to the right.

WORKSHOP

BUILD 2 ■ WORKING WITH UNDERLYING SHAPES

This final hands-on challenge is similar to the Build 1 on pages 202–205. We'll create two drawings that explore a pair of approaches to the same foundational structure, this time using large underlying shapes. The first drawing offers a pre-planned approach: You'll start with an underlying shape structure in place and develop the drawing from there. The second allows you to improvise: You'll start with unplanned, automatic drawing and then explore ways of arriving at the foundational structure. Try them both!

1 Place both drawing surfaces on a surface or wall in front of you, side by side.

2 On one of your drawing surfaces (Drawing A), using a hard pencil and a ruler, lay out a foundational structure of underlying shapes. Remember to limit the number of shapes to five or fewer, and make sure that together they engage the entire drawing surface.

3 On the other drawing surface (Drawing B), quickly and without thinking execute an automatic drawing as you did in chapter 2.

4 You now have your starting place for your two drawings exploring underlying shapes.

DRAWING A: PLANNED STRUCTURE

1 Begin Drawing A by doing some automatic drawing on the surface containing the lightly drawn underlying shapes. Make sure to look at the drawing surface as you draw. Allow the automatic drawing to flow throughout the space, freely moving from one underlying shape to another.

2 Before too long, stop for a moment and take in the drawing as a whole. Look for places in the drawing where the parts of the automatic drawing movements begin to interact with the large underlying shapes. For example, one of the shapes may neatly begin to serve as container for an especially nice bit of linear movement.

3 Using your drawing media, experiment with making these connections stronger. Cover up nearby passages, if you wish, to emphasize certain areas.

4 Initiate more automatic drawing. Then take things in once more, and edit again.

5 Continue to develop the drawing until you're satisfied and experience it as organized, however subtly, by large underlying shapes.

DRAWING B:
FINDING A STRUCTURE

In Drawing B, you'll do the reverse of what you did
with Drawing A.

1 Take some time to absorb the automatic drawing
you've generated. Sense it; feel it with your right brain,
with your body.

2 Look for passages or movements that suggest a
large underlying shape or two, or the potential for such
shapes. With your drawing medium, mark a few of
these possibilities.

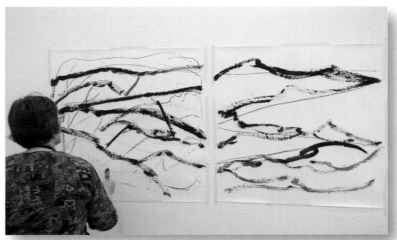

3 Next, establish a large underlying shape or two
more firmly and assertively. Remember, you can cover
up or erase some of the automatic elements to establish
or emphasize larger foundational shapes (at right).

4 Keep the drawing in flux, alive, moving. Feel free to
change course by taking out or de-emphasizing a large
underlying shape (by erasing or covering with paint) to
make room for a new one.

5 Continue to develop the drawing until you're
satisfied with the result and find it to be organized in
subtle ways by the use of these large underlying shapes.

**Nancy Perry develops her two drawings
based on underlying shapes. The bottom
photo shows her two finished pieces.**

Magdalena Abakanowicz uses large underlying shapes in a big way in her powerful charcoal drawing, *Bullface 85c* (figure 24). Although the drawing depicts a face, bull or human, on a gut level it suggests a towering architectural construction.

Abakanowicz's drawing consists of a three-shape understructure. One dark, oversized central triangle sits to the right of center. This triangle is inverted, its base at the top of the drawing, and its implied, cropped apex located well below the bottom of the space. To each side is a smaller triangle, each completely passive and nearly empty. These three triangles join together to strongly engage the entire drawing space.

Now let's look at the drawing in more detail. Do you see how the drawing's shape foundation could be a four-shape understructure instead, with the central dark triangle divided into smaller triangles by a central axis? Can you see how the large dark triangle serves as a container for an oval that seems deeply embedded? Big, big shapes … powerful structural coherency!

Compare Abakanowicz's largely abstracted drawing to Will Barnet's more highly representational and beautifully rendered *Portrait of Carole* (figure 25), and you'll see another pair of kindred spirits. Again, though the two drawings are radically different in purpose and surface appearance, they're fundamentally similar underneath.

Notice how Barnet also constructs his drawing around a central triangle. This time the base of the triangle is at the bottom, with its implied apex just off the top. Observe, too, how the central triangle serves as a container for all the important descriptive elements, while the two modified triangles to either side are empty and act as ground for the figure. Once you sense Barnet's large, distilled three-shape foundation, you can go on to appreciate how the central triangle is broken down architecturally into smaller shapes that are modified geometrics—the modified circular fragment at the bottom, the triangular lower sleeves on each side of the subject's garment, the modified triangles of the clothing draped over her shoulders, the modified rectangle in the middle of her torso, and so on.

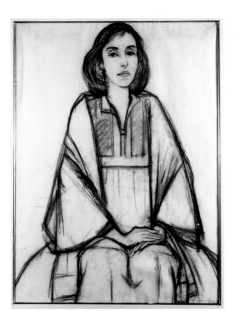

figure 25

Will Barnet
Portrait of Carole, 1982
Charcoal on paper

28½ x 20 inches
(72.4 x 50.8 cm)

Arkansas Arts Center Foundation
Collection: Gift of Will and Elena
Barnet, 2001. 2001.025.041
© Will Barnet / Licensed by VAGA,
New York, NY

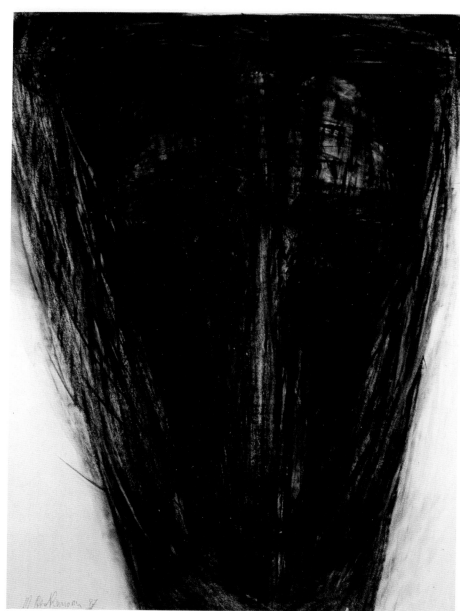

figure 24

Magdalena Abakanowicz
Bullface 85c, 1987
Charcoal on paper

39½ x 29⅝ inches (100.3 x 75.3 cm)

Arkansas Arts Center Foundation Collection: Purchase. 1990.033
© Magdalena Abakanowicz, courtesy of Malborough Gallery, New York

IN CONCLUSION ... DON'T STOP NOW

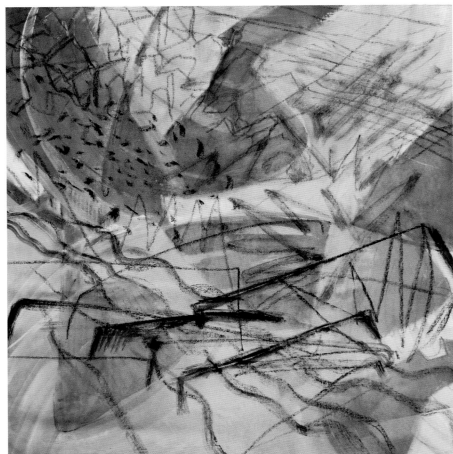

figure 26

Nancy Farrell
Landscape at New Smyrna, 2008
Mixed drawing media on paper
36 x 36 inches (91 x 91 cm)
Courtesy of the Artist

Here we are—hopefully not much older but infinitely wiser. We've had quite a conversation together: 10 chapters covering all major aspects of expressive drawing; more than 100 drawings by master artists to learn from and enjoy; dozens of Play and Build exercises to give you hands-on experience and develop visual acuity; numerous photographs of workshop artists exploring the world of expressive drawing; and several inspiring profiles of artists who began to draw later in life. At this point, I'm confident you have a good idea of what expressive drawing is and what kinds of things it can do for you. You've even likely turned out some satisfying expressive drawings of your own.

After 200-plus pages, this isn't an end but a beginning. You may choose to use the understanding and experience you've gained to continue drawing as a hobby and to appreciate more fully the work of others artists. Or you may also choose to learn more about drawing to further your expressive potential as an artist. In that case, what's the next step?

In this book, I've set the agenda for you. I've furnished you with information, guidance, and inspiration. I've designed the hands-on Play and Build challenges that served to structure the kinds of expressive drawings you created. Now it's your turn to set your own agenda.

If you have an urge to study a specific kind of drawing in more depth, I'd suggest finding an instructor or mentor. Do your research first by checking out your local college or university to see what they have to offer. Local art centers often provide classes, too. Look for an instructor who emphasizes the things you're looking for. Sit in on a class or read something he or she has written. Speak with current or former students. Then, trust your instincts and sign up.

WORKING ON YOUR OWN

On the other hand, if you've already done your classroom time, you can certainly continue by working on your own, as most artists eventually do. In this case, you'll need to establish structured challenges for yourself. For example, challenge yourself to complete a dozen drawings that focus on the dialogue between the geometric and the organic as a metaphor for life, or do a series of narrative "in flux" drawings to reveal your memories or imaginings.

No matter which route you take, I recommend you do some or all of the following:

Set up a studio. Claim a place of your own, such as a room, a corner of a room, or even a large table—an area where you can leave out your drawing supplies, sit comfortably, and have the space to engage in creative drawing.

Establish a time of day or a set number of hours per week as your studio time and stick to it. This is your time to feed your creative urge and satisfy your internal yearning. Whenever you can, make sure your drawing time comes first (you'll be a better spouse, friend, or grandparent if you do).

Study art history and the history of modern art in particular. You can do this in classes, in books, and on the web. Whenever you come across an artist's work that touches you, read everything you can get your hands on about him or her.

Subscribe to at least one art magazine, both to learn new techniques and to keep in touch with what your contemporaries are doing.

Get out and look at drawings and paintings whenever you can. Become a member of the "friends of art" group at your local university galleries and attend exhibitions and artist's talks. Do the same at your nearest art museum.

Use the web to visit major museum sites. Look at their drawing collections in particular, often now referred to as "works on paper."

Take your inspiration seriously, whether it comes from another artist's work or a walk through the woods or alongside the ocean. Feed your soul, and your artistic endeavors will reflect it.

Re-read What Keeps You from Drawing, pages 18–21 in this book. The ideas will remind you that … you can draw!

Be kind to yourself and enjoy. That's the best advice of all.

INDEX

ACKNOWLEDGMENTS

The opportunity to write this book has been a blessing, and it's my hope that it contributes to our understanding and appreciation of the language of drawing. My thanks to all those at Lark Crafts, Sterling Publishing, and AARP for supporting me in this undertaking.

Lark Crafts Senior Editor Deborah Morgenthal has been at the helm of this formidable project from conception to publication. In charge of launching the new AARP Live and Learn book series, Deborah played an integral role in the book's conception and has been an enthusiast and intelligent collaborator throughout the publication process. Thank you kindly, Deborah—in many ways this book is as much yours as it is mine.

Thanks as well to Deborah's counterpart at AARP, Managing Editor Allan Fallow, for his unwavering support and invaluable contributions; to Art Director Dana Irwin for her exquisite design of both the book and its cover; to the production assistance of Bradley Norris: what a patient guy!; to assistant editor Mark Bloom for his thorough proofing; to the photographic artistry of David Aimone, Steve Mann, Stewart O'Shields, and Keith Wright who skillfully documented workshop sessions for the book; to Lynne Harty, whose photographs enliven the front cover; and to Eli Corbin, who had the confidence and generosity of spirit to allow us to photograph her and her artwork for the cover.

Finally, this book would never have come to be without my wife and partner, writer and artist Katherine Aimone. She researched and obtained the reproduction rights for the majority of the wonderful drawings in this book, and she wrote the Artist's Profile sections that enrich and support the text. She also served as "Supporter in Residence"—offering me the encouragement and time needed to work on what became known as "The Book." Thank you in more ways than you'll ever know, and for sharing with me the wonder of it all.

And to all the artist-participants who have taken part in my workshops through the years, and especially to those shown in these pages:

Paul Adams
Katherine Aimone
Judy Alvarez
Tacy Apostolik
Jean Banas
Jeff Brooks
Kathy Casey
Mark Combs
Eli Corbin
Nancy Farrell
Donny Floyd
Charlotte Foust
Fran Gardner
Judy Gilmer
Diana Gilson
Regina Gudelis
Krista Harris
Dana Irwin
Mary Margaret Jones
Catherine Hayden-Cooper
Erin Jones
Louise Lachance Legault
Jim LaFerla

Gwen Magee
Martha Mahoney
Ed Mazur
Annie Miller
Beverly Munchel-Kievet
Una Paris
Audrey Phillips
Nancy Perry
Tim Proctor
Sharon Reed
Maria Rodarte-Reyes
George Rice
Nancy Rice
Kelly Richards
Maggie Rodman
Judy Schwarz
Don Silver
Antoinette (Toni) Slick
Linda Somer
Charlene Thomas
Robin Whitfield
Maryjane Whitfield

I'd also like to take the opportunity to thank many others. To our beloved parents, the late Kenneth and Ruth Aimone and Pope and Margaret Duncan for shepherding Katherine and I through life. To artist-friends Gary Bolding and Steven Palmieri for sharing their intelligence, friendship, and insight through the years. And to my brother, composer and photographer David Aimone, for being there always. Bless you all.

To Atlantic Center for the Arts, New Smyrna Beach, Florida, for serving as host to our workshops for eight years running.

To the artists who allowed us to include their drawings in the book, and to the institutions that loaned us images of those works, particularly the Arkansas Arts Center. Special thanks also to James Dyke, who provided us with images from his private collection.

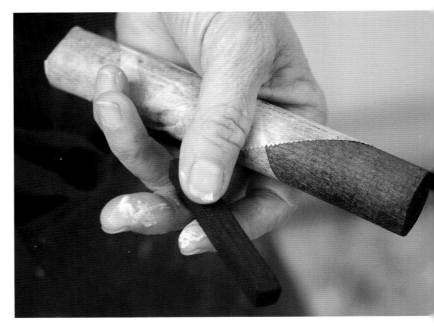

NAMASTE,
Steven Aimone